To the Latest Posterity

PENNSYLVANIA GERMAN HISTORY AND CULTURE SERIES,
NUMBER 4

Publications of the Pennsylvania German Society,
Volume 37 (2003)

Editor

Simon J. Bronner
The Pennsylvania State University, Harrisburg

Editorial Board

C. Richard Beam, Millersville University
Donald F. Durnbaugh, Juniata College
Aaron S. Fogleman, Northern Illinois University
Mark Häberlein, University of Freiburg, Germany
Donald B. Kraybill, Messiah College
Kenneth McLaughlin, University of Waterloo, Canada
A. Gregg Roeber, The Pennsylvania State University, University Park
John D. Roth, Goshen College
Hans Schneider, Philipps University, Marburg, Germany
Denise A. Seachrist, Kent State University, Trumbull
Richard E. Wentz, Arizona State University
Marianne S. Wokeck, Indiana University—Purdue University, Indianapolis
Don Yoder, University of Pennsylvania

Previous titles in the series

Margaret Reynolds, *Plain Women: Gender and Ritual
in the Old Order River Brethren,* edited by Simon J. Bronner

Steven M. Nolt, *Foreigners in Their Own Land:
Pennsylvania Germans in the Early Republic*

Jeff Bach, *Voices of the Turtledoves: The Sacred World of Ephrata*

CORINNE *and* RUSSELL EARNEST

To the Latest Posterity

*Pennsylvania-German Family Registers
in the
Fraktur Tradition*

THE PENNSYLVANIA STATE UNIVERSITY PRESS
UNIVERSITY PARK, PENNSYLVANIA

Library of Congress Cataloging-in-Publication Data

Earnest, Corinne P.
To the latest posterity : Pennsylvania-German family registers in the Fraktur tradition /
Corinne and Russell Earnest.
p. cm.
(Publications of the Pennsylvania German Society ; v. 37.
Pennsylvania German history and culture series ; no. 4)
Includes bibliographical references and index.
ISBN 0-271-02368-6 (alk. paper)
1. Registers of births, etc.—Pennsylvania.
2. Church records and registers—Pennsylvania.
3. Illumination of books and manuscripts, Pennsylvania Dutch.
4. Pennsylvania Dutch—Genealogy.
I. Earnest, Russell D.
II. Title.
III. Publications of the Pennsylvania German Society (2001) ; v. 37.
IV. Series: Publications of the Pennsylvania German Society (2001). Pennsylvania
German history and culture series ; no. 4.

GR110.P4 A372 vol. 37
974.8'00431s—dc22
[929/.2/0893107]
2003022849

To the Latest Posterity:
Pennsylvania-German Family Registers in the Fraktur Tradition
is dedicated to Amos and Nora Hoover. Amos is not only a bibliophile
and scholar, but he and Nora also have dedicated their lives to the Muddy
Creek Farm Library—a collection of imprints and other materials that will
serve students and scholars of Mennonite and Pennsylvania-German history far
into the future. Amos modestly attributes "the success of finding every
piece in this unique Old Order Mennonite collection [to]
a direct intervention of Providence."

This dedication is also in remembrance of happy times
spent around the dinner table where another of Amos's
loves can be found—buttered noodles.

CONTENTS

ILLUSTRATIONS

FIGURES

COLOR PLATES
(following page 58)

ACKNOWLEDGMENTS

We will forever be in debt to Professor Dr. Klaus Stopp of Mainz, Germany, and Dr. Ingrid Faust of Bingen for their enthusiasm and for sharing their expertise. For many years, they and Dr. Donald A. Shelley and his wife, Esther, have patiently guided us into what was for us uncharted waters. In addition, these mentors continue to give their consistent and unwavering support, advice, and encouragement in our fraktur research.

We also want to express our deepest appreciation to our two children, Patricia Corinne (Earnest) Suter and Russell David Earnest Jr. The bright faces of the grandchildren they gave us will forever inspire and motivate us to appreciate and promote their German heritage.

Dr. Simon J. Bronner, editor of the Pennsylvania German History and Culture Series, deserves special recognition and gratitude. His patience and professionalism have made this project highly rewarding, and his constructive suggestions added dimension and depth to this book. Peter J. Potter, Laura Reed-Morrisson, Timothy L. Holsopple, and Jennifer Norton at Penn State Press deserve special thanks for what Simon Bronner correctly calls the "magical process of turning [our manuscript] into a book."

Amos Hoover of the Muddy Creek Farm Library, Carolyn Wenger of the Lancaster Mennonite Historical Society, John Vidosh, Clarke Hess, Elaine Reeder, Josh Reeder, Charles and Tandy Hersh, and Ken Leininger have been especially helpful and engaged in this study. Throughout, they offered assistance and encouragement.

Amos Hoover and Klaus Stopp not only contributed to our study but also reviewed parts of the manuscript. Dr. John L. Ruth also provided helpful comments. Peter Seibert and Wendell Zercher of the Heritage Center Museum of Lancaster County, Jennifer Kindig, Joe Kindig, Vic Leininger, June Burk Lloyd of the York County Heritage Trust, Tom Johnson, Dr. Carola Wessel of Göttingen University, and Richard Machmer were quick to notify us when they discovered examples that added to understanding the history of Pennsylvania-German family registers.

We also wish to thank David and Karen Hampel of Slidemakers (Lansdowne, Pennsylvania), Tim Shreiner of Hayman Studio (York, Pennsylvania), and John

Parmer and Martin Amt for their assistance with images used in this book. Special thanks goes to Georgia B. Barnhill of the American Antiquarian Society for sharing her unpublished manuscript, "Keep Sacred the Memory of Your Ancestors," and to contributors of illustrated examples who chose to remain anonymous.

To the Latest Posterity: Pennsylvania-German Family Registers in the Fraktur Tradition could not have been written without the cooperation and support of the following people, who unselfishly gave time and expertise. We are grateful to Laura Wasowicz, American Antiquarian Society, Worcester, Massachusetts; Roddy Moore, Blue Ridge Institute, Ferrum, Virginia; Urs B. Leu, Central Library of Zurich, Zurich, Switzerland; Jeff DeHart, Conestoga Auction Company, Manheim, Pennsylvania; Jacquelin DeGroff, The Dietrich American Foundation, Chester Springs, Pennsylvania; Kerry Mohn and Michael Showalter, Ephrata Cloister, Ephrata, Pennsylvania; Ann Upton, Franklin and Marshall College, Lancaster, Pennsylvania; William Lang, Karen Lightner, and Joël Sartorius, The Free Library of Philadelphia; Cynthia Marquet, The Historical Society of the Cocalico Valley, Ephrata, Pennsylvania; T. Glenn Horst, Horst Auction Center, Ephrata, Pennsylvania; Gerald Studer, International Society of Bible Collectors, Lansdale, Pennsylvania; Donald F. Durnbaugh, Juniata College, Huntingdon, Pennsylvania; Barry Rauhauser and Ginger Shelley, Lancaster County Historical Society, Lancaster, Pennsylvania; David Smucker, Lancaster Mennonite Historical Society, Lancaster, Pennsylvania; James Green, The Library Company of Philadelphia; Joel Alderfer, Mennonite Heritage Center, Harleysville, Pennsylvania; Julie Zestel, The Metropolitan Museum of Art, New York, New York; Jennifer Bean Bowers, Museum of Early Southern Decorative Arts, Winston-Salem, North Carolina; Jerome Anderson, Chad E. Leinaweaver, Timothy Salls, and D. Brenton Simons, New England Historic Genealogical Society, Boston, Massachusetts; Wendy Shadwell, New-York Historical Society, New York, New York; Jane Richardson, The Northumberland County Historical Society, Sunbury, Pennsylvania; Lee Gruver and William L. Joyce, The Pennsylvania State University, Special Collections, University Libraries; Bert Denker and Margaret Welch, Winterthur Museum, Winterthur, Delaware; and Lila Fourhman-Shaull, York County Heritage Trust, York, Pennsylvania. In addition, we acknowledge the assistance of James Adams, York, Pennsylvania; Kinsey Baker, Lancaster, Pennsylvania; Gary Bollinger, Northfield, Minnesota; Tony Bollinger, Erwin, Tennessee; Gene Comstock, Winchester, Virginia; Richard Cryer, Greenwich, Connecticut; Donna Dews, Scottsville, New York; James and Nancy Glazer, Villanova, Pennsylvania; Donald and Patricia Herr, Lancaster, Pennsylvania; Beverly Repass Hoch, Wytheville, Virginia; John T. Humphrey, Washington, D.C.; Joan and Victor Johnson, Pennsylvania; Fred and Doris Leas, Pennsylvania; Ronald and Isabella Lieberman, Kinzer, Pennsylvania; Ray and Selma Mead, York, Pennsylvania; Kashik and Maria Pukownik, Orrtanna, Pennsylvania; Edward and Linda Rosenberry, Carlisle, Pennsylvania; Jerry Sho-

walter, Ivy, Virginia; Rachel Spease, Lewistown, Pennsylvania; Clarence Spohn, Lititz, Pennsylvania; James and Nan Tschudy, Lancaster, Pennsylvania; Beverly B. Wagaman, Pennsylvania; and John and Sharon Walters, Wharton, New Jersey.

PROLOGUE

The United States is one of the few countries that can boast the luxury of having started its history with a large literate population. As Benjamin Franklin said in 1786, "We are, I think, in the right Road of Improvement, for we are making Experiments."[1] One of those experiments became manifest in the recording of personal histories. Western civilizations typically recorded histories of families of title and wealth, but Americans broke new ground in regularly recording histories of families from humble origins. Because so many Americans were literate, they had the tools and the know-how to write their own family records. The results of their efforts were remarkable: a keen interest in recording family history gave birth to the American family register. Generally, these registers were single-sheet, stand-alone records or multi-page Bible records documenting the immediate family. Pennsylvania Germans, in particular, created an enormous body of this kind of personal literature. And just as important, their love of decoration caused them to turn many of these documents into an art form that mirrored their culture.

The act of immigrating prompted some Americans to document their beginnings on a new continent; later, the Revolution impelled families to record their histories. The turning of the centuries and our first and second centennials of independence similarly stimulated interest in genealogy. Through family registers and other personal documents that record family events—such as numerous types of Pennsylvania-German decorated manuscripts, called "fraktur"—we learn that many early Americans had a strong sense of family history. We also learn that these ancestors were interested less in recording the past than in documenting their present. This "present" meant their posterity—the children upon whom they pinned hopes for their families' futures in the New World.

Americans who invested resources in recording personal histories were addressing future generations, for they created registers intended to last. For example, in 1731, B. Green of Boston published the first genealogy printed in what is now the United States. One of the authors of this book, Roger Clap (1609–1691), incorporated a clearly stated message into the book's title. In his words, he was "Instructing, Counselling, Directing and Commanding" his children and children's children "to the latest Posterity." For emphasis, he added these words from Hebrews 11:4: "He being dead, yet speaketh."[2] Although most American

family registers do not address future generations so pointedly, they echo Clap's sentiment. Early registers were hand-decorated, preserved in Bibles, or machine printed as if carved in stone. Such measures (at least theoretically) ensured that future generations would read and cherish these records.

By the early 1700s, when large numbers of German-speaking immigrants began converting Pennsylvania's mature forests to farmland, Americans were already taking on an identity that would separate them from peoples left behind in Europe. The adjustment to a newly adopted identity was especially acute for Pennsylvania Germans. Unlike English-speaking immigrants, Pennsylvania Germans quickly had to accustom themselves to English language, law, and government. They had to gain at least a rudimentary knowledge of English if they were to market goods to their English-speaking neighbors. To record deeds for the transfer of property, settle estates, and generally abide by the laws of the land, they needed to have their written language translated into English. They had to learn new social customs, monetary standards, and systems for weights and measures; moreover, they had to rub shoulders with adherents of various religions, many of which were strange to them.[3] Yet letters they wrote to friends and relatives still in the homeland show that most saw opportunities in America they could never imagine in Europe. Crossing the Atlantic was like an act of baptism—and for most, the past was washed away. In this environment, the Pennsylvania-German family register was developed, nurtured, tweaked by technology, and then homogenized by evolving social values, mobility, and demographics.

Pennsylvania Germans, often called "Pennsylvania Dutch," were German-speaking immigrants who came to American shores before 1800. Unlike German Americans who emigrated later, primarily from northern Germany (see Appendix C), most Pennsylvania Germans emigrated from southern parts of Germany or from German-speaking areas of France (especially Alsace) or Switzerland. Some came from other areas of German-speaking Europe. Schwenkfelders emigrated from Silesia, the greater part of which is in present-day Poland. Moravians came from Moravia, a province of the Czech Republic, and Pietists and Separatists trickled in from various other parts of Europe. Most German-speaking immigrants were Protestant. About 80 percent were Lutheran and Reformed.[4] The remaining were Catholic or Sectarians, such as Mennonites, Amish, Schwenkfelders, Moravians, and Brethren (Dunkers).

Except for Sectarians, who were often persecuted in Europe, most Pennsylvania Germans came to America seeking economic opportunities and inexpensive land for farming. In their search for suitable land, they spread inland from the ports through which they immigrated—from Philadelphia, primarily—throughout southeastern Pennsylvania, the Shenandoah Valley in Virginia, and eventually to Ohio and beyond. These Americans of German heritage eventually became absorbed into mainstream America. But their descendants often held tenaciously to their land, religion, language, and traditions. Even today, Pennsyl-

vania Germans form a distinct subculture—especially in southeastern Pennsylvania, where most of them settled.

To understand Pennsylvania Germans and their decorative arts, one must have some knowledge of the environment in which Pennsylvania Germans labored, loved, laughed, and cried. First and foremost, they were Americans influenced by their agrarian environment and the economic, political, and religious swirl of events around them. As a result, the decorative arts of the Pennsylvania Germans encompass Old World folklore, styles, and techniques as well as American freedoms. Owning your own land, attending the church of your choice, voting for your favorite candidate, and watching your children grow under their own roofs—all were reflected in the Pennsylvania Germans' arts and crafts, values, temperament, and letters.

Naturally, they shared their experiences with others. Governor William Bradford (1590–1657) of Massachusetts reported the 1620 landing of the Pilgrims in America thus: "If they looked behind them, ther was the mighty ocean which they had passed, and was now as a maine barr & goulfe to separate them from all the civill parts of the world."[5] This separation undoubtedly caused hardship, but there were also advantages in starting over. Americans shed baggage created by excessive government and church control in Europe. They replaced caste systems, feudalism, layers of ritual, oppressive bureaucracy, and heavy-handed religious regulation, dogma, and economic burden with the expedient and the practical. By 1724, Hugh Jones wrote that Virginians were "only desirous of learning what is absolutely necessary, in the shortest and best Method."[6] Clearly, by the early 1700s, Americans were already unencumbering themselves from complex legal, social, and religious systems that continued to hamstring Europeans.

The attitudes in Pennsylvania echoed those in New England or the South. About 1725, immigrant Christopher Saur (1695–1758) wrote to friends still in Europe that Pennsylvania was "like an earthly paradise."[7] He particularly mentioned religious freedom and economic opportunities. He even spoke of people who profited from lands having silver and gold. According to Saur (who later regretted spreading rumors about quick riches), his letters were printed in Europe and prompted about one thousand people to relocate to Pennsylvania.[8]

As Americans left their pasts behind, they sensed an exciting new future made possible by abundant natural resources and newly found freedoms. Benjamin Franklin and others promoted a deep sense of optimism in America. In 1767, Franklin—at this time an Anglophile—wrote, "America, an immense territory, favoured by Nature with all advantages of climate, soil, great navigable rivers, and lakes, etc., must become a great country, populous and mighty; and will, in a less time than is generally conceived, be able to shake off any shackles that may be imposed on her, and perhaps place them on the imposers."[9]

In that same year, Peter Muhlenberg (1746–1807), eldest son of Henrich Melchior Muhlenberg (1711–1787), prematurely cut short his education in Europe

and returned to America—a circumstance that greatly distressed his father. The elder Muhlenberg, who became the patriarch of the Lutheran Church in America, had been born in Europe. He believed that only in Europe could his sons receive a proper education. But Peter, born in the New World, reveled in America's freedom and expanse of land. He revolted against the bureaucracy and imprisonment by indenture the church fathers at Halle thought necessary for his and his brothers' education.

We can only imagine the moment in the Muhlenberg household in Trappe, Pennsylvania, when it occurred to Henrich Melchior Muhlenberg that his sons truly were Americans. Peter was supposed to learn trade skills and further his education in the land of his forefathers. The elder Muhlenberg never doubted that the Pennsylvania one-room schoolhouse fell short of European education. But it must slowly have dawned on him that he had sent his sons not to his *homeland,* but to a *foreign country.* In America, Peter had grown accustomed to walking out his front door to the woods and creeks to hunt and fish. Such freedoms in Europe were severely restricted—and that was just one of many restrictions. Paul A. Wallace said it best when he wrote about Peter and his brothers, "The boys were all right! But they were American boys, not German, not English, not European. It was best to see them against their own background and to judge them by American standards, which were not those of any other country under heaven."[10]

Like his father, Peter eventually became a preacher. But he proclaimed his American independence once and for all the day he threw off his clerical garb and assumed his role as a colonel in the army that wrested America's freedom from an England his father had admired. To this day, Peter is remembered for a speech he gave while enlisting Virginia Germans to join Washington's army: "There is a time to pray and a time to fight."[11] Peter Muhlenberg became an American hero. And for every Peter Muhlenberg, there were many unsung heroes whose early histories in this country were recorded quietly and without fanfare—histories embodied in the spirit of the family register. These citizens staked their claim to the American enterprise through family. They believed that family history should be recorded so that it would remain in the collective memory of their posterity.

Pennsylvania Germans wanted to document their families, and they did so by creating "permanent" records as vehicles to transfer personal information into the future. That they decorated many of these records by hand, or had them printed, demonstrates that families held these documents in high esteem. Even as they created personal histories in the New World, they were contributing essential pieces of evidence to America's broader history and material culture.

In her introduction to *American Broadside Verse* (1930), Ola Elizabeth Winslow made the point that "somewhere between 1650 and 1800," America began to "regard her own landscape and her own heroes possessively." Winslow correctly emphasized that until Americans established local history, they could not

develop a national consciousness. "Pride had to be narrowly local before it could ever be national," she wrote.[12] Certainly, family registers represent a "narrowly local" body of literature from which national pride could grow. Yet Pennsylvania-German family registers have been overlooked as a historical resource and a form of visual culture. Our examination of more than one thousand original examples of family registers, along with our identification and analysis of six forms of Pennsylvania-German registers, suggests that a history stemming from these family documents can now unfold.

Our analysis of the data indicates that although the family register existed in various forms, most Pennsylvania Germans—often at odds with one another regarding theology—favored creating and owning them. In this study, we demonstrate to what extent registers became disseminated among Pennsylvania-German populations in America and why registers played a key role among some elements of those populations—and Mennonites in particular. We explore the idea that the development of these family registers related strongly to Pennsylvania-German identity, helping explain the origin, rise, and persistence of registers within this ethnic group. In this study, we offer perspectives on family registers (Chapter 1); discuss how family registers fit into the fraktur tradition (Chapter 2); and describe stylistic and developmental similarities and differences between Pennsylvania-German and New England registers (Chapter 3). We also consider the texts found on family registers (Chapter 4) and examine six types of registers in order to better understand their history (Chapter 5). Taken as a whole, this study interprets Pennsylvania-German family registers from the perspective of ethnic heritage and a tradition that took root in American soil.

Perspectives on Family Registers

THE FAMILY REGISTER IS ALMOST as old as writing itself. By definition, a register is a system for recording details. The earliest "written" family registers were chiseled in stone or painted on plaster (as in Egyptian hieroglyphs) or inscribed on unbaked mud (as in Old Persian cuneiform script). They documented rulers' lineages and achievements—achievements that often meant subjugating or destroying other peoples. Those from Egypt's New Kingdom portrayed the principal sons and sometimes the daughters of various pharaohs.[1] These registers meant to ensure that each child, at his or her death, would find favor with the gods. Other family registers include the "begats" from the Old and New Testaments, and, eventually, European heraldry. Other examples abound.

Unlike registers from other parts of the world, most eighteenth- and nineteenth-century American registers do not reach far back into the history of the family. Instead, American family registers present the immediate family; that is, they offer detailed information about parents and their children. Pennsylvania-German family registers sometimes include information about the parents' parents, but these registers rarely provide details that trace back many generations. Thus, American registers are similar to what family historians today call "family group sheets." Early American family registers on paper, however, frequently featured watercolor decoration in the borders surrounding the text. These hand- or print-decorated registers predate and look quite different from the undecorated and strictly functional family group sheets used by genealogists today.

European family registers, beginning in the Middle Ages, documented titled ancestry or the ancestry of socially conscious persons. But few Americans of German-speaking heritage created family registers to prove aristocratic lineage.

Instead, today's family historians with German or Swiss ancestry create lists of direct ancestors called *Ahnentafeln* (*Ahnentafel* in the singular). *Ahnentafeln,* like European registers, look back in time to discover lines of ancestry. The American *Ahnentafel,* however, results from curiosity about ancestry—not the desire to document the family's high station.[2] And again, *Ahnentafeln,* like family group sheets, solely function as research tools and lack decoration.

Americans should not assume that Pennsylvania-German family registers grew from a similar tradition in German-speaking areas of Europe. Eighteenth- and nineteenth-century German-language registers are known in Europe. Some are even hand-drawn, broadside-type family registers in black letter or fraktur lettering and watercolor; some limit their texts to the parents with lists of children. But such documents in Europe are relatively rare.[3] They probably seemed superfluous, for they duplicated what existed in church records. Moreover, they served no official function, and having such a document made for the home may have been regarded as unnecessary and even pretentious if the family was not aristocratic.[4]

In Europe, family registers of another sort were favored by aristocratic—or at least well-connected—families. These registers have more to do with armorial bearings and heraldry than with the detailed history of a family. In present-day Germany, hundreds of volumes provide family information and coats of arms for titled families. According to Klaus Stopp, the *Gothaisches genealogisches Wörterbuch der adlichen Häuser* is the genealogical bible for noble families, and J. Siebmacher's *Grosses und Allgemeines Wappenbuch* is the bible for coats of arms.[5] The *Wappenbuch* alone numbers more than one hundred volumes. In addition, there are many regional histories, such as *Hessisches Geschlechterbuch* and the *Deutsches Familienarchiv: Ein Genealogisches Sammelwerk,* for untitled families.[6] To put this in perspective, just one volume of Ottfried Neubecker's *Grosses Wappen-Bilder-Lexikon* has, for the name Ernst (Earnest), eleven coats of arms.[7] That is from just one of hundreds of books on coats of arms. Incidentally, not one of the eleven Ernst coats of arms pictured in the single volume by Neubecker resembles another. In fact, some bear resemblance to coats of arms for people with entirely different surnames. Such "registers" showing coats of arms tell little about specific histories of a family.

The purpose and appearance of the American family register were different from these European examples. Whereas a European register affirmed social status by illustrating ancestry with coats of arms, the American family register documented biographical details about the immediate family. Thus, the American family register focused on the central text, which was occasionally flanked with brief religious or philosophical verses and with decoration that had nothing to do with coats of arms. At least among Pennsylvania Germans, the intent of the family register was not to show status, for most Pennsylvania Germans were rather modest. They sensed that someday, however, their descendants might want to learn about the family in the New World.

When contrasting European and American registers, it becomes apparent that registers made for ordinary families blossomed and flourished in America. Perhaps because they were made for common families, American registers assumed a more humble appearance. They generally lacked the elaborate details that symbolized illustrious heritage—details such as coats of arms or symbols borrowed from them, such as fleurs-de-lis, rams, dragons, chevrons, rampant lions, crosses, eagles, trade symbols, astrological and zodiacal signs, armor and weaponry, and crowns. Some of these motifs transferred to America on fraktur, which, for the purpose of this study, are defined as eighteenth- through twentieth-century decorated manuscripts and certain printed forms made by and for families of Pennsylvania-German heritage. (As Chapter 3 will note, strongly symbolic motifs were used less frequently on Pennsylvania-German decorated manuscripts. Moreover, after transferring to America, such drawings generally became simpler than their more sophisticated and elaborately detailed European counterparts.)

Among Pennsylvania Germans, local schoolmasters and itinerant scriveners created most manuscript family registers. Although they intended the text to become the focus of the register, the addition of art often drew attention from the text. This became especially true in the case of German-language registers as later generations could no longer read them. While Americans continued to appreciate the art, they often had no idea what was written on registers. As a result, the visual impact eventually came to dominate discussion of these manuscripts. But the use of German fraktur lettering and script, or even English-language decorative lettering, plus added illumination, places Pennsylvania-German registers within the larger field of fraktur.

Some believe that family registers, birth and baptism certificates, and other types of fraktur served an official function. In America, among Pennsylvania Germans, this was assuredly not the case. It is unlikely that official documents would have been hand-decorated. In addition, family registers intended for official use would not have been recorded in the family Bible. Most important, they would have been written in English rather than German, for English was and always has been the official language in English North America. Instead, the family register was meant to be enjoyed by the family in the home and to be passed on to succeeding generations. The only official function these documents may have served—and originally, this was not by design—was to document the birth of a soldier or sailor to qualify him, or often his destitute widow, for a pension. The National Archives in Washington, D.C., hold numerous fraktur-related family registers and birth and baptism certificates submitted as proof of a veteran's age, date of marriage, spouse's name, and place of birth. Other official uses are known, but generally, these uses were the exception rather than the rule.[8]

Most fraktur were personal documents, whether they were recording personal and/or family data or given by schoolmasters as instructional keepsakes for dili-

gent students. Most were made for rural families of southeastern Pennsylvania, but fraktur were also made anywhere Pennsylvania Germans settled, including Ohio, Virginia (especially the Shenandoah Valley), West Virginia, western Maryland, New Jersey, the Carolinas, and Ontario, Canada. Pennsylvania-German family registers are potentially found, then, in all regions populated by German-speaking immigrants and their descendants. Because many family registers date from the nineteenth century, examples were made for descendants of Pennsylvania Germans and for later German American immigrants and their families throughout the Midwest. Nineteenth- and twentieth-century examples are known from Indiana, Illinois, Wisconsin, and other mid-American states. But by far, most fraktur, including fraktur-related family registers, derive from southeastern Pennsylvania.

Fewer examples of family registers made for people of German extraction are known in the southern states along the Atlantic seaboard. At an early date, Germans began settlements in Georgia, the Carolinas, and throughout the Shenandoah Valley region of Virginia. Except for nineteenth-century family registers printed by the Henkel Press in New Market, Virginia, and booklet family records made by the Virginia Record Book Artist and copy artists (see Chapter 5), few Pennsylvania-German family registers made on paper in southern states are documented. Germans in southern regions had a fraktur tradition, but anglicization occurred early in the South. Thus, finding English-language *textile* registers in southern states is perhaps more likely than finding examples on paper.

The present volume—in keeping with the fraktur tradition—addresses only works on paper. Many American family registers, especially from New England, are textiles, including ink on silk. We do not cover textiles, such as ink on silk or needlework samplers. Nor do we include tinsel picture–type family registers. (Tinsel pictures are painted on glass, and their texts are written on the reverse of the glass, which is backed with tinfoil and framed. This type of family register dates from the mid-nineteenth century and is still made today, especially among Amish families of Pennsylvania, Ohio, and Indiana.[9]) In *The Jewish Heritage in American Folk Art*, Norman L. Kleeblatt and Gerard C. Wertkin pictured nineteenth- and twentieth-century English- and Hebrew-language registers that grew from a Central European tradition of decorating manuscripts.[10] Although registers were made in America for Jewish families, they did not come directly from the Pennsylvania-German fraktur tradition. Thus, these examples are not included here.

We also exclude from this study fan charts, pedigree charts, family group sheets, printed genealogy books, and other documents now used by all Americans, whether from Europe, Africa, or Asia. Such records warrant their own thorough study, but including these twentieth-century records here would cause this investigation to balloon and lose focus.

Occasionally, family registers appear in Pennsylvania and Virginia church books. One such record is illustrated in *Bucks County Fraktur.*[11] These records

are interesting and worthy of mention, but we exclude them from this study because church records are generally recorded for multiple families in chronological order by dates and within categories of baptism, marriage, and death, so that information concerning a single family is scattered throughout the record. Normally, a single-family entry on a church record page was written when the family wanted personal data updated in the church book.[12] Such records are uncommon. On rare occasions, too, Pennsylvania-German family registers were stitched with colored thread onto punched paper. Some of these were single sheets of punched paper. Others were cut into pages and stitched along the left margin to form a book. Too few examples of either type are currently known, and they are therefore excluded from this volume.

As noted above, we restricted our study to Pennsylvania-German family registers written or printed on paper in the fraktur tradition.[13] Our work shows that, in general, Pennsylvania-German family registers were influenced by the fraktur tradition even after the Civil War, when English gradually supplanted German in Bible records. Local schoolmasters and itinerant scriveners created most manuscript family registers, and descendants of Pennsylvania Germans continued to hire professional scriveners to write genealogical data in Bibles in decorative fraktur lettering, Spencerian English penmanship, or some other calligraphic style until well into the twentieth century. Families could have recorded this data themselves, but their love of color, appreciation for the skill of the scrivener, sensitivity to tradition, and recognition of the value of the register to future generations prompted them to dig deep into their wallets to pay professional penmen.

Unexpectedly, as we examined and recorded more than one thousand primary sources from private and public collections, we determined that a chronological approach to the history of Pennsylvania-German family registers was impractical. The data we compiled pointed instead to another organization—an organization of family registers into six categories, outlined below and discussed in detail in Chapter 5. Although the function of registers in all six groups remained consistent—that is, to create permanent records documenting family data—they varied stylistically and in their historical development.

The six forms of Pennsylvania-German family registers include (1) printed registers with family data, or infill, printed on a printing press; (2) freehand examples; (3) preprinted forms with added, handwritten infill; (4) preprinted forms bound into family Bibles, usually between the Old and New Testaments; (5) freehand registers written on the flyleaves or blank pages of Bibles and other books; and (6) handwritten (as opposed to printed) book-form registers. The first three types are in a broadside format. That is, they were drawn or printed by machine on one side of a single sheet of paper. Often this paper was large, and the record was decorated as if to be displayed. These registers were standalone sheets of paper, not bound into Bibles or other books.

The first form—family registers having infill printed on a printing press—

presents the most surprises. Not only are these registers rare (for they must have been expensive to produce), but some are also quite early, dating from before 1800. In fact, the earliest known surviving American broadside family register with printed infill is a Pennsylvania-German example printed at the Ephrata Cloister in 1763 for the Bollinger family of northern Lancaster County, Pennsylvania (fig. 1). This predates the earliest known New England example, probably

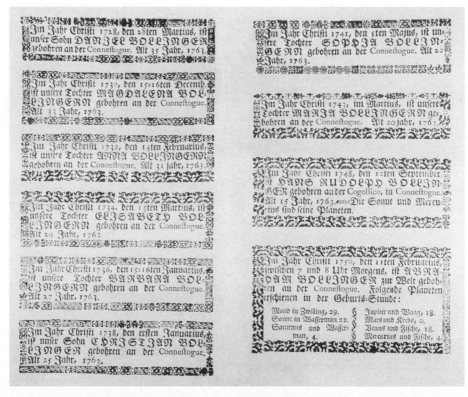

FIG. 1 Family register for the children of Rudolph and Elisabeth (———) and Catherine (Blum) Bollinger. Attributed to the Ephrata Cloister printshop, Lancaster County, Pennsylvania, 1763. Printed on laid paper, 8¼ in. × 10½ in. Paper watermarked "GR" for Georges Rex. Photo courtesy New England Historic Genealogical Society, Boston, Massachusetts. All rights reserved.

The 1763 Bollinger register is the earliest American printed broadside family register known. It lists the children of Rudolph Bollinger (died 1772) and first wife Elisabeth (died 174?) except for the last child, Abraham, whose mother was Catherine Blum (died 1792). Rudolph Bollinger, a Mennonite probably from Switzerland, immigrated before 1728. The Bollinger family had a long association with the Ephrata Cloister. Although the register does not record the parents' names, it does show a location on the Cocalico *(an der Cogollico)*, a creek in Lancaster County. Moreover, it reflects the date of printing, because it gives the ages of the children in 1763. The printing is an interesting assortment of border pieces and types, including English (in roman type) for Indian words. Abraham's entry not only details signs of the zodiac, which was common at that time, but it also documents the appearance of seven planets at the hour of his birth.

printed after 1775 for the Peirce family of Worcester, Massachusetts.[14] The existence of the 1763 Bollinger register is especially surprising, considering that printers from Boston and Philadelphia dominated the colonial American printing market.[15] When searching for the earliest printed family register, one naturally turns to examples from Massachusetts or the Philadelphia area—especially English-language examples. But, to our knowledge, Ephrata produced the earliest surviving printed family register in America, and it was printed in German.[16]

In 1963, Meredith B. Colket wrote that family records were generally not published until the nineteenth century, but he did point out that in addition to the Bollinger example, bibliographers were aware of the 1731 genealogy published by B. Green in "Boston in New England" for the Clap family.[17] The Clap history, however, is a forty-eight-page book and not a stand-alone, broadside-type family register. The full title of the Clap family history reads, *Memoirs of Capt. Roger Clap, Relating some of God's Remarkable Providences to Him, in bringing him into New-England: and some of the Straits and Afflictions, the Good People met with here in their Beginnings. And Instructing, Counselling, Directing and Commanding his Children, and Childrens Children, and Household, to serve the Lord in their Generations to the latest Posterity.*[18] Judging from this lengthy title, Captain Clap was aware that he was documenting his earliest beginnings in the New World. Moreover, he looked forward—to his "latest posterity."

In actuality, the last ten pages of Clap's history were written by James Blake Jr. between 1720 and 1731. Called *A Short Account of the Author and his Family,* Blake's contribution contains Roger Clap's family history. The history written by Clap many years before (Clap died in 1691) is more of an account of the early settlement of Massachusetts with autobiographical elements. The distinction between Blake's contribution and the original Clap narrative becomes important in understanding early family histories and registers in America, for it is actually Blake's addition that turns Clap's account into a genealogy.

According to Colket, "the significance of the *Memoirs of Capt. Roger Clap* as a 'first' has not hitherto been adequately recognized."[19] Colket's point is well taken. He goes on to recognize the 1763 Bollinger family register as an equally important "first" and notes that the Clap family history and the Bollinger broadside "deserve a place as landmarks in the development of printed family records of colonial America."[20] This observation cannot be emphasized enough. The significance of these two early examples of printed family history suggests that immigrant families, along with the next few generations of their descendants, were interested in documenting family history. And *what* they wrote is especially revealing. As will be discussed below, most family registers in this country, whether in English or German, fail to record where in Europe the family originated.[21] Today's family historians find this short-sighted omission especially unfortunate, and it is. But it is also telling. The saying "Don't look back unless

you're going back" seems to apply here: these people were not going back. They were interested in the future.

Colket further wrote, "Germanic peoples frequently employed calligraphers to prepare illuminated family records of birth in *Frakturschrift* [fraktur writing], for framing and hanging on the wall. In the same manner English people encouraged daughters to embroider samplers showing family data."[22] Colket was referring to *Americans* of German and English heritage. It is noteworthy that Colket failed to mention that the "English" made hand-drawn registers on paper. He also speculated that the Bollinger register was printed because of the "availability of the famous Ephrata printing press and the current lack of good calligraphers in the area."[23] The latter observation bears addressing, because the Ephrata Cloister was the source of some of the earliest and finest, most classic, hand-drawn fraktur made in America. Its reputation for illuminated manuscripts was well known even in colonial America. In 1772, Benjamin Franklin so admired the art that he showed samples to his friends in London.[24] Thus, in 1763, there was no lack of "good calligraphers" at the Cloister. Colket's article bears witness to why a study of Pennsylvania-German family registers on paper is needed.

Americans of German heritage can lay claim to an early and widespread interest in recording family events. Gloria Seaman Allen wrote in *Family Record: Genealogical Watercolors and Needlework* that the "earliest family records in the New World were executed in German *fraktur-handschriften,* a type of calligraphy originating in the Middle Ages."[25] Despite the Clap/Blake genealogy, Allen may have been right, especially when one takes into consideration the entire body of family-related manuscripts produced by German-speaking immigrants and their descendants. These records were not occasional. Collectively known as fraktur, they became popular in various forms among most denominational segments of German-heritage populations in America. The use of German fraktur lettering and script (or even English-language decorative lettering), with added illumination, places Pennsylvania-German registers within the larger field of fraktur.

Although none treated the subject thoroughly, numerous authors in published studies have recognized family registers as a type of fraktur. In 1897, Henry C. Mercer wrote that among types of fraktur, Bible entries lasted much longer than "other phases of the art" and still continued in his day.[26] In 1937, Henry S. Borneman listed "Genealogical Records" as a type of fraktur. He specifically mentioned those found in large family Bibles, for, in his words, "genealogy occupied a prominent place" in Pennsylvania-German fraktur.[27]

In the most comprehensive study of fraktur, Donald A. Shelley in 1961 not only categorized family registers as a type of fraktur but also—perhaps for the first time—drew attention to preprinted examples.[28] He observed that preprinted registers with added, handwritten infill were not readily embraced by Pennsylvania Germans, as he saw few examples of it. At the time Shelley conducted his research, however, many such preprinted registers remained with the original

families. The printed certificates were late (circa 1840 to the present) and often printed in English. Thus, families could read them and determine their relevance. When families recognize their grandparents' and great-grandparents' names on a document, they tend to keep that document. Many registers thus remained in private homes and were not available to Shelley. Additionally, when he was collecting evidence, printed family registers had little monetary worth. When they did escape the family's care, they were not always rescued by the marketplace, and many were discarded. (Of interest, as a way of recognizing that decorated manuscripts existed among other ethnic groups in various regions of the country, Shelley described New England and New York family registers as a form of fraktur.[29])

Though the second half of the twentieth century spawned much interest in fraktur, no history specific to fraktur-related Pennsylvania-German family registers has previously been published. In *Papers for Birth Dayes: Guide to the Fraktur Artists and Scriveners*,[30] we documented the known works of major artists and scriveners who worked in the fraktur tradition. Many made family registers (see Appendix A). And in his monumental study, *The Printed Birth and Baptismal Certificates of the German Americans*, Klaus Stopp documented printers who were candidates for having produced anonymously printed broadside-type family registers for the Pennsylvania-German market.[31]

In general, though, scholars may have assumed that family registers made in the fraktur tradition needed little attention. We listed numerous examples of family registers in the 1997 edition of *Papers for Birth Dayes*, and there appeared to be little else to say. Admittedly, we were among those scholars who assumed that a study of family registers would be simple and straightforward, advancing knowledge about fraktur only a small step. But, on further analysis, the data we compiled from original manuscripts and printed registers clearly indicated that the Pennsylvania-German family register deserved its own study. An interpretive framework based on an alternative approach to their history—not a chronological sequence—materialized. We discovered that six forms of registers developed almost simultaneously; in many cases, they overlapped. But, to a great extent, they developed independently from one another. We will demonstrate that the various types of registers did not influence each other so much as they responded to individual preferences based on visual appeal or what was practical in terms of gaining access to printers, artists, and scriveners or in terms of preserving data. Hence, the history of family registers of the Pennsylvania Germans represents a departure from other types of fraktur. The more familiar fraktur birth and baptism certificate produced a linear history, such as a chronology showing major developments. The family register, however, took on a life of its own.

By their nature, family registers had to manage sometimes considerable information concerning births, baptisms, confirmations, marriages, and deaths for numerous individuals. Instead of recording a single event, family registers docu-

mented several life events. Consequently, unlike most types of fraktur, many family registers were "completed" over a span of several years. In fact, the family opting for a totally printed register soon discovered that it was costly and inconvenient to have data typeset and printed only to have additional information, such as unanticipated births, make the print obsolete. For the same reason, hiring a schoolmaster to decorate and record a register for display was impractical if new arrivals to the family were anticipated. As will be discussed in Chapter 5, problems with updating family information resulted in registers in Bibles becoming the favored solution. Consequently, Bible-entry registers numerically dominated nineteenth- and twentieth-century registers. Nevertheless, various options were available to families wanting registers, and families made choices that suited them. The only commonality among the six categories was the impetus for creating registers in the first place. Family registers arose spontaneously in response to an intuitive sense among Pennsylvania Germans that they needed to document, permanently, their families in the New World.

Surprises awaited us as we researched. Among Pennsylvania Germans, Mennonites and members of other small sects led the way in embracing the family register tradition. More than other religious groups, Anabaptists (including Mennonites) were true refugees, persecuted in German-speaking areas of Europe for their religious beliefs. As such, they responded to American freedoms soon after immigrating by recording family data without fear of authorities tracking down and arresting relatives listed in a register. Yet the Mennonite influence on other religious groups—such as neighboring German Lutherans and Reformed—concerning family registers seems to have been limited. Instead, a spontaneous urge to create registers appeared independently among Pennsylvania Germans of many faiths (not to mention among New Englanders), as will be demonstrated in Chapter 3.

One reason for their wide appeal is that registers stood for no particular faith-based "rite of passage," and thus they were acceptable to people of various religious persuasions. While Pennsylvania-German registers often included references to baptism (a sacrament for Lutheran and Reformed families), the purpose of registers was to record numerous life events and to document family relationships (see Chapter 4). Occasional religious verses appear on family registers, and the theme of death—or the brevity of life—also appears in the art or secondary texts. Generally, though, family registers tended to be secular documents. They were often folded and placed in Bibles or written in Bibles, but this practice was for safekeeping, not for indicating that the register had religious significance. Undoubtedly, some families intentionally stored personal papers in their most cherished book (usually the Bible), but it should be remembered that families also wrote personal records in other books, including cookbooks.

Secondary themes emerged during our research. For example, Americans in general tended to be future-oriented in terms of the registers' texts. New England and Pennsylvania-German registers functioned in similar ways, but the art on

the early registers of these ethnic groups differs (see Chapter 3). And while the urge to proclaim the presence of family in America prompted both English- and German-speaking groups to create registers, the tradition for making family registers—either plain or fancy—remained strong in Pennsylvania-German communities for the better part of three centuries.

Family registers may have remained popular among Pennsylvania Germans for several reasons. In *Foreigners in Their Own Land: Pennsylvania Germans in the Early Republic,* Steven M. Nolt pointed out that the assimilation of various ethnic groups into the American culture began with Pennsylvania Germans.[32] Assimilation took place quickly for some, but for others, it did not. For example, people whose first language was not English assimilated slowly. While calling descendants of Pennsylvania Germans "the most 'inside' of 'outsiders,'" Nolt recognized that the difference in language set Pennsylvania Germans apart from their English-speaking neighbors. As a result, descendants of Pennsylvania Germans to this day form a somewhat cohesive American subculture, maintaining the "Pennsylvania Dutch" (Pennsylvania German) dialect, religions, folk culture, love of decoration, and rural traditions. Especially in southeastern Pennsylvania, where populations of Pennsylvania-German descendants remain relatively dense, ethnic sensibilities and traditions linger, including the tradition of creating family registers.

One theory has suggested that family registers were a product of changing familial values.[33] Though the eighteenth-century family was community oriented, following the Revolution—when most family registers were made—the family became increasingly self-reliant and self-centered. In urban areas, as husbands found work outside the home, wives and mothers increasingly took over the management of the household. Families had fewer children,[34] and these children enjoyed greater importance. They achieved their own identity and even gained space in the house for privacy in their own rooms. More value was placed on their education, and children were given every possible advantage to succeed. Concurrently, the demand for registers recording the births of children, drawn and decorated by professional artists, increased. It apparently peaked, at least in New England, about 1810.[35]

This theory may hold for New England—but not necessarily for Pennsylvania. Most Pennsylvania Germans were agrarian. During the heyday of their family registers, which lasted well past 1810, they remained rural. Rural families were generally large. As demonstrated by a random sampling of 101 Pennsylvania-German registers, the typical eighteenth- and nineteenth-century families of German heritage averaged 7.4 children.[36] Judging by this sample, augmented with registers made for urban families, city-dwelling families tended to be smaller.[37] While Pennsylvania-German children in rural areas were afforded a nurturing environment, they shared bedrooms, or the loft, within the farm house. And most were not college-bound; they simply wanted their own farms.

The professional portrait painter of New England would have starved if he

hawked his talents to the frugal Germans. Rather than being academically trained, the Pennsylvania-German fraktur-producing artist was the local schoolmaster, who would draw a fraktur for a few pence (and, following the Revolution, for fifteen to twenty-five cents). By the second quarter of the nineteenth century, the infiller and decorator of the printed certificate was an itinerant scrivener who went from farm to farm across rural Pennsylvania. He carried his printed family registers and other papers, such as birth and baptism certificates, rolled in a tube slung from a strap.[38] German was his first language and the first language of his clientele. This was true in southeastern Pennsylvania throughout the nineteenth century. Societal changes in New England did not necessarily occur at the same rate in rural Pennsylvania. Thus, regional comparisons have value, but only to a limited degree.

Following the Revolution, pride in our new nation spawned the first major wave of family registers. Later, the centennial of the nation's independence renewed interest in family history. Late in the nineteenth century, Americans demonstrated significant interest, if not a general fervor, in searching for their roots.[39] About that time, as print and papermaking technologies improved, the price of paper and printing became so reasonable that it was possible to market many types of books, including biographical encyclopedias. Concurrently, family historians began printing and publishing book-length, family-specific genealogies in great numbers.[40] These published histories, more than anything else, may have caused the gradual decline of family registers.

The centennial of independence ushered in another development in family history research. As memories of the Civil War haunted families torn apart by the conflict, many American historical and genealogical societies were founded. The New England Historic Genealogical Society in Boston, which was established prior to the Civil War (in 1845), was the first such institution in America. But by far, most societies were formed following the Civil War and the centennial. The Daughters of the American Revolution was established in 1890; the Pennsylvania German Society, a year later. It became fashionable during this time for members of the New England Historic Genealogical Society to trace their heritage to Mayflower immigrants and for members of the Daughters of the American Revolution to trace their ancestry to Revolutionary soldiers. The mission of the Pennsylvania German Society focused not only on German heritage and genealogical research but also on preserving the Pennsylvania-German dialect, architecture, historical records (such as local church records), and folk and material culture.[41]

As activity involving family history research increased, many genealogists in this country developed an interest in tracing families to their European points of origin, but they were often sidetracked by trying to find a famous, important, wealthy, or titled ancestor. The bicentennial witnessed a shift in attitude. Americans in increasingly larger numbers finally decided to look back no matter *where* the trail led. Curious Americans fully recognized and accepted that their per-

sonal history might trace back to the court jester rather than the king, but they were as eager to learn about humble origins as about illustrious ancestors. In short, Americans remembered that we are a nation of foreigners. It was time to take stock of who we were and ponder our beginnings. For many, the search led to primary sources, such as family registers.

The study of Pennsylvania-German family registers is not simple, and for good reason. Original sources are scattered, and most early Pennsylvania-German registers were written in German, even though they were made on North American soil. Thus, Pennsylvania-German family registers are hidden behind an intimidating language barrier. We have presented some tools, including illustrations, names of Pennsylvania-German artists and scriveners who made family registers (Appendix A), a time line (Appendix B), and a glossary (Appendix C), to assist readers in understanding that fragile 150-year-old document they hold in their hands.

Recognizing that thousands of registers made for families of Pennsylvania-German heritage exist today, we have selected illustrations that promote understanding of the history of these registers. The captions include translations of relevant portions that support our findings. Note, too, that while there are numerous variant spellings of names on German-language registers, we have decided to spell names as found on originals.

Pennsylvania-German Family Registers
and the Fraktur Tradition

MANY CONSIDER FRAKTUR THE most important body of decorated manu-
scripts Americans ever produced. The word "fraktur" is derived from a style of
German lettering having angular, or "broken," features. Because it is decorative,
it is frequently compared with the Old English Gothic or Wedding Text typefaces
used today. The fraktur style of hand lettering and typeface was used in German-
speaking areas of Europe from the fifteenth century until World War II. Today,
however, rather than referring strictly to a style of typeface or lettering, Ameri-
cans use the term "fraktur" (the word is both singular and plural) to describe
decorated manuscripts made by and for Pennsylvania Germans.[1]

American fraktur has its roots in the illuminated manuscripts of medieval
Europe, which were written in many languages and in many lettering styles.
When the tradition for illuminating manuscripts transferred to America with
German-speaking immigrants, it came not only with the German language but
also with German fraktur lettering. In America, fraktur—meaning decorated
manuscripts—are considered unique to Pennsylvania Germans. Other ethnic
groups in America did decorate manuscripts, though. In fact, while Pennsylvania
Germans were producing family registers, English-speaking residents of New
England and the mid-Atlantic states were creating decorated family registers,
both on paper and in textiles. Similarities and differences between New England
registers and those produced by Pennsylvania Germans are discussed in Chapter
3, but the fact that both ethnic groups felt inclined to produce them about the
same time and in large numbers is important to note. In his introduction to *The
Art of Family: Genealogical Artifacts in New England*, John Demos suggested
why some types of material culture that relate to family were made. For exam-

ple, Demos suggested that silver objects and portraits asserted status. He argued that other types of material culture, such as family registers, were made as "straightforward record keeping." Demos thought that from this type of record keeping, it was a "short step to remembrance, and then to full-blown commemoration."[2]

While Pennsylvania Germans took the same "short steps" by producing fraktur that commemorated rites of passage such as birth, baptism, confirmation, marriage, and death, their family registers represented a departure from these types of fraktur. Family registers recorded a series of events, not a single event. Moreover, the family register tradition lasted an especially long time. In fact, unlike other types of fraktur, some religious groups began making family registers soon after setting foot on these shores early in the eighteenth century—and the practice has lasted to the present. Not even the immensely popular birth and baptism certificate or *Geburts-und Taufschein* (in the plural, *Geburts-und Taufscheine*) enjoyed such a long tradition.

Among Pennsylvania Germans, the art of decorating manuscripts became a means of expressing religious and moral sentiments, a tool for the instruction of youth, and a vehicle for recording personal data. Thus, Pennsylvania Germans made many types of fraktur, most of which were written in German, from about 1740 until the first quarter of the twentieth century. Fraktur are even being made today, though in smaller numbers. Contemporary examples made in the fraktur tradition are often family registers beautifully penned in Bibles. That these works are still being produced—albeit in English—among descendants of Pennsylvania Germans testifies to their lasting importance.

Pennsylvania-German family registers are one type of fraktur. Whether hand-drawn and illuminated by a fraktur artist, printed with fraktur-style typeface, or simply written in *Frakturschriften,* Pennsylvania-German family registers follow in the fraktur tradition in that they were decorated with motifs outside the text, or the decoration is found in the text itself in the form of fraktur lettering, or both. Unlike many Pennsylvania-German decorated documents, fraktur-related family registers (some of which were written in English) were contemporary with and can be compared to certain English-language family documents—especially nineteenth-century family registers from New England and nineteenth- and twentieth-century Bible records that became popular across America.

To understand fraktur-related family registers, it is important to analyze how family registers fit into the fraktur tradition. As mentioned previously, there are many types of fraktur, including family registers, *Geburts-und Taufscheine* (commonly referred to as *Taufscheine*), bookplates (showing book ownership), *Vorschriften* (writing examples), confirmation certificates, birth records, religious texts, death and marriage records, house blessings, love letters, bookmarks, songbooks, New Year's greetings, rewards of merit, and watercolors drawn in a naive style. Some scholars, in their definition of fraktur, use various—and frequently arbitrary—criteria to exclude certain kinds of documents. For

example, scholars have suggested that only freehand-decorated manuscripts are fraktur, while forms such as printed *Taufscheine* are not—even though most printed fraktur have hand decoration, and many are decorated by artists who are today considered major fraktur artists. Some argue that fraktur must have decoration *and* text, thereby eliminating naive watercolors, though major fraktur artists painted some of these watercolors. Some scholars exclude English-language examples even though many fraktur artists and scriveners were bilingual or multilingual. Others suggest that all "true" fraktur were written only in fraktur lettering and that decorated manuscripts written in plain German script are not fraktur. Some even contend that eighteenth-century decorated manuscripts made at the Ephrata Cloister in northern Lancaster County are fraktur—and any made beyond Ephrata are not "real" fraktur. Many set arbitrary dates to limit the field. They maintain that decorated manuscripts, if made after 1800, or 1834 (when the public school act was enacted in Pennsylvania), or 1850, or the Civil War, are not fraktur. And some argue that the Amish never made fraktur, forgetting that the Amish cigar-smoking dwarf Barbara Ebersol (1846–1922), of Lancaster County, made charming German-language bookplates in beautifully formed fraktur lettering with border decoration. (Indeed, Ebersol has had more written about her than most other fraktur artists.[3]) Some scholars exclude examples from the genre of fraktur if the manuscripts lack border decoration. Thus, they exclude most Bible records. Yet many Bible-entry family registers made for Pennsylvania Germans were beautifully decorated with fraktur lettering or illuminated in the margins surrounding text (or both).

Other records were not decorated and thus are not considered part of the fraktur tradition. For example, among smaller sects of German-speaking immigrants, early genealogically significant records are known. Some of the most unusual are eighteenth- and nineteenth-century "course of life accounts" written by Moravian immigrants and their descendants. Moravians wrote these brief biographies and autobiographies, called *Lebensläufe* (singular, *Lebenslauf*), to be read upon their death. Written in plain German script, *Lebensläufe* were not decorated (fig. 2), but they are wonderful genealogical records for descendants of Moravian families. Additionally, they are worth noting because they are among the earliest of American biographies and autobiographies.[4]

To include the full spectrum of Pennsylvania-German family registers, we take a broad view. We consider fraktur to encompass family registers that were penned or machine printed in fraktur lettering or typeface, in German script, or in English decorative lettering and were made for Pennsylvania-German families. These registers may or may not have border decoration. A number of earlier scholars, such as Mercer, Borneman, and Shelley, recognized family registers, including those found in Bibles, as part of the fraktur tradition. They and others acknowledge that the texts on fraktur are key to understanding and interpreting these documents, for the texts are the reason fraktur were created. While art on fraktur formed an integral part of the manuscript, text remained paramount.

FIG. 2 Biography of Johann Jacob Schmick. Attributed to Johann Jacob Schmick, Northampton County, Pennsylvania, circa 1785. Hand-lettered on laid paper, 6 in. × 3½ in. Unrecorded watermark with crown. Private collection.

Lebensläufe were biographies or "course of life accounts" written by Moravians, who had a high literacy rate. *Lebensläufe* were read at the internment of the person who wrote them. This example details the unusual baptism of Jacob Schmick. It was updated, as most *Lebensläufe* were, by adding information concerning Brother Johann Jacob Schmick's marriage to Sister Anna Johanna Kraus on February 9, 1785. Johann Jacob Schmick was born to Johann Jacob and Johanna Schmick in Bethlehem, Pennsylvania, on the morning of October 2, 1757. He was baptized within an hour of his birth in the presence of "many Indians." The sermon given at his baptismal service was then translated from German into Mohican *(Mahikandisch)*. This baptism underscores how successful Moravians were in their campaigns to proselytize among Indians. Just two short years prior to this baptism, General Edward Braddock (1695–1755) was defeated in western Pennsylvania, setting off a firestorm of Indian attacks, including attacks on Moravian frontier settlements.

After all, fraktur conveyed information—that is, they reinforced religious values, instructed, and recorded personal and family data.[5]

Americans frequently assume that fraktur traditions stem directly from similar European practices. They often did, but not always. As noted previously, although Europe had a long and well-developed tradition of decorating manuscripts, European decorated manuscripts generally did not include personal records, such as family registers or birth and baptism certificates.[6] Moreover, American genealogy records, including fraktur, were made for common families, whereas in Europe, they were often made for nobility. Conversely, some types of European genealogical records available to ordinary people never became popular here. For example, in Europe, some families kept a *Hausbuch* (house book, usually maintained by the father), which included moral verse, instruction, recipes, and sometimes genealogy. In America, moral instruction came from the Bible. The family documented business transactions in ledger books, and school instruction—usually loaded with moral lessons having religious overtones—came from the schoolmaster and his teaching aids, such as fraktur *Vorschriften*, alphabet books, rewards of merit, or ciphering books. In the late nineteenth century and throughout the twentieth, the lady of the house may have kept a diary that also included recipes and genealogical notations. But the few examples we have seen suggest that the *Hausbuch* did not become popular in America, though it long remained in use in German-speaking Europe: the *Hausbuch für die deutsche Familie* was still printed in the twentieth century.[7]

Most American fraktur were *Taufscheine*. The history of *Taufscheine* has no parallel among other subcultures in America. Most Pennsylvania-German immigrants and their descendants were Lutheran and Reformed,[8] for whom baptism is a sacrament. *Taufscheine* were thus special to them. Understanding *Taufscheine* helps us understand fraktur-related family registers. Many theories have been advanced concerning the tremendous demand for *Taufscheine* among Pennsylvania Lutheran and Reformed families after the Revolution. These theories attempt to explain why *Taufscheine* became popular in America, while there was little demand for them in Europe. Added to the complexity of understanding this demand is the question of decoration.[9]

Birth and baptism certificates existed in Europe in an official capacity, but they were rarely decorated. Many of these eighteenth-century documents were made for young men who needed them as proof of legitimate birth so that they could inherit or make their way through the guild system. Thus, unlike *Taufscheine*, which were made for children of both genders, most European birth and baptism certificates before the nineteenth century were made for males. Normally, a clergyman would consult church records to create this official document—complete with a wax seal—testifying to the fact that the young man who needed the document could prove legitimate birth (color plate 1). But decorated *Taufscheine* had no real precedent in Europe. So why did they become popular in America?

One theory holds that as American families continued to move west, away from church records that documented family events such as births, baptisms, marriages, and deaths, they might have thought it prudent to take important papers with them. That theory does not hold up, however, for outside southeastern Pennsylvania, numbers of *Taufscheine* drop off precipitously. If these documents were important enough to take west, more examples outside southeastern Pennsylvania would become known. Also, this theory begs the question why those moving to western Pennsylvania, western Maryland, Ohio, present-day West Virginia, and beyond would not have made *Taufscheine* in greater numbers in their new locations. Naturally, some did, but the tradition was not as strong outside southeastern Pennsylvania.

A more plausible theory takes account of the fact that American homes were more scattered than in German-speaking areas of Europe. American families lived on their own farms, not clustered in a small village with the church dominating the immediate landscape. Whereas the church was in plain view to villagers in Europe, with church bells constantly marking the daily routine, this visual and audible orientation was greatly diminished (if not completely absent) for many German immigrants upon relocating to America. Thus, although American clergy continued to document family events, Americans who lived miles from the church might have felt isolated from important records. Perhaps they wanted to keep documentation concerning baptism close to home.

In *Understanding and Using Baptismal Records,* John T. Humphrey explained why Lutheran and Reformed families so diligently documented baptisms in church records. Humphrey pointed out that "the reward of baptism was not merely salvation. Baptism was also seen as means of incorporating the recipient into the church."[10] Amos Hoover of the Muddy Creek Farm Library drove this point home, saying, "in Lutheran and Reformed theology, it was imperative that the individual, 'who could face death at any time,' know that he or she was legitimately baptized." Hoover continued, "A legitimate birth was a nice privilege, but the legitimate baptism was the ultimate. Neglecting this procedure was worthy of capital punishment in the Old World."[11]

Although baptism is a sacrament among Lutherans and Reformed, and thus "imperative," the theory concerning the necessity for keeping *Taufscheine* at home raises another question. Certainly, *Taufscheine* were kept at home, but if they were so important as proofs of faith or of belonging to the church, why were these documents not made in greater numbers during the colonial period? After all, colonial-era families, too, lived on distant farms, sometimes walking miles to attend church. Many *Taufscheine* were made prior to the Revolution, but by far, most were made following the war. The same is true of family registers. Evidence suggests that the need for creating these personal records seemed less of a priority before about 1780.

In *Arts of the Pennsylvania Germans,* Frederick S. Weiser suggested that *Taufscheine* became popular as people acquired "luxury funds."[12] Greater disposable

income may account for families being able to *afford* them, but it does not account for why *Taufscheine* were made. After all, disposable income could have been spent on a host of other items. A more plausible explanation for the increased demand for personal documents such as *Taufscheine* and family registers is that, following the Revolution, national pride was taking hold. The Revolution created a feeling of regeneration not only for a new nation but also for families. Families quickly sensed that they wanted to be part of the fledgling national culture that Franklin, with characteristic optimism and excitement, called an "Experiment."

Still, families could have stamped their claim on America's early history with handwritten records lacking decoration. So why did they decorate their manuscripts? Amos Hoover offered a theory. "The functional value," he suggested, "of exorbitant decoration and color is that no human being will deliberately ever throw [fraktur] away, and that was the main purpose of the fancy decorations."[13] Thus, the decoration not only *enhanced* text but also *preserved* it. Hoover's theory has merit, for stories abound of fraktur rescued from fire or the garbage heap by those who appreciated the folky design, imaginary beasts, colorful birds and flowers, and exquisite penmanship.

To support that theory, we should recognize that not all Pennsylvania-German papers were decorated. Handwritten receipts, personal notes, inventories, business documents, and personal correspondence lacked decoration. Only documents that Pennsylvania Germans deemed important were given this special attention. The criterion for determining importance was remembrance. These "never-to-be-forgotten" documents and the information they contained usually recorded personal and family data.

While parallels in the development of *Taufscheine* and Pennsylvania-German family registers are apparent, as shown by increased demand following the Revolution, the histories of the two genres are dissimilar. By and large, birth and baptism certificates did not become popular among ethnic groups other than those of German heritage until after the Civil War. But family registers were contemporary with and as popular among English speakers in pre–Civil War America as they were among German-speaking Americans. Prior to the Civil War, most *Taufscheine* were made for Pennsylvania Germans and written in German. After the war, birth and baptism certificates gradually became popular among ethnic groups throughout America, including Polish, Swedish, Norwegian, and especially English populations.[14] Although the *Taufschein* tradition was most closely associated with the Pennsylvania Germans of southeastern Pennsylvania, certificates were being printed after 1900 throughout the mid-Atlantic states and the Midwest, and some were printed in German.

The histories of *Taufscheine* and family registers differ in another way as well. Unlike *Taufscheine*, Pennsylvania Germans of most religious persuasions accepted family registers. For denominations that do not practice infant baptism, such as the Mennonites and Amish, the *Geburts-Schein* (birth certificate) was

sometimes substituted for the *Taufschein*. In its freehand form, the *Geburts-Schein* was a decorated manuscript limiting data to details concerning birth. But to serve the same purpose, Mennonites often used printed baptism certificates designed for Lutheran and Reformed families. They simply added data about birth but left the space for baptism blank, or they recorded an adult baptism. Although Klaus Stopp located two editions of certificates printed about 1865 for use among Mennonites, these are rare. These official-looking German-language documents may not have had much appeal, for more often, Mennonites recorded births on colorfully hand-decorated certificates printed for the Lutheran and Reformed markets.[15]

Like other Pennsylvania Germans, Mennonites were eager to document family events, but they did so with family registers, bookplates having biographical data, birth records, and other types of decorated manuscripts. In fact, Mennonites—and, later, their Amish cousins—embraced family registers, perhaps more than other denominations. Research indicates that the number of family registers among Mennonite fraktur is disproportionately high compared to types of fraktur that were popular among Lutheran and Reformed families. And even though the Amish do not support art for art's sake, the decorated family register is considered functional enough as a record of the family unit that it can hang in the Amish house.

Significantly, small sects such as Mennonites, families associated with the Ephrata Cloister (often former Mennonites), and members of the Church of the Brethren (Dunkers) seemed to favor family registers earlier than other Pennsylvania Germans. Moreover, the tradition of creating family registers among Mennonites in America lasted a long time—from the first half of the eighteenth century until today. Perhaps the reason for an early interest in family registers among Mennonites is that they and other small religious sects suffered persecution while in Europe. Following the Reformation of the sixteenth century, German-speaking areas of Europe generally recognized three denominations as legitimate: Catholic, Lutheran, and Reformed. Practitioners of other faiths, such as the Mennonites, Amish, Schwenkfelders, and Moravians, were virtual outlaws. At various times and in various regions, rulers tolerated these groups, but at other times, they fiercely hunted down and arrested—and even tortured and executed—members of unapproved congregations. Thus, if Anabaptists or Separatists created family records in their European homelands, those records could be used against them. But in America, members of small sects quickly took advantage of their new religious freedoms. For example, eighteenth-century printers from Philadelphia and nearby Germantown, such as the Christopher Saurs (father, son, and grandson), Andrew Bradford, Benjamin Franklin, Henrich Miller, Anton Armbrüster, and others, printed devotional books for various segments of the lucrative German-language market without government interference. Coinciding with the religious fervor brought about by the Great Awakening of the 1730s and 1740s,[16] these publications included books promot-

ing fringe or experimental religious beliefs, such as mysticism and the observance of a seventh-day Sabbath.[17]

As Mennonites and members of other small denominations discovered that they could freely express religious beliefs in their new homeland, they began to practice their forms of religion openly. A fraktur that illustrates this point is a bookplate made in 1766 by Lancaster County artist Hans Jacob Brubacher (1725–1802).[18] The bookplate states, "This precious Mennonite book of sermons belongs to me, Hans Jacob Brubacher" (color plate 2). Although Brubacher did not explicitly acknowledge that he was a Mennonite (he was), it is an early handwritten mention of the word "Mennonite" on a fraktur. That Brubacher felt comfortable enough to use the word testifies to the idea that expression of religious preference, at least in Pennsylvania, was becoming safe.

Although there are notable exceptions, Lutheran and Reformed families seemed to lag behind in embracing family registers. Such registers became popular among these families beginning about 1800. Lutheran and Reformed families favored hand-inscribed family registers that were bound between the Old and New Testaments in Bibles. Bible-entry registers made in the fraktur tradition peaked toward the end of the nineteenth century (see Chapter 5). Professional and amateur calligraphers continued penning data into Bibles for Pennsylvania-German families throughout the twentieth century, however.

The shift from German to English among Pennsylvania Germans took place during the second half of the nineteenth century. Coinciding with this gradual shift, certificates across America became standardized in the light of changing decorative taste and the availability of inexpensive prints. Thus, these late examples lost the Pennsylvania-German folk art tradition as printers increasingly took over the design. They became generic, Victorian in style, often drab, and heavily religious—at least when compared artistically with earlier examples having spontaneous and colorful decoration. Early in the twentieth century, family members increasingly recorded data in English in plain hands that lacked the skill of the professional scrivener. The manuscript art so apparent in the exquisite lettering once germane to fraktur became diminished to the point that little of the fraktur tradition remained beyond recording family data. Today, family information is documented in plain handwriting, or on a typewriter or computer. Virtually all vestiges of decoration are absent. But there are exceptions, especially among the Amish and conservative Mennonites, who continue to decorate family-related manuscripts.[19]

Data collected on fraktur in general indicate that less than 5 percent of eighteenth-century broadside-type documents survived, while probably 10 to 15 percent of nineteenth- and twentieth-century examples still remain. As will be discussed in Chapter 5, the survival of family registers in Bibles is much higher. Whether broadsides or Bible-entry registers, many are still held by the original families, stored in attics and cellars across Pennsylvania or wherever descendants of Pennsylvania Germans live. Many can be found in genealogical and historical

archives and libraries, others scattered in antique shops. They are sometimes abused and often ignored, but many await discovery.

Fraktur represents a major—perhaps the premier—body of illuminated manuscript art routinely drawn and painted in America. When separated from the swirl of birth and baptism certificates, writing exercises, bookplates, and fraktur with strong folk art appeal—in short, classic fraktur—family registers offer new dimensions for understanding the broader field of fraktur. Fraktur-related registers present a visual treat for the family historian, the collector, and the student of Pennsylvania-German decorative arts and material culture, and they provide direct links to families' pasts. Furthermore, they represent elementary but essential ingredients for reconstructing local history. As primary sources, family registers contain basic biographical details about the men and women who built our nation, and this information often can be found nowhere else. In the context of American history, registers collectively add the "narrowly local" building blocks that Ola Elizabeth Winslow saw as integral to our emerging national pride.

Comparisons of Pennsylvania-German
and New England Family Registers

IN AMERICA, DECORATED FAMILY registers were made in great numbers by two major ethnic and geographically defined groups. In New England, registers were made for families that had emigrated primarily from the British Isles, and Pennsylvania-German family registers were made for families of German-speaking heritage. The latter registers were not always made in Pennsylvania; instead, they were made anywhere Pennsylvania Germans and their descendants settled.

New England registers have received recognition for years, especially those registers on textiles prepared by girls attending sewing schools, largely because viewers appreciate their charming designs and the young women's domestic skills. They generally fall into the broader category of samplers.[1] New England schoolgirls stitched and embroidered sampler-type family registers from late in the eighteenth century until about 1850. According to Gloria Allen, these registers peaked numerically about 1820.[2]

Pennsylvania Germans also made sampler-type family registers, but they were never as popular within this subculture. Most Pennsylvania-German family register textiles are English-language examples. Pennsylvania Germans who could afford to send their daughters to finishing schools sent them to English-language schools. Factors in determining the provenance of a textile register are family history, whether the textile came from a school documented in the literature, and the surname of the maker (or, in some cases, the owner).

Most American textile family registers come from New England. Tandy and Charles Hersh reported in *Samplers of the Pennsylvania Germans* that the earliest documented needlework Pennsylvania-German family register dated from 1831.[3] Obviously, this English-language example was made much later than the

earliest Pennsylvania-German family registers on paper. Most Pennsylvania-German textile registers were made in the first half of the nineteenth century (color plate 3), and even decorated towel registers—which are especially rare—were made during the same period by Pennsylvania-German families (color plate 4).[4]

Pennsylvania Germans favored family registers on paper versus textiles for a variety of reasons, the most obvious of which was the difficulty in stitching fraktur lettering and script. It was difficult enough to stitch characters of the alphabet in roman (English) lettering and make the words legible, but fraktur lettering—a more decorative style of lettering—was even more difficult.[5] Pennsylvania-German women could, of course, decorate their samplers intricately; indeed, their samplers include a wide range of complex motifs. But family registers required many words and could be written on paper with far greater ease. Moreover, the tradition of decorating manuscripts was so securely fixed in their culture that Pennsylvania Germans felt no strong need to turn to textiles for recording family data.

Entitled "Family Record," "Family Register," "Genealogy," and so on, New England registers were made on paper or fabric, or they combined embroidery with printed text. Many list names and dates with no title, the purpose being evident. Schoolmasters, scriveners, and printers who made Pennsylvania-German family registers gave the registers various titles, such as *"Familien Register"* ("Family Register"), *"Familie Verzeichniß"* ("Family Catalog"), *"Vorväter Verzeichniß"* ("Ancestor Catalog" or, literally, "'Forefather' Catalog"), *"Geburts-Register"* ("Birth Register"), or *"Geschlechtsregister."* (Literally, the term *Geschlechtsregister* means "sex" register, recalling the joke that defines genealogists as people who research their ancestors' sex lives. It is more acceptable to translate *Geschlechtsregister*—as many do—as "Register of Generations."[6]) Most English-language registers infilled for families of German heritage are simply titled "Birth Days" or "Family Record." Some have no title at all and list parents and children, or occasionally, only the children.

The term *"Vorväter Verzeichniß"* is interesting in that most American family registers list only two to three generations, and most of the family members listed are the children of the parents for whom the register was made. An entirely printed *Vorväter Verzeichniß* offers details about the family of Peter and Elisabeth Baumann (fig. 3). The register focuses on their son, David Baumann (1787–1850), and his family. David Baumann was originally from Pennsylvania. He married Maria Bechtel in Canada, and they had eight children who are listed on the register. The register was probably printed soon after the deaths of David and Maria (Bechtel) Baumann, both of whom died in 1850—the latest date printed on the register. David and Maria Baumann's oldest son, Joseph D. Baumann (born 1815), probably had the register printed. Published by Bauernfreund in Waterloo (Ontario, Canada), two copies of this example are known.[7]

Happily, this register names not only David's parents, Peter and Elisabeth Baumann, but also his wife's parents (Joseph Bechtel and Magdalena Allebach),

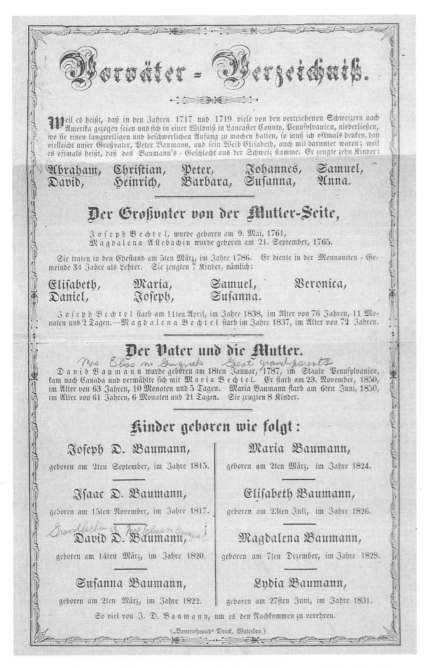

FIG. 3 Family register for David and Maria (Bechtel) Baumann. Printed by Bauern-freund in Waterloo, Ontario, Canada, circa 1850. Printed on wove paper, 10³/₄ in. × 7¹/₂ in. Courtesy Muddy Creek Farm Library, Ephrata, Pennsylvania.

This three-generation register illustrates how the Mennonite interest in documenting family history transferred with families emigrating from Pennsylvania to Canada. The register was apparently printed for J[oseph] D. Baumann not only as a memorial to his parents but also for the benefit of his descendants *(um es den Nachkommen zu verehren).*

rather than focusing on the paternal side alone. This register mentions the word *"Schweizern,"* suggesting that the family immigrated to North America from Switzerland. But according to Amos Hoover, the term actually means that the family was Mennonite, for Mennonite immigrants were often called "Swiss." Many Mennonites originally came from Switzerland, but others emigrated from areas in present-day Germany and from Alsace, where they settled for several generations prior to immigrating to North America.[8]

In spite of its name ("Forefather Catalog"), the Baumann/Bechtel register covers only three generations. Like many registers, the Baumann/Bechtel register causes confusion with phrases such as "grandfather on the mother's side" *(Großvater von der Mutter-Seite)*. Because the reader has no frame of reference to know which generation is meant and, therefore, whose grandfather and mother are meant, determining family lines and relationships requires close examination.

Some family registers, such as the Baumann/Bechtel register, were entirely printed. This practice was also known in New England. In "New England Family Record Broadsides and 'The Letterpress Artist' of Connecticut," D. Brenton Simons made the point that New England broadside registers from small printshops or itinerant printers were subject to errors in spelling, typography, and accuracy of data.[9] Certainly in Pennsylvania, special allowance must be made for inconsistencies and sometimes bizarre attempts at spelling. Spelling conventions were hit-and-miss throughout the eighteenth century and into the nineteenth. Moreover, many Pennsylvania Germans felt indifferent about spelling and often spelled phonetically, frequently attempting to write English words using their own sound system.

Spelling inconsistencies cannot be emphasized enough. Throughout the history of fraktur, standardized spelling became a major casualty when Pennsylvania Germans put spoken words to paper. Even when they wrote their own names, they varied the spelling. For example, the surname Meyli has numerous known variations. A Mennonite family of Meylis immigrated to Lancaster County early in the eighteenth century. Several Meyli descendants had family registers made. Researchers looking for records with the name Meyli must search through variant spellings such as Maily, Meyli, Myley, Meily, Meylin, Meili, Miley, Myly, Mayley, Meillen, Mili, Milly, and more. Creative spelling is less of an issue for researchers trying to locate registers made for English-speaking families, but those dealing with German records quickly learn that they must sometimes "reach" to find ancestors with German names.

Family registers made in the fraktur tradition are similar to their contemporary New England examples in several ways. They served the same purpose in that they recorded family information, and they tended to record the names and dates of two to three generations, often with no location. Additionally, by the mid-nineteenth century, many registers made for Pennsylvania-German families were written in English. But from the standpoint of art, differences appear in

family registers from the two ethnic groups. While some New England registers resemble those from Pennsylvania, most pre–Civil War manuscript registers from the two cultures appear dissimilar. In fact, prior to the Civil War, New England and Pennsylvania-German makers of registers shared little freehand art. By the mid-nineteenth century, decorative elements on both New England and Pennsylvania registers became dominated by printers. Printers using copperplate engravings, lithography, and color technology achieved detailed scenes that illustrated special events in family life, such as baptism, marriage, and death. As these prints spread in popularity, the former individualistic styles found on New England and Pennsylvania registers yielded to widely popular Victorian tastes.

Many early Pennsylvania-German registers lacked decoration of any kind, but when decoration was present, it appeared spontaneous. Arrangements of motifs were less formal on Pennsylvania registers than on New England examples. While decorative elements suggested a love of nature, imaginary birds and flowers were common. New England folk art tended to be more sober and formal. Thus, New England registers included stylized trees, trees growing from hearts, arches, pillars, swags and draperies, and classical or neoclassical figures. This is not to say, however, that all New England registers were formal. New Englanders loved their birds and flowers, too, but their printers and trained artists were influenced by the ready availability of broadsides and books, finishing schools, the latest decorative trends, and an urban environment. The format and motifs of the Letterpress Artist of Connecticut (active circa 1820), for instance, are closely associated with New England decorative arts. The Letterpress Artist utilized preprinted forms with hand-set, letterpress infill. He then decorated these with silhouettes or hollow-cut profiles, an art form associated with New England as well as English-speaking urban centers throughout the mid-Atlantic states.[10]

Other New England registers dating from the first half of the nineteenth century appear architectural and plinth-like, with extensive columns framing the text at the sides and rectangular and square boxes at the bottom and top (color plate 5). Except for numerous Bible-entry registers made by fraktur artist Karl Friedrich Theodor Seybold (active circa 1813–46), architectural motifs appear significantly less often on Pennsylvania-German registers than on New England registers (color plate 6).

Obviously, New England and Pennsylvania-German registers have some motifs in common. For example, the heart appears on registers from both cultures. But such shared motifs came not from an exchange of ideas among New England and Pennsylvania artists but from common, widely circulated sources. Illustrations in books and on broadsides, centuries-old pagan and Christian symbols common throughout Europe, countless representations from European culture, folklore, art, literature, and especially images from nature—all contributed to the repertoire of American family register artists.

Some motifs shared by both ethnic groups—especially those depicting

death—are strongly symbolic. Death is often denoted by a simple coffin, black cross, or weeping willow. In no region were renditions of people (other than angels and allegorical figures) common, but examples do exist. New England artists used allegorical motifs such as a woman with an anchor (symbolizing hope) and angels, probably guardian angels. These motifs are also found on Pennsylvania-German fraktur. And motifs used simply to adorn—birds, flowers, and geometric designs—were popular among members of both groups.

Typical New England motifs may be expected in Maine and Massachusetts, just as typical Pennsylvania-German motifs would be prevalent in southeastern Pennsylvania. But there are areas of gray. The anonymous Heart and Hand Artist of New England (active circa 1850–55) drew a birth and marriage record for Eli Harnish and Elizabeth Eshleman of Lancaster County (color plate 7). William Murray (1756–1828) of New York made numerous freehand family registers. Because his decoration is "fraktur-like" and because several of his works migrated to Pennsylvania, he is often included among fraktur studies despite the British-American names on many of his registers. Fraktur artist John Van Minian (active circa 1805–42) used formal formats for his family registers. He drew stylized eagles and human profiles, he often wrote in English, and he made registers for families in Pennsylvania, New Jersey, Maryland, and even Vermont. And fraktur artist David Bixler (active circa 1828–64) of Brecknock Township, Lancaster County, made a family register for his own family showing profiles of his parents and two brothers, Absolom and Levi.[11] Bixler gave his own birth date as January 5, 1808. He is the only person on the register shown frontally (color plate 8). This register is unusual because of its architectural columns and arches and especially because of the portraits. Eighteenth- and nineteenth-century Pennsylvania Germans generally avoided portraiture on fraktur, for they felt likenesses were vainglorious.

Whereas academically trained artists often created New England family registers, Pennsylvania-German artists were usually self-trained. The typical fraktur-producing schoolmaster in the one-room Pennsylvania schoolhouse taught rudimentary subjects such as reading, writing, and arithmetic. Seldom were classical literature and the fine arts part of his curriculum. Because Pennsylvania-German schools were founded by and closely linked to churches, the schoolmaster often had musical training and became the church organist and song leader. He was familiar with the Bible, hymnals, and folk and religious literature popular in his day. And many Pennsylvania-German schoolmasters were, of course, excellent penmen. But most of these schoolmasters had limited exposure to the classical and neoclassical art forms favored by New Englanders and their English-language cousins throughout the mid-Atlantic region. Instead, they lived and taught in rural communities. They were surrounded by farming families that retained Old World customs, superstition, language, and love of folklore and nature. As a consequence, we find a heavier reliance on birds and flowers on Pennsylvania registers. We even expect to see folky lions on Pennsylvania-

German registers, as opposed to pillars, urns, columns, and static family trees (color plate 9).

Because Pennsylvania-German fraktur were so closely associated with rural communities, those familiar with fraktur express surprise that motifs related to farming rarely appear on fraktur. Fraktur artists drew few horses and cows, farm houses and barns, or plows and other farm implements. Such motifs may have seemed too mundane. Instead, artists drew creatures they had never seen and would likely never see. Rather than horses and cows, they drew lions, mermaids, griffins, parrots, alligators (or salamanders), and unicorns. And rather than farmhouses and barns, they drew castles.[12]

A striking and important difference in motifs found on pre–Civil War Pennsylvania-German and New England registers is that New England motifs show significantly stronger symbolism. Except for images concerning death, symbolism on Pennsylvania-German family registers is often inconspicuous, ill-defined, or entirely absent. On New England registers, the stylized tree, commingled hearts, intertwining vines, chains, houses, engravings of families, and entire compositions all visually reinforce family unity and generations forever linked. But such visual reinforcements on Pennsylvania-German registers are rare.

The tree motif best illustrates this point. In their respective chapters contributed to *The Art of Family*, Peter Benes and Georgia Barnhill pictured numerous examples of New England paper and textile registers that graphically show unity of family.[13] Many of these are arranged in tree-like fashion, prominently showing the parents' names at the top or the bottom of the page. While Pennsylvania-German examples often show parents' names at the top, the concept of placing these names at the bottom—as if they were the "roots" of the family tree—rarely, if ever, occurred to Pennsylvania-German artists.

New Englanders drew family trees in many forms. These range from the realistic—roots and all—to a tree having no trunk, but consisting of a vertically oriented format with circles provided for data. Pennsylvania-German artists, on the other hand, may have shied away from creating registers in tree-like formats. Perhaps they viewed them as too similar to European family charts depicting coats of arms, which were often arranged in tree-like fashion. Although this formal format was not necessary, for trees could have been drawn as border decoration, trees appear infrequently on fraktur-related registers (or, for that matter, on other fraktur).

As in all fraktur, there are exceptions. In "Andreas Kolb (1749–1811): Mennonite Schoolmaster and Fraktur Artist," Mary Jane Lederach Hershey pointed out that fraktur artist Andreas Schwartz Kolb often drew trees on his fraktur.[14] And a combination birth record/family register made for the Schörch [Shirk]/ Berg family includes trees as lower border decoration. It remains speculative, however, whether the anonymous Ehre Vater Artist (active circa 1782–1828), who made the Schörch/Berg fraktur, drew the trees from a sense of representing the "family tree" or a sense of decoration.[15]

According to Benes, "together, or in combination with other symbols, the heart and the tree were the most common devices used to express the art of family."[16] While the heart is ubiquitous on Pennsylvania-German fraktur, including family registers, it is perhaps surprising that trees are absent from most Pennsylvania-German registers. As Benes points out, trees have a long association with "religious and genealogical meaning": "the family 'tree' and its related 'roots,' 'branches,' and 'fruits' have been synonymous for bloodlines in Western culture" for centuries.[17]

No explanation for the absence of trees on fraktur has been forthcoming, but a current school of thought concerning fraktur art in general might shed light on the subject. As previously mentioned, discussion of fraktur in past decades frequently centered on the art rather than the text. Much of this discussion focused on the symbolism various authors saw in fraktur art. In *Faith and Family: Pennsylvania German Heritage in York County Area Fraktur,* June Burk Lloyd reviewed the widely diverse opinions of those authors, who not only disagreed with one another but also were occasionally quite opposed in their views. Lloyd's excellent review summarized published theories concerning symbolism, motif by motif. When presented in this light, the multiple symbolic meanings expressed in the previous literature dilute and trivialize many interpretations, making them all but meaningless. It is as if anyone can read anything into fraktur art.[18]

John Joseph Stoudt, author of several mid-twentieth-century studies on Pennsylvania-German folk art, found religious symbolism in almost every fraktur motif. He speculated about symbolic meaning to such an extent that he has been roundly criticized for his sometimes far-reaching conclusions. One motif illustrates this point. According to Lloyd, "Everyone seems to have a different definition for the meaning of tulips." But Stoudt seemed dissatisfied with advancing just one interpretation. As Lloyd pointed out, Stoudt equated the tulip with the lily, but then offered "a four-level explanation of the lily that covers everything from all believers to eternal flowers of paradise."[19]

Stoudt's analysis of symbolic meaning on Ephrata fraktur may have merit, for Ephrata was a mystical sect, and every act of its members' lives had spiritual ramifications. The very act of illuminating manuscripts at the Cloister was replete with religious significance, so religious meaning in Ephrata fraktur art might be expected. Outside the Cloister, fraktur are known on which the Lamb of God, the Crown of Righteousness, the cross, the Crucifixion, and other overtly Christian images appear, but these motifs are relatively uncommon. The most common religious motif on fraktur is the angel, but hearts—a pagan symbol—are just as ubiquitous. Generally, most scholars agree that religious expression on fraktur appears more frequently in the text rather than in the decoration.[20]

Fraktur artists employed their favorite motifs on all fraktur they produced. Rather than attempting to adapt art to different types of records, they repeated

motifs that were comfortable to them. Thus, artistically speaking, a *Vorschrift* made by Lancaster County artist Christian Strenge (1757–1828) appears much the same as a Strenge family register. Moreover, two motifs—hearts and tulips—were common to most types of fraktur and to most fraktur artists. It is highly doubtful that these motifs had special meaning on *Vorschriften* and that they represented something entirely different on family registers.

The tulip might represent the Trinity; the peacock, resurrection; the eagle, national pride; and the heart, affection. But scholars today take the approach that while some motifs on fraktur had special meaning, most did not. Scholars conclude that fraktur art represented anything the owner wanted, but for the most part, it was inspired by nature as well as exposure to a host of other experiences, such as familiarity with Old World folklore, current events, spiritual awareness, and sensitivity to design.[21]

Taking current thought about symbolism in fraktur art a step further, the typical Pennsylvania-German schoolmaster may actually have *avoided* symbolism, and certain religious symbolism in particular. Religious symbolism is more closely associated with Catholicism rather than Protestantism, and most Pennsylvania Germans were Protestant. Their aversion to displays of religious symbolism may have spilled over to symbolism of any kind.

But there is another important issue—one that helps explain the art on Pennsylvania-German family registers, especially when compared to New England registers. As we discussed in *Fraktur: Folk Art and Family,* motifs on fraktur generally have little to do with illustrating the text. In fact, fraktur art seems all but divorced from text. There is no obvious reason to show lions on family registers—let alone the eagle, a chandelier, vases of flowers, the sun, a pair of women, compass designs, and other motifs that appear on Pennsylvania-German registers—when a house would be more appropriate.[22]

Of course, some fraktur do picture motifs that illustrate the text. For example, two clasping hands between adjoining hearts appear on a birth and marriage record made for the Maily/Herr family. The texts in the adjoining hearts detail biographical information concerning Martin Maily and his wife, Elisabetha Herr (color plate 10). In addition, this fraktur depicts an anvil and other blacksmith tools that represent Martin Maily's occupation, but such trade symbols are exceedingly rare on fraktur. Overall, the strongly symbolic Maily/Herr register represents an exception to the rule.

Other Pennsylvania-German family registers suggesting symbolism are known. A man and woman facing one another appear on a register made for the Altland/Streher family of York County, Pennsylvania (color plate 11). Certainly, a man and woman on a family register seem appropriately symbolic of the union of the couple, the core of the family. But on the other hand, a register is known on which two women appear rather than a man and woman. And a register made for the Bollinger/Nees family of Lancaster County depicts two men per-

haps meant to portray George Washington, who was an immensely popular fig-
ure but likely had nothing to do with the Bollinger family (color plate 12).

Current theories suggesting that fraktur motifs derive more from nature than
religion run counter to previous interpretations. Scholars will debate these issues
for years, but suffice it to say that it comes as no particular surprise that lions
are as apt to appear on Pennsylvania-German family registers as anything else.
All this helps explain the curious lack of trees on fraktur and especially on family
registers, where the symbolic meaning would be so obvious. Trees are part of
nature and they are not difficult to draw, but Pennsylvania Germans showed
little interest in them as symbolic of family unity or genesis. Moreover, as illus-
trated by other types of fraktur, there was little connection between the text on
fraktur and the decoration. Thus, a major difference between New England and
Pennsylvania-German family register art is that New England artists were *illus-
trating the text* whereas Pennsylvania-German artists were *decorating a manu-
script*.

As expected, English-language family registers were made for British-Ameri-
can families living in southeastern Pennsylvania. For example, James M. New-
comer (active circa 1868–73) made English-language registers for families in
Cumberland County, Pennsylvania. Some of these families were British-Ameri-
can. Although Newcomer's surname suggests German ancestry, he may not have
known German. Thus, his clientele would be limited to English-speaking popu-
lations. Nevertheless, he followed in the tradition of decorating family register
manuscripts (color plate 13).

Based on art alone, it can be difficult to prove that an English-language regis-
ter was made for a New England family. Still, in the absence of written locations,
the family names, language, identifiable artists, and style of lettering in addition
to the art often make it possible to distinguish a New England register from a
Pennsylvania-German example. Other factors include the provenance of the
piece, if known. And, of course, watermarks provide clues.[23] Watermarks should
not be confused with water stains. Used to identify papermakers, watermarks
can be seen by holding paper to strong background light. Faint lines in the paper
show papermakers' initials or names or a pattern that identifies them. Although
recent research identifies many early American papers and their makers, gaps in
this research often hinder students of fraktur. Klaus Stopp, for example, found
early fraktur birth and baptism certificates made on paper having watermarks
that remain uncatalogued in standard works such as *American Watermarks,
1690–1835*.[24] Fortunately, Stopp described and/or sketched these watermarks
that identify papermakers who supplied paper to the Pennsylvania-German mar-
ket, including printers at Ephrata.[25]

Another clue for differentiating between a New England register and a Penn-
sylvania-German one is found in the penmanship. As Shelley wrote, "New En-
gland family registers are more apt to be described as 'watercolor drawings,' and
usually employ roman letters rather than Gothic. Nowhere outside of Pennsylva-

nia, in fact, was Fraktur writing practiced in quite the same manner, or with the same motifs and meanings."[26] This is not to say, however, that the use of English (roman) letters was restricted to New England, especially after the middle of the nineteenth century.

Another indicator for determining the difference between an English-language register made for a New England family and one made for a Pennsylvania-German family is the surname. For example, in 1826, fraktur artist John Van Minian made an English-language register for the Hunt/Shannon family of Dorset, Vermont (color plate 14). Had there been no location noted on the register, researchers might, from the surnames, suspect that the family was of British extraction. Researchers must be careful, however, to ensure that names have not been translated or anglicized. Names such as Weaver, Taylor, and Carpenter might have been translated from Weber, Schneider, and Zimmermann, respectively. Or names such as Snyder and Wall may have been anglicized from Schneider and Wahl.

Frequently, families were ethnically diverse. The freehand register of the John W. Roberts family falls into the realm of fraktur-related examples because, even though the name Roberts suggests a British-American family, John W. Roberts's wife, Katie, was of German heritage. Her family names include Weidner and Sterner. In addition to Katie's ethnic background, the artist—August Baumann (active circa 1879–1905)—is well known as a professional scrivener among Pennsylvania-German families of Bucks and Lehigh Counties. Fortunately, Baumann did include locations in Lehigh County when he made the Roberts/Weidner family register in 1905 (color plate 15).

First names are also helpful. Until about 1830, Pennsylvania Germans used a relatively limited number of first names. Before the Victorian era, most first names for women were Catharina, Eva, Hanna, Barbara, Sophia, Susannah, Louisa, Veronica, Apollonia, Elisabetha, Maria, Anna, Magdalena, Sarah, Lydia, Margaretha, and Christina. Note that most female names end with the "a" sound as in "father"; their English counterparts often do not. Instead, comparable New England names might be Catharine, Susan, Louise, Elizabeth, Mary, Ann or Anne, Margaret, and Christine. Jane, Joan, Molly, Sally, Patsy, Priscilla, Suky, May, Hattie, Nancy, Pamela, Betsy, and Abigail are also commonly found on New England registers.

For male names among Pennsylvania Germans, the name Johannes (or Johann, Hans, or another variant) was the "saint's name" or first name for most boys. Thus, when the first name for a man or boy is Johannes or a variant of that name, the chances are that the fellow was Pennsylvania German. The second name was a "call name," the name by which a man was addressed. Andreas, Jorg or Georg [George], Jacob, Christoph [Christopher], Heinrich or Henrich, Wilhelm, Friederich, Conrad, Carl, and Frantz were common call names. In families of British origin, Thomas, Lemuel, Charles, Robert, Ronald, Franklin,

George, Ebenezer, James, Richard, Edward, and Nathaniel were common first names for boys.

The system is not perfect. Both groups used biblical names such as Abraham, Benjamin, John, Daniel, Esther, David, Jacob, Joseph, Peter, Michael, Rachel, Martin, Matthew, and Samuel. But there are naming patterns common to various subcultures, at least until the middle of the nineteenth century.

Naturally, New England can boast important "firsts" in American family registers. According to Barnhill, the Isaiah Thomas Bible of 1791 published in Worcester, Massachusetts, was the first to have a preprinted family register, infilled by hand, bound between the Old and New Testaments.[27] Its simple headings, such as "Family Record of Marriage and Births of Children" and "Family Record of Deaths," gave structure to the family register. In the 1790s, Richard Brunton of Connecticut made the earliest American preprinted broadside registers on which family information was infilled by hand. His certificates, like the Thomas Bible, provided three columns, entitled "Names," "Born," and "Died," placed below a "Register" section where the names and dates of marriage of the parents were penned.[28] Later, from about 1810 to 1832, other printers made broadside-type certificates available in Massachusetts.[29]

As discussed by Barnhill, preprinted family registers began declining in the 1860s, but production continued until the 1890s.[30] During that time, Pennsylvania Germans used these same forms but, as Shelley discovered, they used them to a lesser degree. Undoubtedly, these preprinted, broadside-type registers met with competition from registers printed in Bibles, for Bible-entry registers came to dominate the Pennsylvania-German family register market (see Chapter 5).

Following the Civil War, modifications made to preprinted registers included lithography, chromolithography, and inserts for photo likenesses. Eventually, taste and technology saw the family register fade from the New England scene, replaced in part by the Victorian photo album and book-length family histories. Pennsylvania-German registers suffered basically the same fate, except perhaps at a slower rate. In fact, as shown in Chapter 5, registers made in the fraktur tradition, and especially those found in Bibles, persist to the present day. Importantly, while the folk art quality on earlier registers gave way to late Victorian–appearing forms, the texts on family registers remained constant. Too often, these texts omitted locations, but they continued to detail names and dates concerning two or three generations of Americans.

4

Texts on Pennsylvania-German Family Registers

FAMILY RELATIONSHIPS CAN BE seen at a glance on most registers that list two generations—parents and children. In Bible-entry registers, especially, families frequently added generations of grandchildren and great-grandchildren. A major problem with multi-generational registers is that, when written with little thought, texts quickly became confused. Generally, this occurred when families neglected to state family relationships clearly. For example, some families recorded data concerning *all* births on pages or in columns with "Births" pre-printed on the register. Thus, they skipped from one generation to another or even mixed generations on the "Births" portion of the register without giving clear indications regarding lineage. Occasionally, direct and collateral lines are simultaneously developed, making it all but impossible to distinguish family units. Nineteenth-century professional scriveners were generally aware of these pitfalls and presented data in an organized fashion, but families recording data often left readers adrift.

Added notes on registers frequently frustrate those reading them. For example, an English-language register made for the family of George O. and Daisy R. Boyer of Lykens, Pennsylvania, has a note at the bottom that reads, "Mrs. Malinda M. Bellon was born February 13, 1872 and diet [died] January 16, 1927. Her age wood [would] be 54 years, 11 month[s], and 3 days. She diet at my place." None of George and Daisy Boyer's children was named Malinda, so Mrs. Bellon does not appear to be a married daughter of this couple. And the unclear pronoun antecedent in the phrase "my place" offers no clue as to whose place is meant.

As previously discussed, New England artists creating single-page registers

reinforced family relationships with elaborate compositions that offered unmistakable visual clues, such as the family tree. On most Pennsylvania-German examples, the format of the single-page register begins with the parents' names at the top, followed by the names of their offspring, listed in order of birth. An undecorated register made for the Franz/Miller family demonstrates this simple arrangement (fig. 4). The uncomplicated format gives visual clues, and it requires little pre-planning in terms of text and design. Certainly, some freehand examples were carefully formatted, but most consisted simply of text with or without border decoration. Obviously, meticulous planning was essential for printers to typeset totally printed registers and preprinted registers requiring handwritten infill. From the standpoint of technical skill, these were the most difficult of all registers to create.

On freehand fraktur, scholars have long debated whether the artist wrote the text first and then decorated, or whether he decorated first and then wrote the text. Because the text was meant to be the focal point on Pennsylvania-German family registers, it would seem reasonable to assume that the text was written first. But the actual answer to that question almost always depends on the specific fraktur. For example, Christian Strenge appears to have decorated the Kauffmann/Brubacher family register before he wrote the text (color plate 16). But fraktur artist Friederich Leonhard (active circa 1803–27) probably wrote the text on the Kindig/Meÿli register before he decorated it (color plate 17).

Unlike other types of fraktur, such as *Taufscheine* and *Vorschriften,* family registers generally lack religious verses—perhaps because family data on registers consumed too much space. Of course, *Taufscheine* commemorated the act of baptism, so they featured verses appropriate to that occasion. And *Vorschriften* were made by schoolmasters as teaching tools. Thus, they contain lengthy religious texts meant to serve as moral instruction. Aside from annual dates that begin, "In the year of our Lord . . . ," the most frequently encountered religious reference found on Pennsylvania-German registers is the family's specific religious denomination.

Naturally, names, dates, and locations are essential pieces of information on almost any document. Family registers from New England and among Pennsylvania Germans provide names and dates, but not always locations. And occasionally, crucial names are absent on Pennsylvania-German registers—names such as the family surname or the names of the parents. (For example, the 1763 Bollinger register lacks the names of the parents.) At times, it is impossible to determine whether the names of parents appeared on a page that is missing from a multi-page Bible-entry family register. A superbly penned register made for the Funck family, for instance, lists four children, but it lacks the parents' names (fig. 5). This register may have been written on blank pages in a book, such as a music book. If so, other pages, now lost, might have yielded additional family information.

Dates on family registers are generally reliable, and they are rarely omitted.

FIG. 4 Page from family register of Jacob and Anna (Miller) Franz. Attributed to Karl Friedrich Theodor Seybold, Manor Township, Lancaster County, Pennsylvania, circa 1830. Hand-lettered on wove paper, 11½ in. × 9 in. Private collection.

Based on handwriting, this register is attributed to fraktur artist Karl Friedrich Theodor Seybold (active circa 1813–46). The text begins in the first person, as if Jacob Franz, the father of the family, wrote it. It was common in early Pennsylvania-German registers for fraktur artists to use the first person as if standing in for the father. Thus, scholars are cautious when attributing registers to the father of the family. This register gives the names of Jacob's parents, but not Anna's. Jacob's parents were Jacob and Barbara (Hostetter) Franz. Note the error made by Seybold, who first recorded Barbara Hostetter's maiden name as Habecker. Jacob and Anna (Miller) Franz married on February 18, 1806 *(18ten Horni[n]g 1806)*, and had ten children.

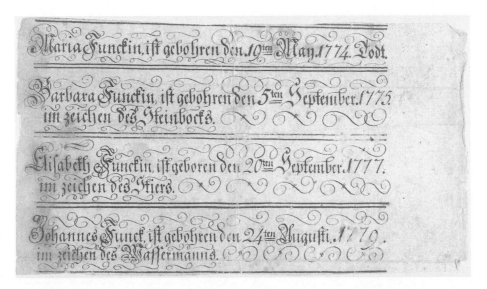

FIG. 5 Birth register for the Funck children. Anonymous scrivener, no location, circa 1779. Hand-lettered on laid paper, 4½ in. × 8¼ in. Possibly removed from a songbook. Private collection.

The Funck register illustrates a common problem. The entries might once have been part of a book that had data regarding the rest of the family. On the other hand, the scrivener simply may have intended to record only the children in this family. As it stands, the register is a beautiful example of fraktur writing waiting for a Funck family historian to reunite the children with their parents and possibly other siblings.

There are exceptions. For example, the previously mentioned Funck register has the word *Todt* (dead) following the entry of the first child, Maria, who was born in 1774. Presumably, this means that Maria died young, perhaps as an infant. Age at death is commonly included and expressed precisely, e.g., "62 years, 2 months, and 12 days."

Women were often ignored in eighteenth- and nineteenth-century records, even official ones. Pennsylvania-German women fared better in personal records, such as fraktur. But even in many Pennsylvania-German records, the mother's maiden name is forever lost. In fact, too often her *entire* name has been lost. Even her tombstone reads "consort" or "relict." In the old German cemetery, her tombstone says she was the *"Weib," "Ehefrau," "Gattin,"* or *"Ehegattin"* of the mate sleeping at her elbow. Additionally, some fraktur birth and baptism certificates say that the mother of the child was "Anna Maria Schröder, daughter of Jacob Schröder." Never mind that Jacob had a wife who was also responsible for Anna Maria's existence. Or a *Taufschein* might list sponsors at a baptism as "the child's grandparents, Michael Lang and his wife." Fortunately, most fraktur are more detailed than that, and they do give names of women.

Like women, children are often ignored in early records. Some nineteenth-century obituaries and so-called Glory Album biographies offer details about heads of families, but not the families themselves. Glory Albums include county-

wide biographical sketches, such as the *Commemorative Biographical Encyclopedia of Dauphin County, Pennsylvania,* published in 1896 by J. M. Runk and Company in Chambersburg, Pennsylvania.[1] There are many others. The biographical sketches presented in Glory Albums often provide significant genealogical data. At other times, they disappointingly describe a man's achievements in his public, religious, political, social, and business life, but not in his personal life. In a few instances, these biographies simply say that the father had four sons and three daughters. These children apparently made their father proud (but not proud enough to name them). The reverse is true on family registers, which occasionally omit the parents' names, not those of the children.

Fortunately, most family registers record the names of all immediate members of the family, irrespective of gender or status in the family. All are equal. And the register usually contains the names of all the children, even those who died before the register was made. Indeed, too frequently encountered are notations regarding infants who were apparently stillborn or died soon after birth. They are usually remembered only as "a daughter" or "a son." Sadly, these babies did not live long enough to receive a name.

The family register, overall, can serve as one of the most complete and accurate "snapshots" that exists for a family. The family provided the data to the artist, scrivener, or printer. There was no middleman, such as a supply preacher walking about the countryside with slips of paper stuck in his pocket, waiting until he got home to make entries in a church ledger. In terms of family research, family registers are often a tremendous improvement over the "checklist" approach of the census taker. And some surpass the Glory Album biography that speaks at length about the fine, upstanding Victorian father who is a pillar in the community while adding only vague references to his household—as if his anonymous wife and children were footnotes.

When family registers provide locations, the locations frequently refer to areas where an event, such as marriage, birth, or death, took place. At other times, locations refer to where the family was living at the time the register was made. Unfortunately, descendants of people mentioned on registers are interested in the one location that is most often absent from the register—the place in Europe whence the family came.

The fact that American registers focused on lives in the New World rather than the Old becomes apparent when one looks for registers that mention family origins in Europe. Early Pennsylvania-German family records tying a family to a specific location in Europe are difficult to find. Such records do exist, but they exist in disappointing numbers. In *A Genealogical History of the Kolb, Kulp, or Culp Family and Its Branches in America,* Daniel Kolb Cassel details information from a bookplate that reaches back across the Atlantic. As was typical of these early—but rare—bookplates that give glimpses into family roots in Europe, information about Dielman Kolb was written in German on the flyleaf of an "old book." According to the bookplate, Dielman Kolb was born about one

o'clock in the afternoon on November 10, 1691 (no location given).[2] At age twenty-three, he married Elisabeth Getraut [Elizabeth Gertrude], whose maiden name, according to Cassel, was Schnebli [Snavely]. The bookplate further relates that three years later, on March 21, 1717, Kolb emigrated from Ibersheim in Pfalz to Pennsylvania. He arrived at Philadelphia on August 10, 1717. The bookplate goes on to say that the book belonged to Kolb and that he got it from Jacob Schnebli of Mannheim in Pfalz. It came into Kolb's possession in 1722, while Kolb was living in Salford Township in Philadelphia County (today's Montgomery County). Although Cassel says that this book "was brought over at the time the Kolbs came"—perhaps in 1707—Kolb's bookplate suggests that Dielman Kolb received the book after he immigrated in 1717.[3]

One of the earliest Pennsylvania Germans to write a comprehensive family record appears to have been Dielman Kolb's sister-in-law, Magdalena (Van Sintern) Kolb (born circa 1685, died after 1771). Magdalena Kolb became the grandmother of fraktur artist Andreas Schwartz Kolb (1749–1811). Magdalena was the daughter of Isaac and Neeltje (Classen) Van Sintern, who were married in Amsterdam. In 1700, Magdalena immigrated to Pennsylvania with her parents and sisters from Altona, near Hamburg, Germany.[4] This Mennonite family settled in Germantown, near Philadelphia. Magdalena married Martin Kolb (1680–1761), who was the older brother of Dielman Kolb. Martin Kolb immigrated in 1707, and Dielman Kolb immigrated ten years later.

Martin and Magdalena (Van Sintern) Kolb lived in Skippack in present-day Montgomery County. Ten years after the death of her husband, Magdalena sent a record of her family to a "genealogist at Altona."[5] This transaction was recorded by Cassel in his *History of the Kolb Family*. According to Cassel, "under date of October 28, 1771," Magdalena Kolb "gave a record to the genealogist at Altona, which he received under seal through Hendrick Roosen, the 20th day of June, 1772; it was dated March 2d, 1772, giving the descendants of the family to be 202 souls." Presumably, Magdalena's record was a manuscript of several pages and included information about her extended family, including Kolbs, Van Sinterns, Rittenhouses, Detweilers, and others.[6] In *Maintaining the Right Fellowship*, John L. Ruth wrote that Kolb's was "the first known Mennonite genealogy outside of Europe."[7] In the sense of having recorded data concerning her extended family, it may even be that Magdalena Kolb was the earliest Pennsylvania-German genealogist, just as James Blake Jr. might have been the earliest New England genealogist.

Most family registers in America were made by descendants of immigrants. But Magdalena Kolb's genealogy illustrates that immigrant families also had an interest in documenting family history. Although Kolb's work was instigated by a distant cousin—the "genealogist at Altona"—she took her task seriously enough to locate and record 202 family members.

Significantly, most German-language registers before 1850 appear to have been made on North American soil. A comprehensive study comparing Euro-

pean and American genealogical documents, including family registers penned into Bibles, would be useful. Evidence from a random sampling of German-language Bibles published in Europe but now located in America suggests that most registers made for Pennsylvania-German families were made on this side of the ocean (see Chapter 5).[8] In other words, most were not started in Europe and continued here.

Immigrants and their first generations of descendants made one regrettable mistake when creating their registers. As noted above, almost all failed to record where in Europe the family originated. In fact, most types of fraktur having family data give no clues regarding European origin. This is not to say that all families neglected to record this information *somewhere*. Some did, but such manuscripts are rare, and they were not necessarily family registers. Many such records were bookplates like Dielman Kolb's. Some give limited but valuable biographical data. For example, a Bible printed in 1743 in Halle came into the possession of Oswaldt Neff, who was living at Conestoga near Ephrata in Lancaster County. The Bible has a simple bookplate written in fraktur lettering and dated 1749. This bookplate says that Oswaldt's brother, Peter Neff in Pfalz, sent him the Bible. The reference to Pfalz represents a rare, but welcome, notation (fig. 6). The Neff bookplate is then followed by two family registers made for the Bamberger family (figs. 7 and 8). These registers offer no locations.

Although they are in the minority, some early records are rich with locations. In *From Ziefen to Sally Run: Swiss Pioneer Jacob Repass (1737–1814) on the American Frontier,* Beverly Repass Hoch pictures a songbook written in 1769 by her immigrant ancestor. This small, decorated songbook gives information about Hans Jacob Rippas [Johann Jacob Repass], who immigrated in 1768. The combined songbook and family register says that Rippas was born September 26, 1737, in "the Canton of Basel in Ziffen [Switzerland]." Rippas recorded the names of his parents, Hans Jacob Rippas and Anna Spiess, "both from Ziffen." Rippas goes on to say that he married Anna Gerber in the church in Bübendorff in 1760. And, he says, Anna Gerber, daughter of Johannes and Ursula (Moller) Gerber, was born January 15, 1740, in Riegenschweil in the Canton of Basel. Rippas then lists the names and dates of birth of his children, some of whom were born in Switzerland. After settling first in Pennsylvania, Hans Jacob Rippas eventually moved to Wytheville in southwest Virginia, where he died in 1814. (To read how his songbook ended up in Seattle, Washington, and how it was eventually discovered makes one appreciate the difficulties involved in finding these early shreds of information crucial to family histories.[9])

The omission of European locations in early Pennsylvania-German family registers seems odd, and it raises a key question: *Why* did immigrants and their immediate descendants of Swiss or German heritage show so little interest in documenting their families' European origins? The first and second generations of immigrant families probably learned the names of the villages in Europe where the family originated, but like many of us today who ignore or forget

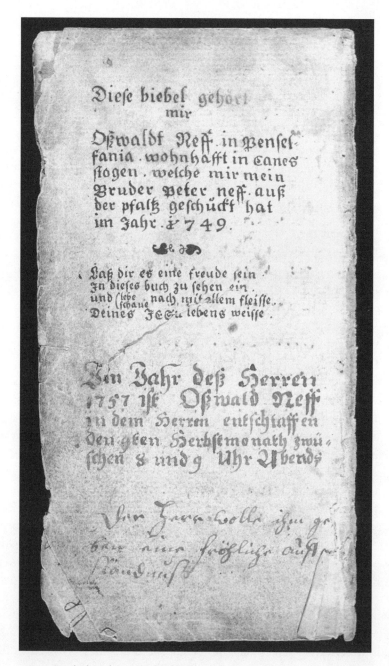

FIG. 6 Bookplate for Oswaldt Neff. Anonymous scrivener, Conestoga, Lancaster County, Pennsylvania, circa 1749 and 1757. Hand-lettered on laid paper, 6 in. × 3 ¼ in. Endpaper from 1743 Halle Bible. Collection of Clarke E. Hess.

The first paragraph of this bookplate says that the Bible belongs to Oswaldt Neff, residing at Conestoga, and that it was sent to him in 1749 by his brother, Peter, from Pfalz. This is followed by a short religious text. Possibly the same hand recorded that Oswaldt Neff "went to sleep in the Lord" the 9th day of September in the year 1757 between eight and nine in the evening. Additional endpapers in this Bible include two family registers for the Bamberger family (see figs. 7 and 8).

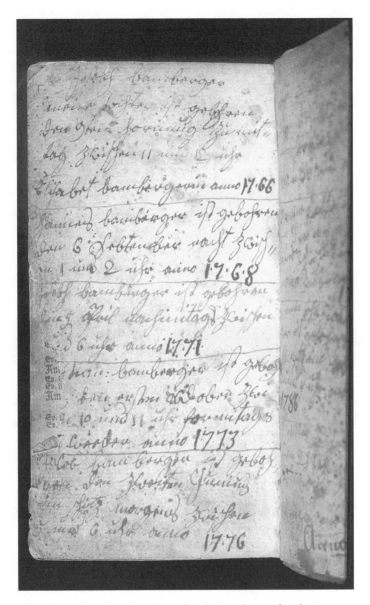

FIG. 7 Page from family register for the Bamberger family. Anonymous scrivener, Dauphin and Lancaster Counties, Pennsylvania, circa 1792. Hand-lettered on laid paper, 6 in. × 3 ¼ in. Endpapers in 1743 Halle Bible. Collection of Clarke E. Hess.

Oswaldt Neff's Bible (see fig. 6) was apparently passed to the Bamberger family. The first entry in this two-page register lists Joseph Bamberger (no dates) followed by data regarding the 1766 birth of Elisabet Bamberger. The subsequent data list birth dates until 1792 for nine Bamberger children. It is possible that the father was the same Joseph Bamberger who died in Lebanon Township, Dauphin County, in 1803. Dauphin County was carved from Lancaster County in 1785. In 1813, Lebanon County was carved from Dauphin and Lancaster Counties. This scrivener wasted no space and wrote only in German script.

FIG. 8 Page from family register for the Bamberger family. Anonymous scrivener, Lebanon Township, Lebanon County, Pennsylvania, circa 1821. Hand-lettered on laid paper, 6 in. × 3¼ in. Endpapers in 1743 Halle Bible. Collection of Clarke E. Hess.

The Bible once owned by Oswaldt Neff passed to another generation of Bambergers. An unknown scrivener recorded data for eleven children born between 1805 and 1821. Although location and names of the parents are not recorded, research indicates the parents of the children were probably Joseph Bamberger (born 1771) and Elisabeth Smith, who farmed in today's South Lebanon Township, Lebanon County. The two Bamberger registers illustrate how some "fraktur" fall into gray areas. Technically, because these examples are written in plain German script and lack decoration, they are not considered fraktur. Still, they serve the same purpose as any other Pennsylvania-German family register.

what our grandparents handed down as oral tradition, the information seemed of little consequence. Except for small children, immigrant families no doubt remembered their European beginnings, but they may have felt it painful to recall the past, with its lack of opportunities and, in extreme cases, deprivation and persecution. Some intentionally closed those chapters in their lives. Perhaps they truly believed that it was better to start fresh—a new family in a new nation. Immigration and the Revolution put the past behind them once and for all, rupturing ties to a family's personal history—and perhaps the first generations of U.S. citizens liked it that way. Had early generations anticipated the intense curiosity their descendants would have about family origins, perhaps their registers would have been more explicit and thorough. As it was, Americans creating family registers ignored the past and championed the future.

There are other reasons for neglecting to record family origin. Americans of German ancestry undoubtedly knew that Europeans were interested in documenting "pedigree." But Americans had abandoned the caste system, titles (other than professional titles), and other signs of "pretension," and thus they had little interest in finding and documenting illustrious ancestry. No outward signs of "class" appear on Pennsylvania-German registers. Class distinction would likely only manifest itself in the fact of families' being able to afford fam-

ily registers or *Taufscheine*. Yet few families lacked access to fraktur records due to affordability. Instead, the fraktur tradition flourished throughout rural communities, saturating the countryside seemingly without regard to families' financial success or status.

As further evidence that registers were accessible to the average Pennsylvania German, most eighteenth- and early-nineteenth-century examples were made for farming families rather than urban dwellers. Certainly, tradesmen living and working in cities—many of whom were Pennsylvania Germans—could afford family registers, but fraktur in general remained entrenched in rural communities. While some farmers undoubtedly were more successful than others, economic status presented little or no barrier to owning registers, nor did it create a particular enticement.

The one exception to affordability concerns the size of paper used to create registers. To our knowledge, fraktur artists charged similar rates, and they based these rates on paper size rather than labor and artistic talent. Most freehand fraktur were made on "half-size" or "full-size" paper. Half-size paper measured approximately 8 inches by 13 inches, and full-size, about 16 inches by 13 inches. Occasionally, families commissioned artists to use large, "royal folio" paper (approximately 24 inches by 17 1/2 inches), for which they undoubtedly paid more. The Maily/Herr birth and marriage record appears to have been made on a large sheet that was trimmed. Thus, a hint of economic scale becomes apparent when paper size is considered.

The absence of economic scale or class distinction apparent on fraktur continued into later generations of Pennsylvania Germans as they became assimilated into the American "melting pot." Attitudes regarding equality became so ingrained in Americans that family historians today are often as delighted to find a pirate in their background as they are to find a knight. If pedigree was the main intent of documenting family history in Europe, that was fine. But most Americans establish status based on personal achievement, not ancestry. Consequently, the family register seemed suitable for people from all walks of life—and people from all walks of life created family registers.

Forms of Pennsylvania-German Family Registers

PENNSYLVANIA-GERMAN FAMILY REGISTERS on paper fall into six groups, each of which took a form of its own. Rather than a linear development in their history, as if one group yielded to or greatly influenced another, the various forms of registers developed simultaneously in many instances—and independently. In short, they each had their own history (see Appendix B). Consequently, as Simon J. Bronner has observed, considerable visual diversity is apparent in family registers.[1] For example, a totally printed register with its black ink and typeset text looks completely different from a freehand register that shows a riot of color and folky border decoration. And a broadside-type register made on a single sheet of large paper that was decorated as if to be displayed looks different from a four-page Bible-entry register.

Aside from their aesthetic diversity, registers in all six groups have a common denominator. They were created as permanent records to be passed to future generations. Most record two and three generations. In reality, immediate family members had no need to detail their own names and dates—after all, they knew who they were. Still, families not only recorded this information but also put considerable effort into making these documents visually presentable by having them printed or handwritten and decorated by fraktur artists and scriveners. In addition, many were written in Bibles to assure the record's preservation and longevity. The six forms of Pennsylvania-German family registers include: (1) entirely printed broadside-type family registers; (2) freehand broadside-type family registers; (3) preprinted broadside-type family registers with added, hand-written infill; (4) preprinted family registers bound into Bibles and infilled by

hand; (5) freehand family registers recorded inside the covers or on the flyleaves of Bibles and other books; and (6) handwritten family registers in book form.

The first category includes broadsides that have typeset, machine-printed infill. Few examples of this type of register exist. As noted above, the earliest surviving example appears to have been made for a Pennsylvania-German family, the Bollingers. These are in many ways among the rarest and most interesting of all Pennsylvania-German family registers.

The second category includes texts penned entirely by hand, often with illuminated letters and freehand decoration added in watercolor or colored ink. Freehand family registers were drawn on half-size or full-size sheets of paper and decorated as if to be displayed. As in all fraktur, however, there are no absolutes. Small, bookplate-size and oversize family registers are known.

It is perhaps surprising that the earliest Pennsylvania-German freehand example we documented dates from about 1784, long after the 1763 Bollinger printed example. Scholars have long assumed that freehand fraktur predated printed fraktur, but this assumption might be challenged. For example, although freehand *Taufscheine* were made prior to the Revolution, especially by Daniel Schumacher (circa 1729–1787), most were made following the Revolution. That is precisely the time when quantities of printed *Taufscheine* came on the market. In fact, with the exception of the works of Schumacher and a handful of others, most printed and freehand *Taufscheine* were contemporary with one another. Thus, it should come as no surprise that freehand family registers made their debut numerically following the Revolution.

The third type of family register is a preprinted form; an illuminator would color the certificate and a scrivener would infill the family data. Although Richard Brunton began making these forms about 1790 in Connecticut, not until the second quarter of the nineteenth century did this type of family register become especially popular. After 1840, printers such as Nathaniel Currier in New York, the Kellogg family from Hartford, Connecticut, R. H. Trumbull in Chicago, Illinois, and many others made them available by the thousands. This type became popular in Pennsylvania-German communities in the mid-nineteenth century during the heyday of the professional scrivener. They were printed in German and in English.

The above three categories are broadside formats. For families owning them, broadside family registers presented a challenge not often encountered with other fraktur. To frame and hang a family register meant that each time an entry was made concerning birth, baptism, confirmation, marriage, or death, the certificate had to be taken from the wall, removed from the frame, updated, and then reframed—a tedious business. This inconvenience probably cemented the popularity of the family Bible as the keeper of the family data. It was much easier to write on pages in a book than to take a document off the wall. Besides,

the Bible was the most important book a family owned, and it would be preserved. Thus, the register would theoretically be safe forever.

Consequently, the fourth category—preprinted registers bound into Bibles—came to dominate the family register market. These have remained immensely popular among Pennsylvania Germans from the beginning of the nineteenth century to the present day, although the Bible insert probably peaked numerically among Pennsylvania Germans between about 1890 and 1920. The Bible insert began to appear among New Englanders slightly ahead of Pennsylvania Germans, with the publication of the Isaiah Thomas Bible in 1791. In 1802, Mathew Carey (1760–1839) of Philadelphia printed an English-language Bible that was dated October 27, 1802.[2] Like the Isaiah Thomas Bible, this Bible had a preprinted family register bound between the Old and New Testaments.

For the Pennsylvania-German market, Gottlob Jungmann (circa 1757–1833) in Reading, Pennsylvania, is credited with having printed the first German-language Bible with a preprinted family register. Notably, this Bible predates European German-language Bibles having bound-in registers: Jungmann printed his Bible in 1805.[3] In Bibles, the family register was usually bound between the Old and New Testaments, but some were "tipped in" (pasted in) or sewn in rather than bound. Jungmann's four-page register was bound into the Bible.

For the Pennsylvania Germans, some registers were written on the flyleaves, inside the covers, or on blank pages of Bibles—category five. Because these were blank pages, they have little structure in terms of text. That is, the writer was not held to a rigid format that began with the names and birth and marriage dates of the parents. Instead, those creating the register could begin with any information they thought important. Occasionally, family information was written on blank pages of hymnals, prayer books, ciphering or "reckoning" books, textbooks, catechisms, and cookbooks.

The sixth and last category comprises registers handwritten in book form. Creating this type of register undoubtedly became too ambitious a project, for the book-type registers are quite rare. The best-known fraktur-related examples in this group are booklets made by the so-called Virginia Record Book Artist (active circa 1795–1825) and various artists who copied his works. These booklets generally consisted of fewer than two dozen pages.[4] A variation on the theme—partially handwritten and partially printed books—also fits into this category. The few known examples made for Pennsylvania German families were written after 1860, and they were often written in English. With as many as one hundred pages, these handwritten books are exceedingly rare, for it was a painstaking task to organize, write, proofread, and update pages and pages of handwritten family data. The attempt to create such books brings family registers full circle—back to the Clap/Blake history printed in 1731—as well as forward to the present, when computers, in-house desktop publishing, and more

affordable printing allow family historians to publish book-length family histories.

Preprinted Broadside-type Family Registers with Printed Infill

In many respects, preprinted family registers having printed infill are the most remarkable of all family registers. It is somewhat surprising that these registers were ever made, for they must have been costly. They were usually made for a single family, and thus there would be no need for many certificates. This meant that the printer had to set type for an extremely short print run. Commercial printing was never cheap and, until the middle of the nineteenth century, paper was not cheap. So why would someone go to the expense to print a document that might have a print run of only a handful of copies? In all probability, the answer centers on families wanting permanent records.

The Ephrata Press

The history of totally printed registers begins with the 1763 Bollinger family register at the Ephrata Cloister. In 1732, Georg Conrad Beissel (1691–1768) established a religious order on the banks of Cocalico Creek in northern Lancaster County.[5] Writers have referred to the settlement as the Ephrata Cloister, but the occupants, who were celibate men and women or married householders associated with these Sectarians, referred to themselves as a "community."[6] The community was held together by the charismatic Beissel; following his death in 1768, the members gradually died out and the physical structures fell into disrepair. In 1941, what was left became a museum site administered by the Pennsylvania Historical and Museum Commission. The first illuminated fraktur made in America were drawn by members of the Ephrata community before 1740.[7] About the same time, a press was established at the community. Ephrata printers became the first in America to use both English (roman) and German typefaces.[8]

The community had its own paper mill, so paper should have been no problem. It overcommitted its printing operation about 1748, however, when the community agreed to print the *Martyrs Mirror* for neighboring Mennonites in southeastern Pennsylvania. This was the largest book printed in colonial America, and it consumed a great deal of paper. This project, in addition to other major print runs of book-length materials, forced the community to look elsewhere for paper. To print fraktur, especially *Taufscheine,* they used paper from their own mill as well as from Coatesville (Pennsylvania), Maryland, and beyond.[9] The 1763 Bollinger register has a British watermark: "GR," for Georges Rex (King George III). Thus, this paper was imported and probably expensive.[10]

In 1763, the only documented pressman at Ephrata was Johannes Georg Zei-

siger, who seems to have worked at the community only a short time.[11] He may have started a tradition at Ephrata, however, that lasted until 1831. Over the next 68 years, the Ephrata press produced a succession of entirely printed family registers. A second Bollinger register was printed about 1794, possibly by Salomon Mayer (died 1811). Other printers associated with Ephrata were John Bauman (1765–1809), who likely purchased the Ephrata press in 1800 and moved it to his home nearby, as well as Samuel Bauman (1788–1820) and Joseph Bauman (1789–1862).[12]

John Bauman probably printed a register for the Bar family. This register was likely made about 1802 when the father of the family, Johannes Bar, died. The paper had the "CB" watermark, which stood for Christian Bauman (1755–1815), who leased the paper mill at Ephrata and was making paper there by 1783.[13] John Bauman may also have printed a register for the Mohler/Bollinger family in 1802 (fig. 9). With the exception of noting locations, records such as this offer numerous details. Before about 1810, *Taufscheine* and family registers often give the time of day children were born. Some also note the day of the week and signs of the zodiac. The Mohler/Bollinger example says that Jahannes [Johannes] Mohler was born Friday, September 16, 1757, at about one o'clock in the middle of the day in the sign of Scorpio. His wife, Ann Bollinger, was born Tuesday, April 22, 1760, at about seven o'clock in the evening in the sign of Leo. The Mohlers' marriage date is also recorded. They married on Tuesday, June 9, 1778, and had thirteen children.

In all probability, John Bauman also printed an English-language register listing births of his own children (fig. 10). Printed in roman types on laid paper measuring 11 inches by 6 1/2 inches, the register is pasted inside the cover of a Bible.[14] It begins with the birth date of John's oldest child, Samuel Bowman (the English spelling of Bauman), and it concludes with the birth on December 12, 1801, of Samuel's younger sister Susana. This register excludes the births of Samuel's sisters Christina and Sarah, who died in 1798 and 1800, respectively. It also excludes two Bauman children born after Susana. Joseba was born June 27, 1805, and died August 18, 1809; Maria was born July 25, 1808. These last two children appear on a similar German-language register (fig. 11). Because Joseba and Maria are absent from the English-language register, it is probable that it was printed before the German-language version. In all likelihood, the English-language register was printed between 1801 and 1805. To date, it is the earliest known English-language register printed for a Pennsylvania-German family.

Either John Bauman or his son, Samuel, printed a German-language register about 1809 for Samuel and his siblings (see fig. 11). On this register, the printer used five typefaces, including roman upper- and lowercase and italic upper- and lowercase, in several point sizes. Curiously, none of the typefaces was fraktur lettering. Thus, although the register is printed in the German language, the use of roman types gives it an "English" look. As is true of the English-language

FIG. 9 Family register for Jahannes and Ann (Bollinger) Mohler. Attributed to John Bauman, Ephrata, Lancaster County, Pennsylvania, circa 1802. Printed on wove paper, 10 in. × 7½ in. Collection of Victor G. Leininger.

Jahannes [Johannes] Mohler's father was immigrant Ludwig Mohler. In a personal communication (January 26, 2002), Mohler descendants Victor and Ken Leininger indicated that the Mohlers were affiliated with the Church of the Brethren and are buried a short distance north of the Ephrata Cloister in the Brethren cemetery. John Bauman (1765–1809) and his wife, Margaret Fahnestock (1768–1809), were householders at the Ephrata Cloister. According to Clarence Spohn, Bauman may have purchased the Ephrata press in 1800 and operated it in his home until he died.

FIG. 10 Family register for children of John and Margaret (Fahnestock) Bowman [Bauman]. Attributed to John Bauman, Ephrata, Lancaster County, Pennsylvania, circa 1802. Printed on laid paper, 11 in. × 6½ in. Pasted under the cover of a European Bible. Courtesy of the Herr House Museum and the Lancaster Mennonite Historical Society, Lancaster, Pennsylvania.

An English edition of a similar German-language register documenting births of five of the nine Bauman children (see fig. 11). Excluded were daughters who died before 1801 and Joseba and Maria, born in 1805 and 1808, respectively. This is the earliest printed English-language register we have documented that was made for a Pennsylvania-German family.

register, the parents' names (John Bauman and Margaret [Fahnestock] Bauman) are missing. Instead, the register begins with Samuel's birth on June 25, 1788, at about 8:35 in the morning.[15]

A family register that may have been printed in Ephrata reads like a narrative rather than a list of individual family members. It was made for the Weber/Ruth family of Earl Township, Lancaster County (fig. 12). Titled "Christian Weber," it begins by stating that Christian Weber was born on Christmas Day in 1731. He married Magdalena Ruth on September 30, 1749. It continues by saying that Weber was Mennonite and hoped that his descendants would share his faith. According to the register, Weber died February 13, 1820; the register may have been printed soon after his death. Rather than list his descendants, the register documents that he and Magdalena had 17 children, 99 grandchildren, 188 great-grandchildren, and 5 great-great-grandchildren. The register says of Weber, *"Seine ganze Nachkommenschaft, was von ihm, und bey seinem Leben von seinem Geschlecht, gebohren worden ist, belauft sich auf 309"* (All of those who descend from him and were born in his lifetime number 309).[16]

Families having registers printed at Ephrata may not have been celibate members (who often had families before joining the community) or even householders (Beissel followers who supported the Cloister), but all were apparently in close geographic association with Beissel's community. In time, it is almost cer-

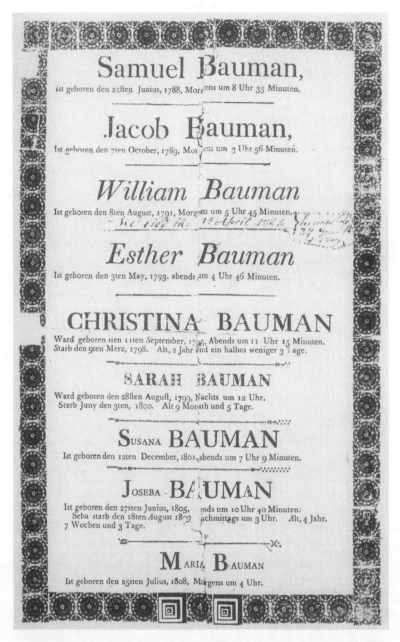

FIG. 11 Family register for children of John and Margaret (Fahnestock) Bauman. Attributed to John or Samuel Bauman, Ephrata, Lancaster County, Pennsylvania, circa 1809. Dimensions, type of paper, and location of original unknown. Courtesy the Historical Society of the Cocalico Valley, Ephrata, Pennsylvania.

This register, of which only a facsimile is known, was probably printed by John Bauman or his son Samuel Bauman (1788–1820). It lists Samuel and his siblings. Their parents, John Bauman and Margaret (Fahnestock) Bauman, were householders at the Ephrata Cloister. The Bauman register does not include signs of the zodiac, but birth dates and, remarkably, times of birth to the minute are recorded. In this respect, the German version of this register is more complete than its English-language counterpart (see fig. 10).

Christian Weber

Ward gebohren in Earl Taunschip, Lancaster Caunty, im Staat Pennsylvanien, den 25sten December, (auf den Christtag) nach der alten Zeit, im Jahr 1731. Er ist in den Ehestand getreten den 30sten September, 1749, mit Magdalena Ruth, und hat 55 Jahre lang mit ihr in der Ehe gelebt, und 16 Jahre im Wittwenstande. Er war der Mennonisten-Gemeine zugethan, und ein warmer Bekenner ihres Glaubens. [Es wäre zu wünschen, daß seine Nachkommen ihm hierin nachfolgten.] Seine Krankheit war Alter und Schwächlichkeit. Er ist gestorben den 13ten Februar, 1820; und hat sein Alter gebracht auf 88 Jahre, 5 Wochen und 2 Tage. Sein Weib hat ihm gebohren 8 Söhne und 9 Töchter. Von 7 Söhnen und 5 Töchtern wurden ihm gebohren 99 Enkel, 188 Urenkel, und 5 Ur-Urenkel. Seine ganze Nachkommenschaft, was von ihm, und bey seinem Leben von seinem Geschlecht, gebohren worden ist, belauft sich auf 309.

Bey seiner Beerdigung wurde eine Rede gehalten über die Worte aus der Offenbarung Johannes, Capitel 14, Vers 12 und 13. Hie ist Geduld der Heiligen, ꝛc.

Leichenlied: Meine Sorgen, Angst und Plagen laufen mit der Zeit zu End, ꝛc.

FIG. 12 Family register/memorial for Christian and Magdalena (Ruth) Weber. Anonymous printer, possibly Lancaster County, Pennsylvania, circa 1820. Printed on wove paper, 9 in. × 6¾ in. Private collection.

The Christian Weber genealogy is a virtual horn of plenty for genealogists. It records not only Weber's dates of birth, marriage, and death but also where he was born, whom he married, his religion, and the number of his children, grandchildren, great-grandchildren, and great-great-grandchildren. By the time he died, at age eighty-eight years, five weeks, and two days, the number of descendants born in his lifetime was 309. Weber's wife, Magdalena Ruth, predeceased him by sixteen years. When considering the number of descendants born to Christian Weber during his life, it is no wonder that one-page family registers evolved into books.

tain that the number of documented Ephrata printed family registers will increase. At present, families for whom registers were printed at the Ephrata Cloister or by the Baumans include the Bollingers, Baumans/Bowmans, Bars, Mohlers, Schenks, and Kellers, and possibly the Webers and Stauffers.

The 1763 and 1794 Bollinger family registers stand out from the others. To our knowledge, the 1763 Bollinger family register is the most important register of its kind in America. Its significance was recognized over one hundred years ago by authors and historians Julius Friedrich Sachse and William Henry Egle. Egle reported in 1896, "we are in possession of what we consider the first Family Record published in America."[17] Decades later, Meredith Colket placed the Bollinger register in context with other early printed genealogies.

The 1763 Bollinger register was decorated with border pieces of type—in fact, a virtual alphabet soup of decorative border pieces—which served to set off each entry made for the ten Bollinger children (see fig. 1). Colket speculated that the register was typeset not to make multiple copies but to make an attractive document.[18] Some scholars might disagree. In *The Art of Family,* Simons wrote that family registers were printed in multiple copies so that they would be available to several family members.[19] Probably both suppositions are true. We would add that a printed register seemed more permanent than a handwritten record.

Colket was also the first to report that the 1763 Bollinger register was printed in fraktur typeface as well as in Caslon, an English type.[20] On typeset family registers and other printed materials, the Ephrata typesetter used English typefaces for words with no German equivalent, such as Indian, Latin, and English words. On the 1763 Bollinger certificate, English types were used for the words *Connestogue* (Conestoga) and *Cogollico* (Cocalico). These were Indian names given to creeks in the Ephrata area.

Although the parents' names are not given, the Bollinger children listed on the 1763 register were the offspring of immigrant Rudolph Bollinger (died 1772), whose first wife was Elisabeth (died 174?). The tenth child, Abraham (1756–1814), was born to Rudolph and his second wife, Catherine (Blum) Bollinger (died 1792). Rudolph and his second wife had the register made in 1763. By then Rudolph's first son, Daniel, was thirty-five years old, and the next seven children were already grown.[21]

Abraham's entry is significant in that it gives detailed information, including Abraham's date of birth (February 11, 1756), his time of birth (between seven and eight o'clock in the morning), and his place of birth. It also provides full details about the alignment of the planets and signs of the zodiac appropriate for his birth. As noted above, early fraktur *Taufscheine* often mentioned the signs of the zodiac, and a few fraktur artists and scriveners felt it necessary to state the alignment of the planets. These details, including the time of day the child was born, were a holdover from medieval Europe, when physicians needed complete information about the lives of their patients in order to recommend cures for afflictions.

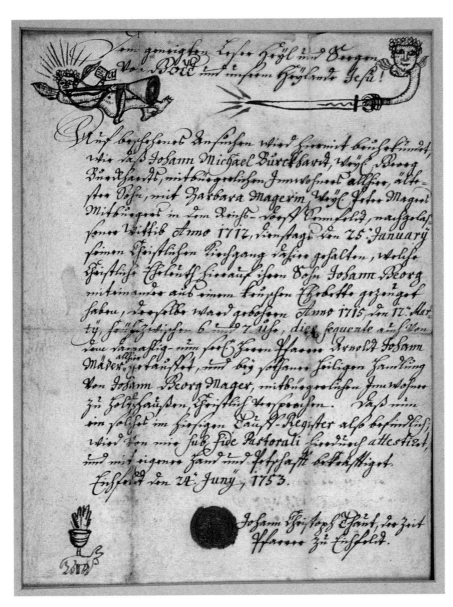

COLOR PLATE I Official European birth and baptism certificate used to prove legitimate birth of Johann Georg Burckhardt. Signed Johann Christoph Thaut "at the time Pastor at Eichfeldt," 1753. Hand-lettered on laid paper, 12 in. x 8 1/2 in. Indistinct watermark appears to be a devil with a torch and the initials "IGR." Private collection.

This official Taufschein was used by Johann Georg Burckhardt to prove legitimate birth. Georg's parents were Johann Michael and Barbara (Mager) Burckhardt. This certificate gives additional information about Georg's parents, saying that Johann Michael Burckhardt was the eldest son of the late Georg Burckhardt, and Barbara Mager was the daughter of the late Peter Mager. Michael and Barbara married January 25, 1712. Georg Burckhardt was born March 12, 1715. The information was copied from the baptismal register and the Taufschein certified on June 21, 1753. Note the wax seal at the lower center. According to Klaus Stopp, these official documents were used throughout German-speaking areas of Europe to prove legitimate birth. Although this example has hand decoration, most do not.

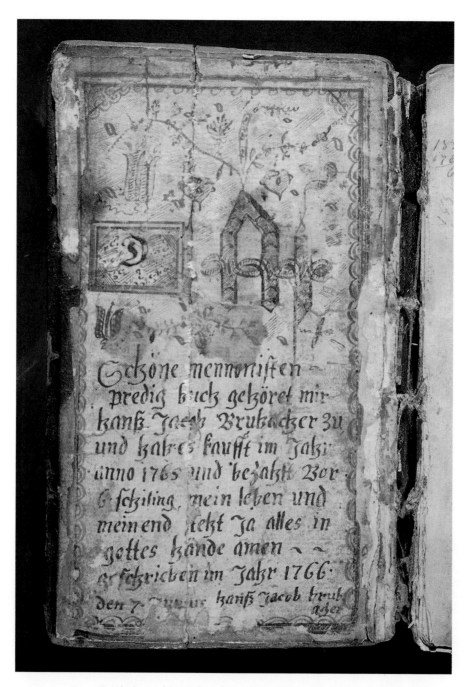

COLOR PLATE 2 Bookplate of Hans Jacob Brubacher. Signed Hans Jacob Brubacher and dated June 7, 1766. Lancaster County, Pennsylvania. Hand-drawn on laid paper, 6 1/4 in. x 3 3/4 in. Courtesy Muddy Creek Farm Library, Ephrata, Pennsylvania.

Fraktur artist Hans Jacob Brubacher (1725–1802) felt comfortable enough to write on his bookplate that this "precious Mennonite book of sermons" belonged to him. He bought the book in 1765 for six shillings. To date, this is the earliest known use of the word "Mennonite" written on a fraktur.

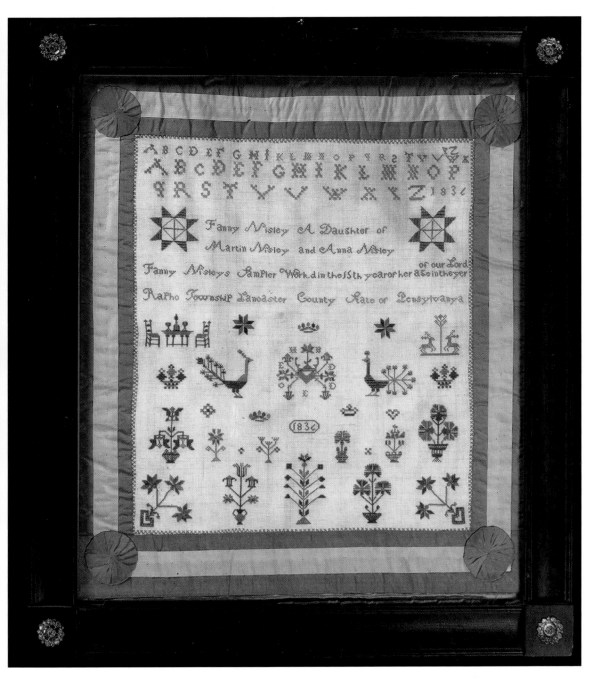

COLOR PLATE 3 Family register sampler sewn by Fanny Nissley. Lancaster County, Pennsylvania, 1836. Cotton and silk on linen, 21 in. x 18 in. Collection of Dr. and Mrs. Donald M. Herr.

Fanny Nissley (1821–1888) was the daughter of Martin and Anna (Bamberger) Nissley of Rapho Township, Lancaster County. Fanny was fifteen when she made this striking two-generation register in 1836. Pennsylvania-German textile family registers were rare. As with works on paper, they were usually restricted to two or three generations.

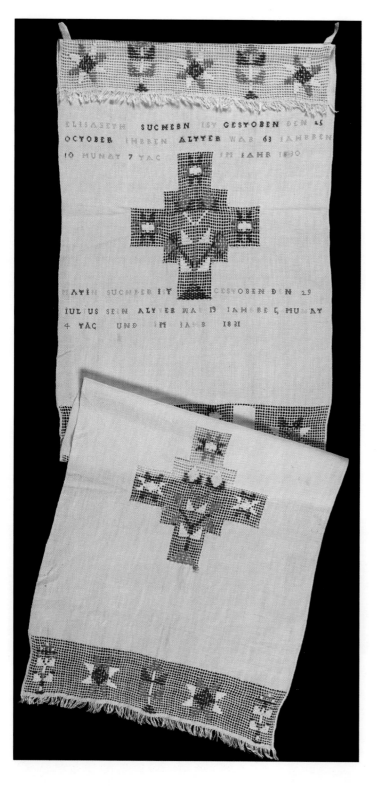

COLOR PLATE 4 Decorated towel, possibly sewn by a daughter of Elisabeth Sucher. Probably Lebanon County, Pennsylvania, circa 1835. Silk and cotton on linen, 52 in. X 17 in. Collection of Dr. and Mrs. Donald M. Herr.

As with works on paper, the maker of this decorated towel memorialized family members. The towel—which is extremely rare—reads, "Elisabeth Sucher died the 25th of October. Her age was 63 years, 10 months, and 7 days in the year 1830. Ma[r]tin Suchker [sic] died the 29th of July. His age was 19 years, 5 months, and 4 days in the year 1831."

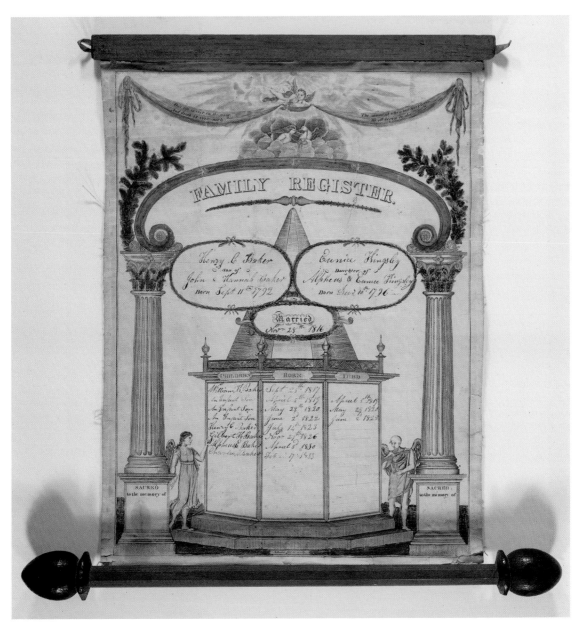

COLOR PLATE 5 Family register for Henry C. and Eunice (Kingsley) Baker. Anonymous printer and scrivener, probably New England, circa 1833. Printed and watercolored on paper backed by canvas attached to rollers. Excluding rollers, 14 1/2 in. × 11 in. Private collection.

As with many Pennsylvania examples, no location was given by the scrivener or the printer. The style of this example and the family names suggest a New England origin. As is typical of New England engravings, there are columns, urns, the trigon, and swags. This example also depicts the grim reaper and the unhappy thought, "The moment when our lives begin, / We all begin to die."

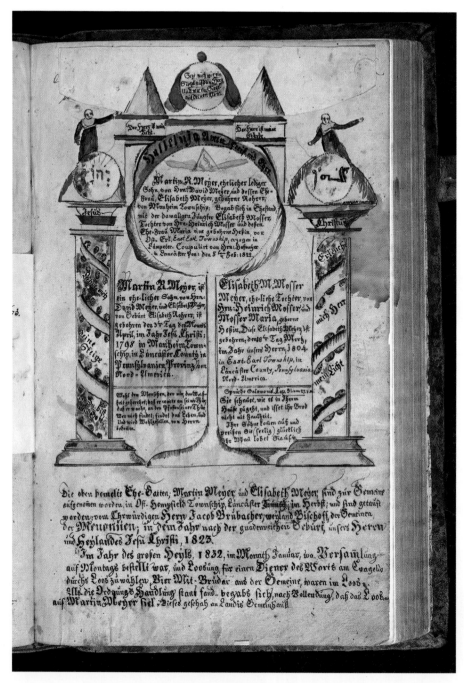

COLOR PLATE 6 One page of multi-page Bible-entry family register for Martin R. and Elisabeth M. (Mosser) Meÿer. Attributed to Karl Friedrich Theodor Seybold, East Hempfield Township, Lancaster County, Pennsylvania, circa 1832. Hand-drawn, lettered, and watercolored on wove paper, 14 1/2 in. X 9 in. In an 1819 Bible printed in Lancaster, Pennsylvania, by Johann Bär. Courtesy Lancaster Mennonite Historical Society, Lancaster, Pennsylvania.

Fraktur artist Karl Friedrich Theodor Seybold (active circa 1813–46) may have copied motifs and composition from a printed register. As a result, with flanking columns and figures "pointing the way," the Meÿer/Mosser register has the formal appearance of New England examples.

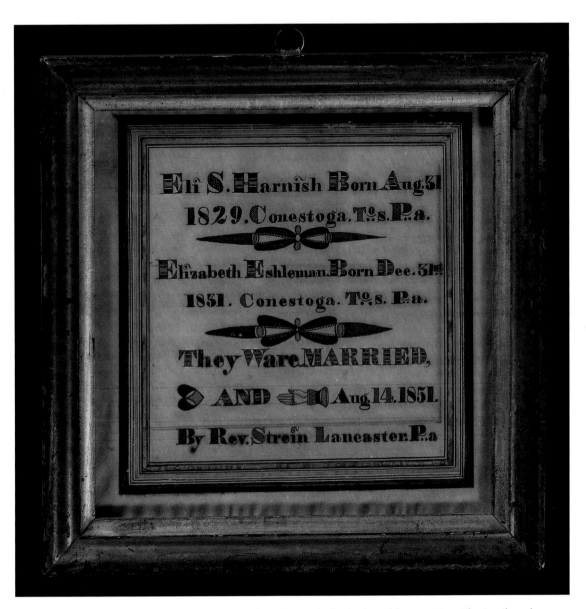

COLOR PLATE 7 Birth and marriage record for Eli S. and Elizabeth (Eshleman) Harnish. Attributed to the Heart and Hand Artist, Conestoga Township, Lancaster County, Pennsylvania, circa 1851. Hand-drawn, lettered, and watercolored on wove paper, 7 3/4 in. x 8 in. Courtesy Raymond Mead.

A few fraktur artists made fraktur for New England families, and New England artists such as the Heart and Hand Artist (active circa 1850–55) occasionally made fraktur for Pennsylvania-German families. The Heart and Hand Artist worked primarily in Maine and Vermont.

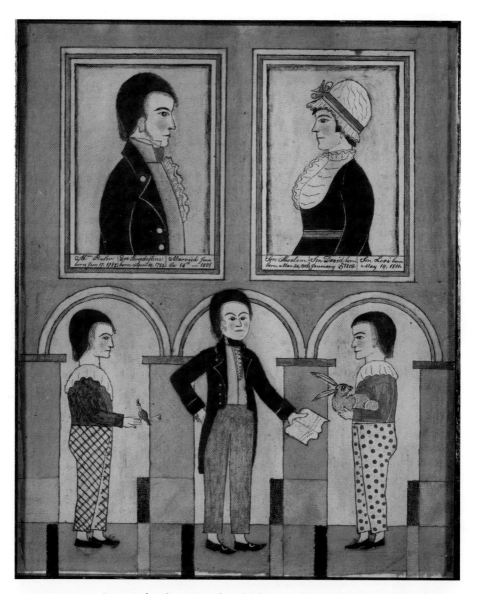

COLOR PLATE 8 Portrait family register for Abraham and Eve (Broadestone [Breidestein])
Pixler [Bixler]. Attributed to David Bixler, Brecknock Township, Lancaster County,
Pennsylvania, circa 1828. Hand-drawn, lettered, and watercolored on laid paper, 9 3/4
in. x 7 15/16 in. Courtesy The Metropolitan Museum of Art, Gift of Edgar William and
Bernice Chrysler Garbisch, 1966. (66.242.3) Photograph © 1989 The Metropolitan
Museum of Art.

Clarke Hess, author of Mennonite Arts, *suggested that this rare family portrait is the
work of fraktur artist David Bixler (active circa 1828–64), son of Abraham (1782–1847)
and Eve (Broadestone) Bixler. David Bixler was a farmer, stonecutter, and fraktur artist
who lived near Fivepointville in Lancaster County. David is shown lower center. His
brother, Absolom (1802–1884), is shown in profile at the lower left. Absolom was a
potter, wood carver, and justice of the peace. Portraiture among Pennsylvania Germans
was extremely rare, but David Bixler clearly had the talent to make such a drawing.
Among Pennsylvania Germans, the letters "P" and "B" were interchangeable, which
accounts for the phonetic spelling of Bixler. Most of David Bixler's fraktur are signed
"David Bixler," though on a religious text drawn by Bixler, he wrote his surname as
"Bizler." For more on David Bixler, see Miriam Bixler's article, "David Bixler, Folk
Artist,"* Journal of the Lancaster Historical Society *81, no. 1 (1977): 38.*

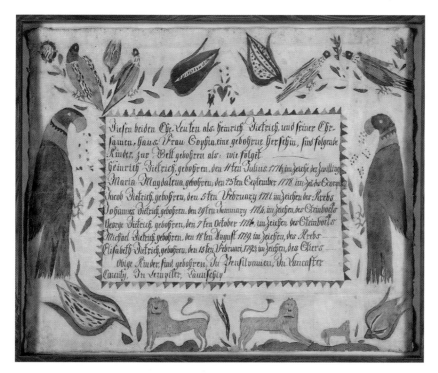

COLOR PLATE 9 Family register for Heinrich and Sophia (Hersch) Dietrich. Attributed to Andreas Victor Kessler, Lampeter Township, Lancaster County, Pennsylvania, circa 1793. Hand-drawn, lettered, and watercolored on laid paper, 13 in. × 16 in. Courtesy Raymond Mead.

Andreas Victor Kessler (active circa 1791–1821) infilled preprinted birth and baptism certificates and drew freehand certificates for families throughout southeastern Pennsylvania. His trademark droopy parrots and swaybacked lions were drawn on family registers and Taufscheine.

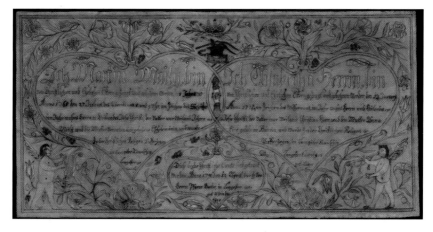

COLOR PLATE 10 Birth and marriage record for Martin and Elisabetha (Herr) Maily. Attributed to the Johannes Schopp Artist, Lampeter Township, Lancaster County, Pennsylvania, circa 1796. Hand-drawn, lettered, and watercolored on laid paper, 8 1/2 in. × 17 1/4 in. Private collection.

Trade symbols on fraktur are rare, but the anonymous Johannes Schopp Artist (active circa 1774–1800) put an anvil, tongs, horseshoe, and nails on this example, which suggests that Martin Maily was a blacksmith.

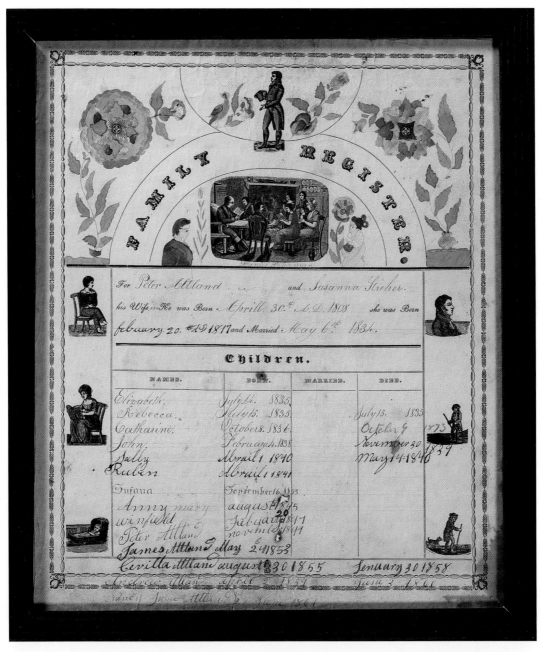

COLOR PLATE 11 Family register for Peter and Susanna (Streher) Altland. Signed Daniel Peterman, plus anonymous additions. Anonymous printer, York or Adams County, Pennsylvania, circa 1840. Printed, hand-decorated, and watercolored on wove paper, 13 5/8 in. x 11 1/2 in. Private collection.

To date, only two certificates by this anonymous printer are currently known. Both have infill for York County families. The certificate for the Altland family was decorated and initial entries were made by Daniel Peterman (1797–1871), York County's most prolific fraktur artist. Peterman's last entry was 1843, but other hands added the names of children and dates of death until 1873. Peterman, whose wife was an Altland, was a schoolmaster and stonecutter who knew German and English (see also color plates 18 and 20).

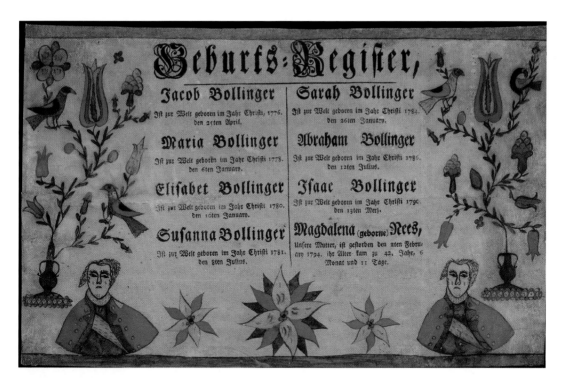

Geburts-Register,

Jacob Bollinger	Sarah Bollinger
Ist zur Welt geboren im Jahr Christi, 1776. den 25ten April.	Ist zur Welt geboren im Jahr Christi 1784. den 26ten Januar.
Maria Bollinger	Abraham Bollinger
Ist zur Welt geboren im Jahr Christi 1778. den 6ten Januar.	Ist zur Welt geboren im Jahr Christi 1786. den 12ten Julius.
Elisabet Bollinger	Isaac Bollinger
Ist zur Welt geboren im Jahr Christi 1780. den 10ten Januar.	Ist zur Welt geboren im Jahr Christi 1790. den 13ten Merz.
Susanna Bollinger	Magdalena (geborne) Nees,
Ist zur Welt geboren im Jahr Christi 1781. den 8ten Julius.	Unsere Mutter, ist gestorben den 2ten Februar 1794. ihr Alter kam zu 42. Jahr, 6 Monat und 11 Tage.

COLOR PLATE 12 Family register for children of Abraham and Magdalena (Nees) Bollinger. Anonymous artist, Ephrata Cloister printshop, possibly Salomon Mayer, Lancaster County, Pennsylvania, circa 1794. Printed, hand-decorated, and watercolored on laid paper, 8 in. x 12 3/4 in. Watermarked for Christian and Joseph Bauman. Private collection.

The second Bollinger register printed at Ephrata lists the children of Abraham Bollinger (1756–1814) and Magdalena Nees (1751–1794). Following Magdalena's death, Abraham married Mary Pfautz (1767–1833). Abraham probably meant the register not only to record the births of his children but also to commemorate the death of their mother, Magdalena.

Christian Bauman (1755–1815) and Joseph Bauman (1789–1862) were father and son. They operated the Ephrata paper mill and used the C & IB watermark from 1794 to 1808. Salomon Mayer (died 1811), a native of York County, was a bookbinder and printer at the Ephrata community until 1795.

COLOR PLATE 13 Family register for Michael and Elizabeth (Caldwell) Seavers. Signed James M. Newcomer, Cumberland County, Pennsylvania, circa 1870. Hand-drawn, lettered, and water-colored on wove paper, 11 in. x 14 in. Private collection.

Little is known regarding James M. Newcomer, who was active from 1868 to about 1873. He may have been deaf. If this is true, his clientele must have written notes to him, which he then copied in a decorative style to make colorful family registers.

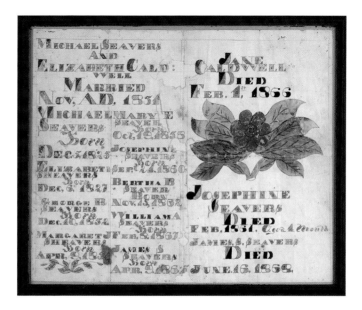

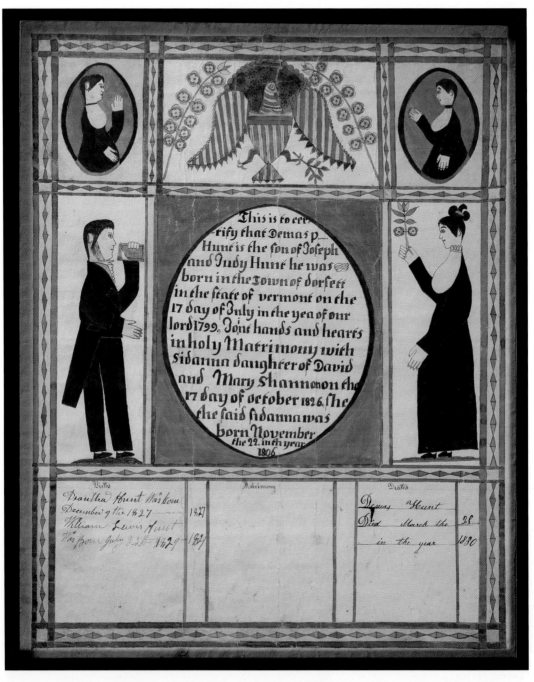

COLOR PLATE 14 Family register for Demas P. and Sidanna (Shannon) Hunt. Attributed to John Van Minian, Dorset, Vermont, circa 1826. Hand-drawn, lettered, and watercolored on wove paper, 15 3/8 in. x 12 1/4 in. Courtesy Richard S. and Rosemarie B. Machmer.

John Van Minian (active circa 1805–42) was a major fraktur artist who knew both German and English. Most of his documented fraktur are for Pennsylvania, New Jersey, and Maryland families. A family member with an untrained hand added data regarding the children born after 1826.

COLOR PLATE 15 Family record for John W. and Katie E. (Weidner) Roberts. Signed August Baumann, Lehigh County, Pennsylvania, 1905. Hand-decorated and lettered in colored ink on wove paper, 14 in. x 17 in. Private collection.

Hungarian-born August Baumann (active circa 1879–1905) infilled printed birth and baptismal certificates and Bible inserts; he also drew freehand fraktur. He worked throughout southeastern Pennsylvania and was proficient in German and English. He was an itinerant who rode trains to reach clients. Thus, he made fraktur mostly for townspeople as opposed to rural families. Although the Roberts register was written in English, Baumann signed in German, "Federzeichnung von August Baumann den 4 ten May 1905," or, "pen and ink by August Baumann, the 4th [of] May 1905."

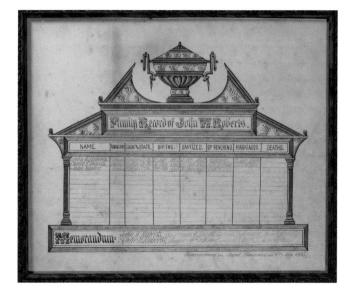

COLOR PLATE 16 Family register for Isaac and Eliesabetha (Brubacher) Kauffmann. Attributed to Christian Strenge, Lancaster County, Pennsylvania, circa 1790. Hand-drawn, lettered, and watercolored on laid paper, 12 1/4 in. x 15 1/4 in. Courtesy Heritage Center of Lancaster County, Inc., Lancaster, Pennsylvania. Gift of Henry J. Kauffman.

Christian Strenge (1757–1828) came to America as a Hessian soldier. Following the Revolution, he remained here and became a schoolmaster and justice of the peace in Lancaster County. He was a talented fraktur artist and a gifted schoolmaster.

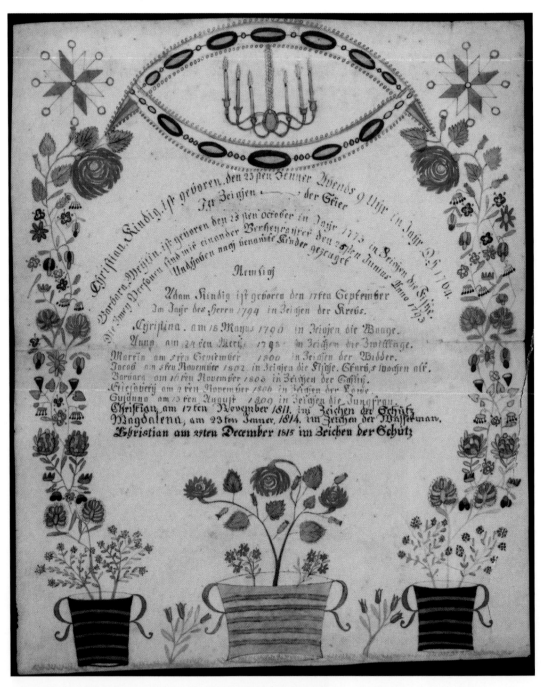

COLOR PLATE 17 Family register for Christian and Barbara (Meÿli) Kindig. Signed Friederich Leonhard, Conestoga Township, Lancaster County, Pennsylvania, 1810. Hand-drawn, lettered, and watercolored on laid paper, 15 3/4 in. X 12 3/4 in. Courtesy James and Nancy Glazer Antiques.

Friederich Leonhard (active circa 1803–27) was known as the Chandelier Artist before being identified. He worked primarily in Lancaster County, drawing family registers for Mennonite and Amish families. He signed, dated, and wrote a location on the reverse of the Kindig/Meÿli register.

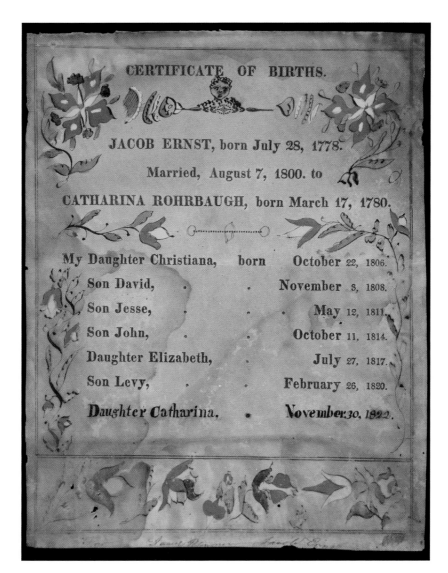

CERTIFICATE OF BIRTHS.

JACOB ERNST, born July 28, 1778.

Married, August 7, 1800. to

CATHARINA ROHRBAUGH, born March 17, 1780.

My Daughter Christiana,	born	October 22, 1806.
Son David,	.	November 3, 1808.
Son Jesse,	.	May 12, 1811.
Son John,	.	October 11, 1814.
Daughter Elizabeth,	.	July 27, 1817.
Son Levy,	.	February 26, 1820.
Daughter Catharina,	.	November 30, 1822.

COLOR PLATE 18 Family register for Jacob and Catharina (Rohrbaugh) Ernst. Signed Daniel Peterman, York County, Pennsylvania, circa 1820. Anonymous printer. Printed, hand-decorated, and watercolored on wove paper, 10 in. X 8 in. Collection of James F. Adams.

The Ernst family had this register printed in the belief that they were through having children. The last entry, for Catharina, born November 30, 1822, was added by an anonymous hand. Catharina's mother died on December 27, 1822, at the age of 42, possibly as a result of bearing Catharina. Jacob Ernst (1778–1841) was probably a York County gun maker and justice of the peace. He was the son of John and Catharine Ernst of North Codorus Township, York County. The register is important because it is an early register printed in English. Because Jacob was a justice of the peace, he undoubtedly knew English, but he was probably also fluent in German, a dialect of which would still have been spoken at home.

Daniel Peterman was York County's most prolific fraktur artist as well as a schoolmaster, stonecutter, and laborer.

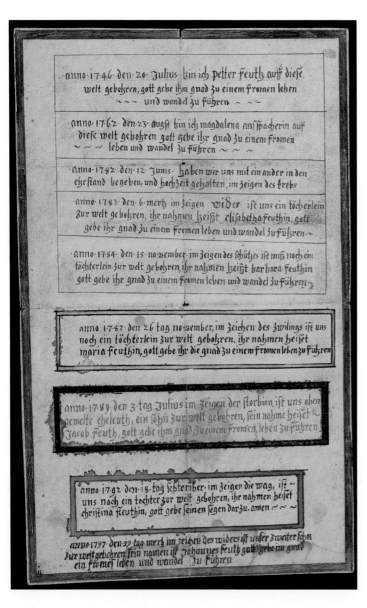

anno·1746· den·20· Julius bin ich petter feutz auff diese
welt gebohren, gott gebe ihm gnad zu einem fromen leben
~ ~ ~ und wandel zu führen ~ ~ ~

·anno·1762· den·23· augst bin ich magdalena ansspacherin auf
diese welt gebohren gott gebe ihr gnad zu einem fromen
~ ~ ~ leben und wandel zu führen ~ ~ ~

·anno·1742· den·12· Junis· haben wir uns mit einander in den
ehestand begeben, und hochzeit gehalten, im zeigen des krebs

·anno·1783· den·6· mertz· im zeigen wider ist uns ein töcherlein
zur welt gebohren, ihr nahmen heißt elisabetha feuthin, gott
gebe ihr gnad zu einem fromen leben und wandel zu führen ~

·anno·1784· den·15· nowember· im zeigen des schützes ist mir noch ein
töchterlein zur welt gebohren, ihr nahmen heißt barbara feuthin
gott gebe ihr gnad zu einem fromen leben und wandel zu führen

anno·1787· den 26 tag nowember, im zeichen des zwilings ist uns
noch ein töchterlein zur welt gebohren, ihr nahmen heißet
maria feuthin, gott gebe ihr die gnad zu einem fromen leben zu führen

anno·1789· den 3 tag Julius im zeigen der storbion, ist uns oben
gemelte eheleuth, ein söhn zur welt gebohren, sein nahme heißet
Jacob feuth, gott gebe ihm gnad zu einem fromen leben zu führen

·anno·1792· den·18· tag september· im zeigen die wag, ist ~
uns noch ein tochter zur welt gebohren, ihr nahmen heißet
christina feuthin, gott gebe seinen segen darzu. amen ~ ~ ~

anno·1797· den·29· tag mert im zeigen des widers ist uiser zweitee söhn
zur welt gebohren sein namen ist johannes feuth gub gebe im gnad
ein fromes leben und wandel zu führen

COLOR PLATE 19 Family reg-
ister for Petter and Magdalena
(Ansspacher) Feuth. Attributed
to Hans Jacob Brubacher,
Lancaster County, Pennsylvania.
Register started circa 1784
with added information to
1797. Hand-drawn, lettered,
and watercolored on laid
paper, 13 1/4 in. x 8 1/4 in.
Watermarked (circa 1784) for
the mill of Frederich Wilhelm
Hoffman, Baltimore County,
Maryland. Private collection.

*Hans Jacob Brubacher record-
ed that Petter [Peter] Feuth
and Magdalena Ansspacher
[Anspacher] were married on
June 12, 1782, in the sign of
Cancer. It was customary at
the time this record was made
to record the zodiacal sign
under which a child was born,
but it was less common to
record the sign for a marriage.
In terms of dates, signs of the
zodiac on fraktur do not reflect
the same dates used for today's
signs of the zodiac.*

*Brubacher was an impor-
tant fraktur artist who was a
Mennonite schoolmaster and
farmer in Providence Town-
ship, Lancaster County,
Pennsylvania. He drew a wide
range of fraktur, including
New Year's greetings, book-
plates, writing exercises, birth
records, and religious texts.
Only two family registers
made by Brubacher are docu-
mented.*

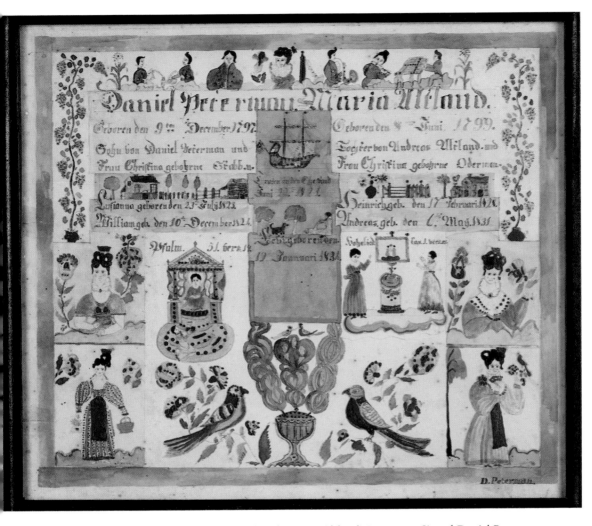

COLOR PLATE 20 Family register for Daniel and Maria (Altland) Peterman. Signed Daniel Peterman, York County, Pennsylvania, circa 1840–50. Hand-drawn, lettered, and watercolored on wove paper, 13 1/2 in. x 11 1/2 in. Private collection.

This artistic and important freehand family register is a primary genealogical source—if your surname is Peterman or Altland—but it is also a vignette of everyday life in rural nineteenth-century Pennsylvania. Pictured are what may have been the Peterman home with outbuildings, Maria (Peterman's wife) in her finest dress, a ship, the family dog at the pump, Daniel and his sons writing and playing music, and the daughter babysitting and at play. Daniel Peterman signed most of his works, whether preprinted or freehand.

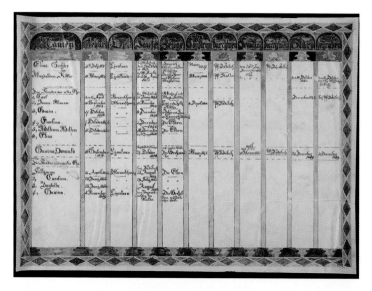

COLOR PLATE 21 Family register for Elias and Magdalena (Kistler) and Sawina (Oswald) Sechler. Attributed to John Bouer, Lehigh and Schuylkill Counties, Pennsylvania, circa 1860. Hand-drawn, lettered, and watercolored on laid paper, 13 1/2 in. x 18 1/2 in. Private collection.

Elias Sechler was married twice—first to Magdalena Kistler, who died October 10, 1853, and then to Sawina Oswald, who died in 1859. Magdalena's dates of death and burial may have been recorded inaccurately, because Elias married Sawina on February 2, 1853. Sadly, Sawina's daughter Sawina was baptized on December 31, 1859—the same day her mother was buried ("am Begraebnißtag der Mutter"). In spite of discrepancies in dates, the register is a model of completeness. Special thanks to John and Sharon Walters for helping us attribute this register to John Bouer (active circa 1832–60).

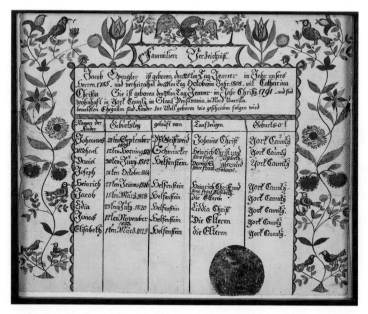

COLOR PLATE 22 Family register for Jacob and Catharina (Christ) Spengler. Attributed to Adam Wuertz, Paradise Township, York County, Pennsylvania, circa 1825. Hand-decorated, lettered, and watercolored on wove paper, 13 in. x 16 in. Private collection.

Adam Wuertz (active 1813–36) was a schoolmaster and one of York County's most important fraktur artists. He apparently knew no English, infilling preprinted Taufscheine and drawing freehand German-language fraktur.

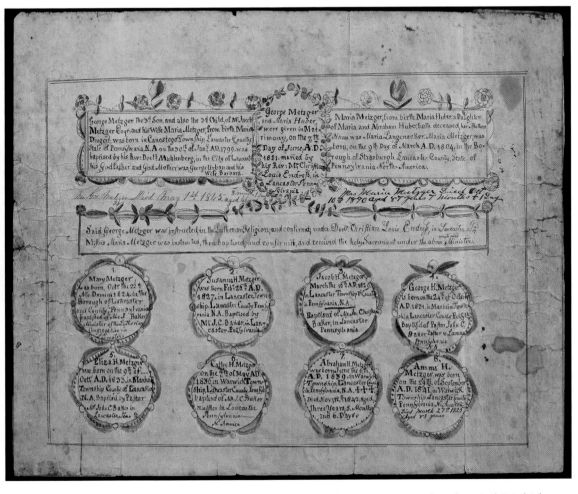

COLOR PLATE 23 Family register for George and Maria (Huber) Metzger. Attributed to Karl Friedrich Theodor Seybold, Conestoga Township, Lancaster County, Pennsylvania, circa 1842. Hand-drawn, lettered, and watercolored on wove paper, 12 1/2 in. X 15 1/4 in. Private collection.

Karl Friedrich Theodor Seybold made this family register for the Metzger family. It is a genealogist's dream. The register provides three generations of familial data, and unknown persons penned in George's and Maria's death dates. This single document includes data for grandparents, parents, children, location, and religion—an unusually complete document. Seybold was a schoolmaster who worked in Lancaster and Northampton Counties. He immigrated on the ship Fair America *in 1806. He was well educated and knew German, English, and Hebrew. He wrote cures for illnesses, taught school, and made numerous fraktur, but he led something of a tortured life, longing to join the Harmonist Society.*

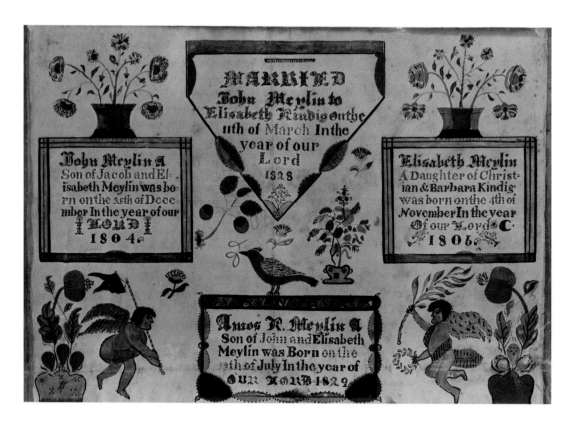

COLOR PLATE 24 Two-part family register made for John and Elisabeth (Kindig) Meylin. Attributed to Eli Haverstick, Lancaster County, Pennsylvania, circa 1829 and 1831. Hand-drawn, lettered, and watercolored on wove paper, 7 1/4 in. x 10 3/16, and 1 1/2 in. x 3 1/4 in. Courtesy H. Richard Dietrich Jr., The Dietrich American Foundation, Chester Springs, Pennsylvania. Photographs by Will Brown, Philadelphia.

Based on artistic elements and handwriting, Wendell Zercher, curator at The Heritage Center Museum of Lancaster County, was able to attribute this unusual, two-part register to fraktur artist Eli Haverstick (active circa 1829–37). It is amazing that the two parts of this register did not become separated over the years.

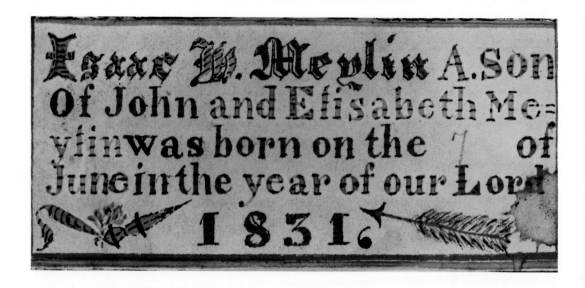

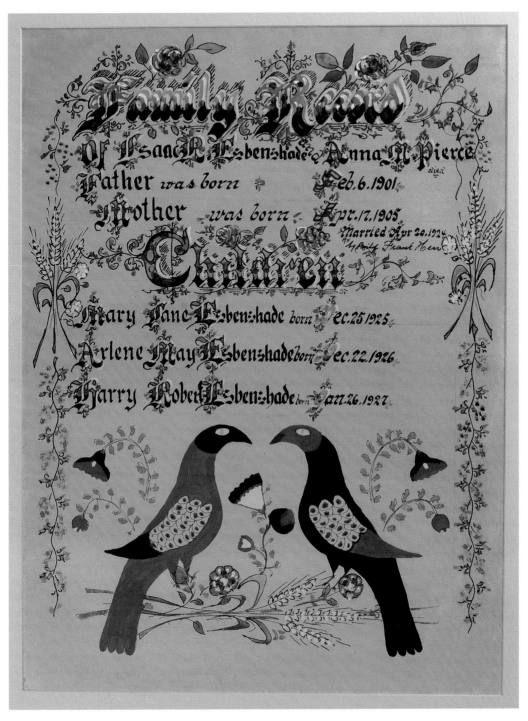

COLOR PLATE 25 Family record for Isaac P. and Anna M. (Pierce) Esbenshade. Signed David C. Hoke, probably Lancaster County, Pennsylvania, circa 1927. Hand-drawn, lettered, and watercolored on wove paper, 24 in. x 18 in. Courtesy Heritage Center of Lancaster County, Inc., Lancaster, Pennsylvania.

David C. Hoke (1869–1938) was a talented scrivener and artist who worked in the Amish and non-Amish communities of Lancaster and Lebanon Counties. This example is interesting because Hoke drew two large birds where the parents probably preferred the names of children.

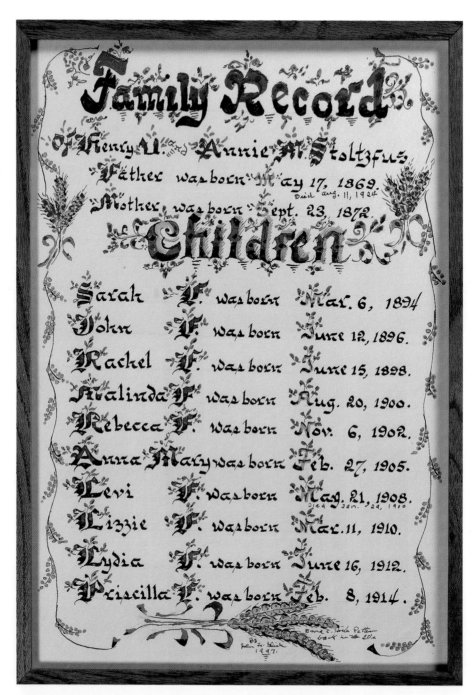

COLOR PLATE 26 Family record for Henry U. and Annie M. (Fisher) Stoltzfus. Signed John F. Glick, Lancaster County, Pennsylvania, 1997. Hand-decorated, lettered, and watercolored on wove paper, 22 in. X 15 in. Courtesy Heritage Center of Lancaster County, Inc., Lancaster, Pennsylvania.

John F. Glick (born 1912) is an Amish bishop who drew bookplates and family registers for much of the twentieth century. The example pictured shows the family of Henry U. Stoltzfus and Annie M. Fisher. Glick copied a register made in the 1920s by David C. Hoke. But because Hoke drew the wheat stalks with the heads down, Glick thought it more appropriate to show the wheat pointed up.

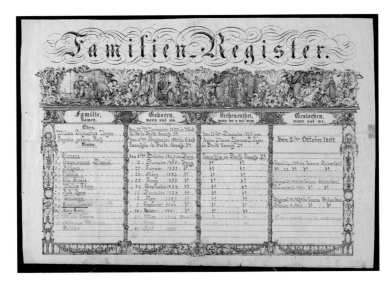

COLOR PLATE 27 Family register for William Augustus and Fayetta (Roth) Unger. Infill attributed to Gottlieb Schmid, Berks County, Pennsylvania, circa 1861. Anonymous printer. Printed, hand-lettered, and watercolored on wove paper, 9 1/4 in. x 14 in. Private collection.

Gottlieb Schmid (active circa 1845–63), who knew German and English, worked throughout south-eastern Pennsylvania as a scrivener and, possibly, a printer. Anonymous hands added data to the certificate until 1897. The influx of English into the German community is clearly evident by the first names, such as Elenora, Walles [Wallace], Roseyns [Rose Ann?], Emma, Wilabe [Willoughby], and Oscar.

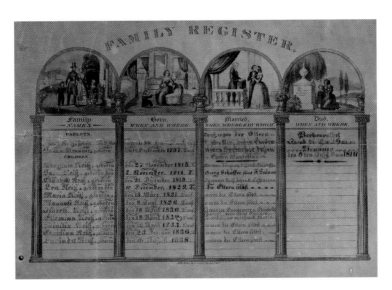

COLOR PLATE 28 Family register for Jacob and Hannah (Brunner) Reitz. Anonymous scrivener, south-eastern Pennsylvania, circa 1840. Lithographed and published by Nathaniel Currier, New York. Printed and hand-tinted on wove paper, 11 1/2 in. x 15 3/4 in. Private collection.

An anonymous scrivener recorded data in German fraktur lettering on an English-language certificate. The scrivener ignored column headings by omitting locations and writing names of witnesses to the baptisms under the "Married" column. The only entry under the "Died" column was the marriage ("Verheurathet") of Jacob and Hannah Reitz [Reiss] on July 9, 1816. No explanation is offered for the birth date of the Reitzes' first child, Abraham. Abraham was either born to Jacob and a former wife, or he was born out of wedlock. The scrivener may also have recorded his year of birth in error.

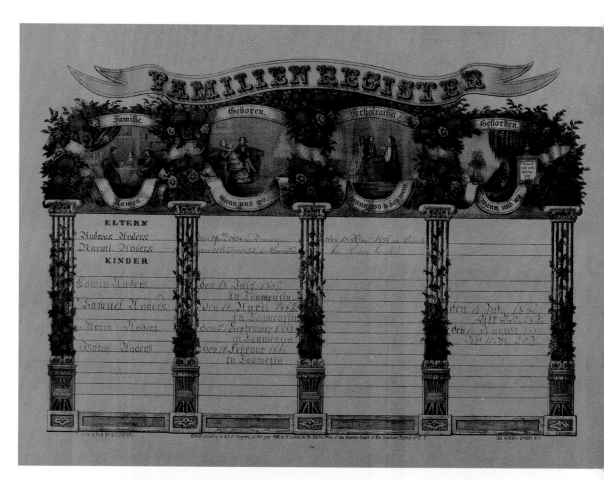

COLOR PLATE 29 Family register for Andreas and Naemi (Anders) Anders. Anonymous scrivener, Towamencin Township, Montgomery County, Pennsylvania, circa 1866. Lithographed and published by Nathaniel Currier, New York. Printed and hand-tinted on wove paper, 13 1/2 in. x 18 in. Private collection.

Andreas and Naemi (Anders) Anders may have been members of the Schwenkfelder sect. Even though their register is relatively late, high infant mortality was still a problem. Samuel lived only two months and twenty-eight days; Maria, ten months and twenty days. German-language family registers were copyrighted by Nathaniel Currier in 1846 and by Nathaniel Currier and James Merritt Ives in 1869. These registers were commercially available until late in the nineteenth century.

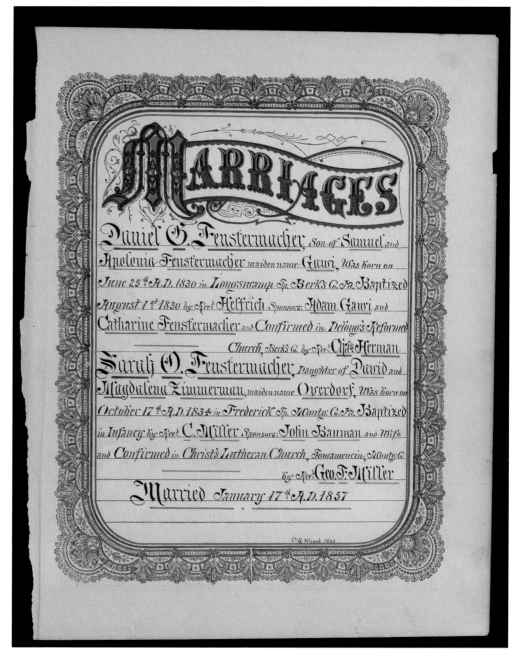

COLOR PLATE 30 Page from family register for Daniel G. and Sarah O. (Zimmerman) Fenstermacher. Signed C[hristian] G. Hirsch, Upper Providence Township, Montgomery County, Pennsylvania, 1893. Printed and hand-lettered on wove paper, 11 1/2 in. X 9 in. Preprinted insert removed from Bible. Private collection.

Christian G. Hirsch (active circa 1875–1908) was an itinerant scrivener, fluent in German and English. He worked in Berks, Bucks, Chester, and Montgomery Counties, Pennsylvania. The Fenstermacher register consists of five pages and is remarkable for its completeness. Hirsch not only recorded life data pertinent to Daniel and Sarah Fenstermacher and their children but also listed the paternal and maternal grandparents as well as locations. All nine children were apparently born in Montgomery County. Hirsch made one entry in the Bible after 1893. He recorded the death of Daniel Fenstermacher, which occurred on April 1, 1894.

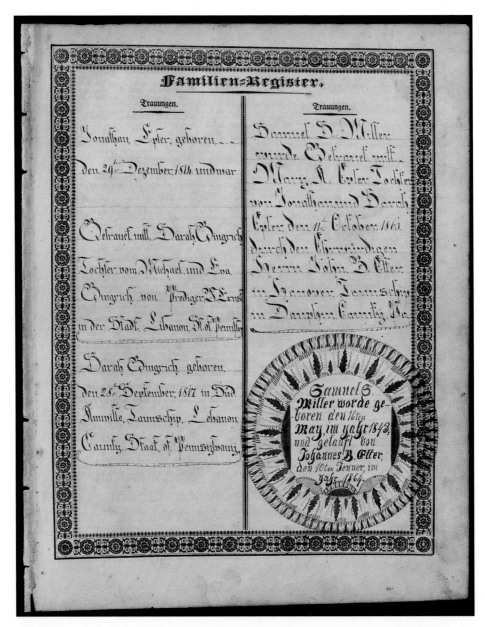

COLOR PLATE 31 Page from family register for Jonathan and Sarah (Gingrich) Epler. Attributed to Ferdinand Klenk and the Spiral Artist of Dauphin County, Middletown, Dauphin County, circa 1855–68. Printed and hand-drawn, lettered, and watercolored on wove paper, 11 in. x 8 1/2 in. Preprinted register removed from Bible. Private collection.

The Epler register consists of four pages with family data recorded by multiple scriveners for four generations. Rather than a page devoted to each generation, data are mixed. That is, data for all four generations appear on pages set aside for marriages, births, and deaths. The parents listed by Ferdinand Klenk (left column) were Jonathan and Sarah (Gingrich) Epler. Their daughter Maria (born January 29, 1843) married Samuel Miller in 1863. The Spiral Artist of Dauphin County (lower right column) recorded the birth of Samuel S. Miller, born May 16, 1843.

Ferdinand Klenk was born in the Duchy of Württemberg in 1824. He immigrated in 1846 and worked as a scrivener until 1882. The anonymous Spiral Artist of Dauphin County was active from 1853 to 1878.

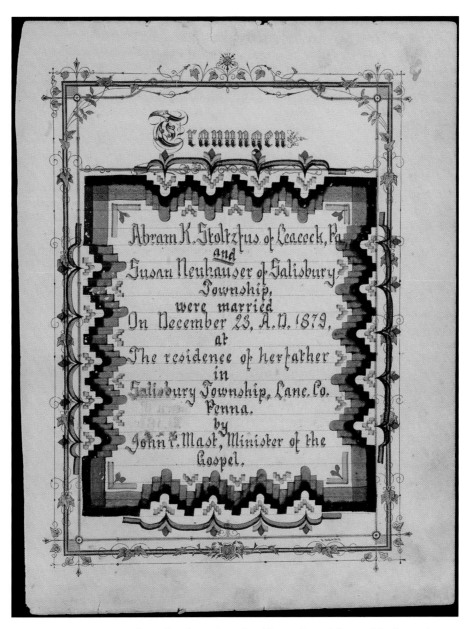

COLOR PLATE 32 Page from family register for Abram K. and Susan (Neuhauser) Stoltzfus. Signed Joseph McGlaughlin, Salisbury Township, Lancaster County, Pennsylvania, 1891. Printed and hand-lettered in colored ink on wove paper, 11 3/4 in. x 9 in. Preprinted insert removed from Bible. Private collection.

On July 20, 1891, Joseph McGlaughlin (1867–1942) infilled the family Bible for Abram Stoltzfus and Susan Neuhauser, who married on December 23, 1879. McGlaughlin apparently knew no German. He wrote in English on this German-language Bible register. He was a popular scrivener among Lancaster County Amish. The ribbon-candy style of decoration, made with various pen nibs and colored inks, was popular with scriveners late in the nineteenth century and early in the twentieth. On another page, McGlaughlin recorded the names and dates for Abram's and Susan's parents, and he mentioned that the Stoltzfuses had "brought up" Isaac S. Walker, born on August 25, 1877. Apparently the Stoltzfuses had no children of their own.

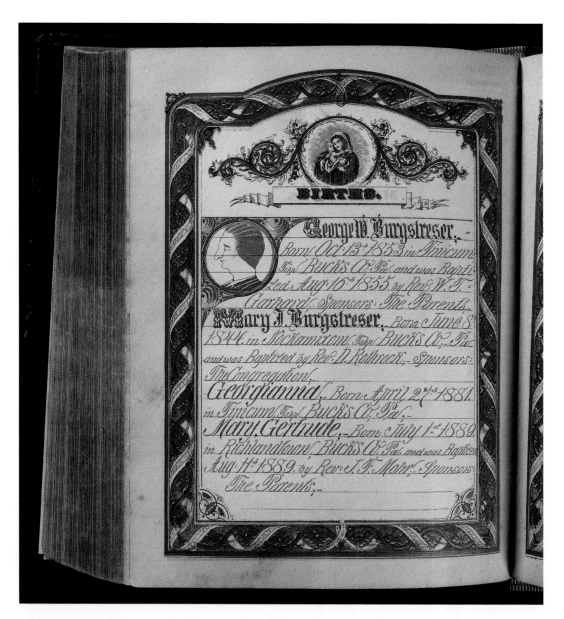

COLOR PLATE 33 Page from a family register for George W. and Mary (Fabian) Burgstreser. Signed August Baumann, Bucks County, Pennsylvania, 1901. Printed, hand-lettered, and decorated in colored ink on wove paper, 10 in. x 6 3/4 in. Collection of Thomas K. Johnson II.

August Baumann was the only penman who routinely drew likenesses in Bible-entry registers and on Taufscheine. Unless the drawing of George Burgstreser is accurate, it appears that Baumann might have been prone to exaggeration. The Burgstreser record consists of six pages. The family had three children, but sadly, only one survived childhood.

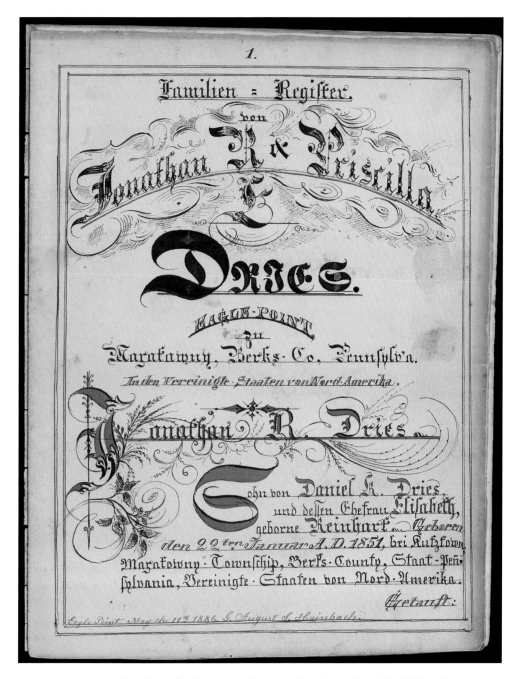

COLOR PLATE 34 Page from family register for Jonathan R. and Priscilla (Bleiler) Dries. Signed G[eorg] August S. Hainbach, Maxatawny Township, Berks County, Pennsylvania, 1886. Hand-drawn, lettered, and watercolored on wove paper, 11 1/2 in. x 9 in. Endpapers removed from Bible. Private collection.

On May 11, 1886, August Hainbach (active circa 1876–1919) probably sat in the parlor of the Dries home and penned four pages of an eight-page register on end pages in the family Bible. He drew a title page (pictured) that included the husband's parents, a page recording the marriage of Jonathan and Priscilla, and two pages recording the births of three children. Jonathan Dries obviously wanted to continue the tradition of having family data recorded in decorative lettering (see color plate 35).

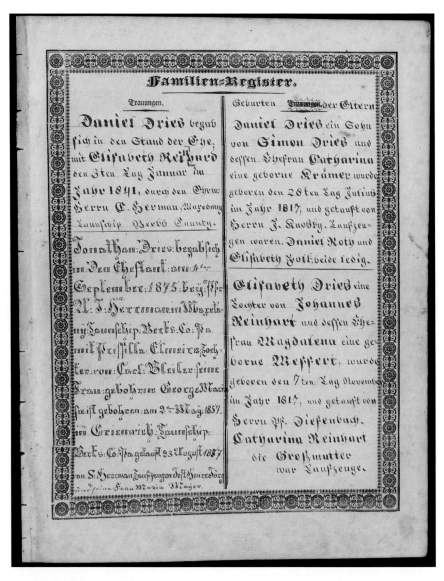

COLOR PLATE 35 Page from family register for Jonathan R. and Priscilla (Bleiler) Dries. Infill attributed to the Footed Letter Scrivener and Martin Wetzler, Berks County, Pennsylvania, circa 1860–75. Printed and hand-lettered on wove paper. Preprinted register removed from Bible, 11 1/2 in. × 9 in. Private collection.

The Dries Bible register, covering several generations, is a cornucopia of data recorded by four prolific scriveners. On the page pictured here, beginning top right, the Footed Letter Scrivener (active circa 1843–63) recorded the birth of Daniel, son of Simon and Catharina (Kramer) Dries, on July 28, 1817. Lower right, he recorded the birth of Elisabeth, daughter of Johannes and Magdalena (Meffert) Reinhart, on November 7, 1817. Top left, he recorded the marriage of Daniel Dries and Elisabeth Reinhard on January 3, 1841. (They became the parents of Jonathan R. Dries.) Lower left, Martin Wetzler (active circa 1854–88) recorded the marriage of Jonathan and Prissilla [sic] Elmira Bleiler on September 4, 1875. Note that on the same page, the Footed Letter Scrivener spelled Reinhard both with a "t" and with a "d." In addition to what is shown here, scriveners J. George E. Franck (active circa 1878–1912) and Georg August S. Hainbach (see also color plate 34) contributed entries to the register.

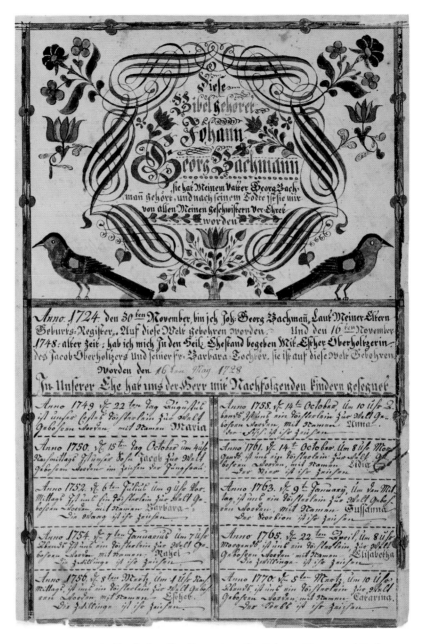

COLOR PLATE 36 Bookplate/family register for Johann Georg and Esther
(Oberholtzer) Bachmann. Attributed to Johann Adam Eyer, Bucks County,
Pennsylvania, circa 1792. Hand-drawn, lettered, and watercolored on laid
paper, 13 in. x 8 1/2 in. Endpapers in a 1536 Froschauer Bible. Collection of
Henry L. and Charlotte G. Rosenberger. Image courtesy Mennonite Heritage
Center, Harleysville, Pennsylvania, and Mary Jane Lederach Hershey.

*The Bachmann register represents the artistic talent of a frakturist at his best.
The page pictured lists dates of birth of the children of Georg [George] and
Esther Bachmann. On the second page of this register, Johann Adam Eyer
(1755–1837) recorded the birth dates of Georg Bachmann and his ten sib-
lings. The earliest date Eyer recorded was 1717, but the latest entry in his
hand was 1792. As often occurred in fraktur, events were recorded years after
they had happened.*

Geburden Jamillien Regiſter Sterbfälle

Den 1 ten Jenner im iahr 18 31
Iſt Mei dade Samuel Blank
Geboren Sein zeigen iſt der Löb

Den 3 ten November im iahr 1867
Starb Mei dade Samuel Blank
Iſt alt Worden 36 iahr 10 M.2 tag

Den 3 ten März im iahr 18 33
Iſt Mei Mamme Hanna Blank
Geboren ihr zeigen iſt der Löb

Den 2 ten November 1909 Starb
Mei mamme Hanna Blank iſt alt
Worden 76 iahr 7 mo 29 Tag

Ich Johannes, Blank Bin
Geboren den 27 ten Jenner im
Jahr 1858 mei zeigen iſt der Krebs

Johannes Y Blank Starb
April. 10. 1915 iſt alt Wo
57 iahr 2 monat 13 Tag

Chatharina Blank iſt Geboren
Den 2 ten November Im iahr
1859 ihr zeigen iſt der Waſſerman

Catharina Blank iſt Geſtorben
Den 5 ten april im iahr 1867 iſt
Alt Worden 7 iahr 5 Monat 3 Tag

Chriſtian Blank iſt Geboren
Den 21 ten Auguſt Im iahr
18 61 Sein zeigen iſt der Jiſch

Samuel Blank iſt Geboren
Den 22 ten März Im iahr
18 63 Sein zeigen iſt der Löb

Samuel Blank iſt Geſtorben
Den 9 ten März im iahr 18 65 iſt
Alt Worden 1 iahr 9 Monat 18 tag

David Blank iſt Geboren den
5 ten November Im iahr 1865
Sein zeigen Sin die Zwilling

Dies Buch Gehöret Mir
Johannes Blank 18 78

COLOR PLATE 37 Family register for Johannes Y. and Mary (Stoltzfus) Blank. Attributed to Barbara Ebersol, Lancaster County, Pennsylvania, 1878 with added infill circa 1915. Hand-lettered and watercolored on page removed from Bible. Wove paper, 8 1/2 in. × 6 in. Courtesy Muddy Creek Farm Library, Ephrata, Pennsylvania. Image courtesy John A. Parmer.

Barbara Ebersol (1846–1922) was the most prolific Amish frakturist. In her plump fraktur letters, she began recording family data in a Bible belonging to Johannes Blank in 1878. She recorded data in the first person, as if Johannes Blank (died 1915) had written it. Note her phonetic spelling of "my daddy" and "my mommy" ("mei dade" and "mei mamme"). Though she finished making family registers in the twentieth century, Ebersol still recorded the signs of the zodiac under which the children were born, and she recorded death in the traditional German way, showing ages in years, months, and days.

Abraham grew up to marry Magdalena Nees, who died in 1794 at age forty-two. After her death, Abraham or his children had the second Bollinger register printed at Ephrata. This register lists the seven children of Abraham and Magdalena (Nees) Bollinger (see color plate 12). Just as Rudolph's name is absent from the 1763 Bollinger register, Abraham's name is absent from this register. The watercolor illumination of what might depict images of George Washington is a surprise. Presumably, the Bollinger family had the register set in type in order to produce several identical copies, but it was set so that ample borders surrounded the text. At the time it was printed, Ephrata printers were printing decoration on their *Taufscheine,* and they could just as well have printed decoration in these borders. But instead, the Bollingers had the borders filled with hand decoration. The question is, did they do that for each copy printed? No other example is known for comparison, but it would seem that these pieces were designed to be decorated individually, despite the care taken to create identical texts.[22]

As early as the 1763 Bollinger example is, evidence suggests that it may not have been the earliest family register printed at Ephrata. Three identical copies exist of a circa 1830 reprint of an earlier register made for Johannes and Catharina (Schenck) Stauffer and their family (fig. 13). This register says Catharina (Schenck) Stauffer died November 29, 1760—the latest date on the register. As Catharina died late in the year, the original register was likely made in 1761.

Some family registers appear to have been made after the death of a family member. Georgia Barnhill suggests that family registers and memorials are closely related. She dedicated a major section of her article, "Keep Sacred the Memory of Your Ancestors: Family Registers and Memorial Prints," to memorials.[23] Families suffering a loss may have felt the need to create a lasting record in memory of the deceased. Much like tombstones were meant to be permanent markers, family registers may have been "permanent" records that expressed recognition of our own mortality. Yet while registers hinted at mortality, they also looked forward. By listing children, they clearly conveyed the sentiment that life goes on.

The 1794 Bollinger/Nees example appears to have been printed after the death of Magdalena (Nees) Bollinger, who died February 2, 1794. Likewise, the Stauffer/Schenck register appears to be a reprint of a register either penned by hand or printed after Catharina (Schenck) Stauffer's death in 1760. The date of death of Johannes Stauffer is missing (he died in 1767),[24] and the last of the thirteen children in this family was born in 1758, making Catharina (Schenck) Stauffer's death date in 1760 the latest date on the register.

It is possible that information on the Stauffer/Schenck register was taken from a freehand Bible record. Colket, who was aware of the Stauffer/Schenck register, suggested that the example he saw was a broadside that was probably printed no earlier than 1830. He went on to say that it was "based possibly upon an unknown *Frakturschrift* prepared as a family memorial by a calligrapher in 1761."[25] In other words, Colket believed that rather than a reprint of a *printed*

Johannes Stauffer, geboren in Wartenberg in der Pfaltz, Anno 1715, den 6. August, auferzogen auf dem Mückenhäuserhof, verehlichet sich Anno 1738, im Herbst Monate.

Catharina Schenckin, welche geboren in Canestoges, Anno 1720, im April, starb Anno 1760, den 29. November, nach dem sie in der Ehe gelebt 22 Jahr, ihres Alters im ein und vierzigsten Jahr. GOtt gebe ihr Gnade am Tag des Gerichts.

Sie haben in einer friedlichen Ehe erzeugt nachfolgende Kinder, als

I	II	III	IV	V	VI	VII	VIII	IX	X	XI	XII
Anna Barbara, 1739 im August.	Elisabetha, 1741, den 9 Tag	Veronica, den 1742, März;	Christian, den 1744, 31. Juli.	Jacob, den 1745, 31. Juli.	Anna, den 1746, 7. Mai.	Christina, den 1748, 30 Sept.	Catarina, den 1750, 2 Febr.	Eva, den 1751, 26 Febr.	Ano. 1754 Johannes u. Heinrich Dieser nach alt 3 Wochen.	Maria, 1756 im Zwillinge. Zeichen des Waßermang.	Michael, 1758, den 18 Dezem. im Zeichen des Löwen.

GOTT, dem sie waren, ehe sie waren, und der durch seine ewige Güte sie hat laßen werden, mache sie zu einem Vorwurf seiner Barmherzigkeit. Er segne sie und ihr Nachkömmlinge, und lase ihren Saamen besitzen die Thore ihrer Feinde.

FIG. 13 Family register for Johannes and Catharina (Schenck) Stauffer. Attributed to Jacob Stauffer, Lancaster County, Pennsylvania, circa 1830. Printed on wove paper, 11 in. × 14½ in. Private collection.

Johannes Stauffer was born at Wartenberg in the Pfalz on August 6, 1715. He was raised in the Mückenhäuserhof, but he immigrated to Lancaster County in 1737. In 1738, he married Catharina Schenck, who was born at Conestoga, Lancaster County. This register is also a memorial to Catharina, who died November 29, 1760—having been married for twenty-two years and given birth to thirteen children, including a set of twins.

The Stauffer/Schenck register may be a reprint of an earlier register that was printed at the Ephrata Cloister. The register pictured here was probably printed about 1830, perhaps by Jacob Stauffer (1808–1880), who began printing in Manheim, Lancaster County, about that time. A gifted man, Jacob Stauffer was a naturalist, printer, lithographer, scrivener, and photographer. He moved to Mount Joy in 1838 and later to the city of Lancaster, where he became a patent officer.

broadside, the text came from a *handwritten* source—and he may be right. A Stauffer family Bible with an identical text is thought to exist, and the circa 1830 printed family register may have been taken from that source rather than an earlier print. The current location of the Bible is unknown, although the Lebanon County Historical Society in Lebanon, Pennsylvania, has a transcript of the register. According to the Society, the transcript was taken from a "Stauffer family Bible," which the Society apparently deaccessioned.[26]

It is speculative to conclude that the original record was a printed register, but the typesetting on the circa 1830 reprint does suggest a printed source. The

use of fraktur lettering for the majority of the text, with roman types for non-German words such as "Conestoga," suggests that there might have been an earlier printed register similar to that of the 1763 Bollinger register.[27] Moreover, most Bible records are written in a single- or double-column format. The arrangement of the text on the Stauffer register, with the children listed side-by-side across the page, suggests an arrangement other than a Bible record.

Clues may also come from family history. According to family historians, Johannes Stauffer remarried after the death of Catharina (Schenck) Stauffer.[28] He had two more daughters, but they are listed neither in the transcript of the Bible record nor on the circa 1830 Stauffer/Schenck broadside register. Had they been listed in the Bible, evidence would have been stronger that the Stauffer printed register was taken from another source. Whatever the source, it is interesting that the family did not have the register updated when it was reprinted about 1830. By then, the family undoubtedly knew Johannes Stauffer's death date, and they probably had information concerning his two daughters by his second wife.

The circa 1830 Stauffer/Schenck register may have been printed in Manheim, Lancaster County, near where Johannes and Catharina (Schenck) Stauffer settled. If it was printed in Manheim, it may have been printed by Jacob Stauffer (1808–1880), who began printing in Manheim in 1830. In all likelihood, Stauffer printed Manheim's first newspaper, but his printing career in Manheim was short-lived, for he printed there only until 1838.[29]

The Stauffer/Schenck register is important in that it is one of the few printed registers that specifies a location in Europe whence a family member came. According to this "bonus" information, Johannes Stauffer was born in Wartenberg in Pfalz and raised at the Mückenhäuserhof.[30] Because he was married in 1738 to Catharina Schenck, who was born at Conestoga, he immigrated prior to that date. Family historians say that he immigrated in 1737.[31]

Whereas the Stauffer and Bollinger registers may have been the first of their kind, Joseph Bauman may have produced the last documented register printed at Ephrata. Printed about 1831 for the Keller family, this register uses German fraktur lettering (fig. 14). About the time this register was printed, Bauman relocated to Cumberland County. As Joseph Bauman took the Ephrata press with him to Cumberland County, he may have printed the Keller family register there. More likely, however, he printed it before leaving Ephrata, because the Keller family had long been associated with Beissel's community in Lancaster County.[32]

Without a doubt the Bauman family would have been in touch with the larger world of printers around them. But at the time Joseph Bauman relocated, broadside family registers requiring handwritten infill with the now familiar three- or four-column format had yet to appear in great numbers from printing centers such as New York and Chicago. When Joseph Bauman left Ephrata, the entirely printed Ephrata family register press run from 1763 to 1831 ended.

The earliest American fraktur were drawn by members of the Ephrata com-

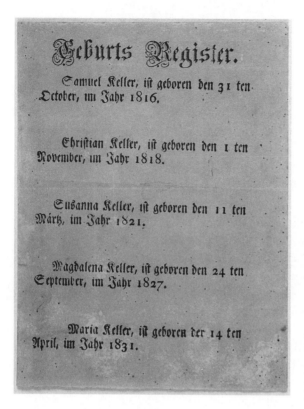

FIG. 14 Family register for the children of Samuel and Magdalena (Erb) and Catherine (————) Keller. Attributed to Joseph Bauman, Ephrata, Lancaster County, Pennsylvania, circa 1831. Printed on wove paper, 8½ in. × 6½ in. Private collection.

Research indicates that the children listed here were those of Samuel Keller and Magdalena Erb and Samuel's second wife, Catherine, whose maiden name is unknown. Maria, born April 14, 1831, was born to Catherine. It is not clear, however, whether the preceding child, Magdalena, was born to Magdalena or to Catherine. The Kellers, like the Bollingers and Baumans, had a long association with the Ephrata community. This register was probably printed by Joseph Bauman (1789–1862), who printed in Ephrata from 1817 to 1831.

munity. These freehand examples had little or no impact on fraktur drawn for families outside the tightly knit sect. Fraktur printed on the Ephrata press, however—especially *Taufscheine*—had a tremendous influence on other fraktur made throughout southeastern Pennsylvania and beyond. This is true both artistically and in terms of the text, which became more standardized as printed forms were circulated. Printed *Taufscheine* from Ephrata had the added effect that these forms became widely available, stimulating demand for them even more.

Conversely, family registers printed on the Ephrata press seemed to have little influence on family registers printed outside the community. Ephrata family registers maintained a basic printed design, generally varying only in the border, in orientation (vertical versus horizontal), in fonts, and, to a lesser extent, in verbiage. More important, totally printed registers did not catch on among Pennsylvania Germans to the extent that printed *Taufscheine* did.

Beyond Ephrata

Although never in great numbers, broadside-type family registers with printed infill were made beyond Ephrata for most denominations of Pennsylvania Germans, and they were made into the first decades of the twentieth century. It must be emphasized, however, that totally printed registers remained uncommon.

Judging from examples we surveyed, Mennonites, Brethren (Dunkers), and other small sects seemed to favor these records more than other denominations. Of Pennsylvania counties, Bucks, Montgomery, and Lancaster Counties had and still have especially high numbers of Mennonite families. To date, no totally printed broadside-type family registers made for Mennonite families from Bucks or Montgomery Counties are known, while several Lancaster County examples have been identified.

But a register was printed for the Lutheran and Reformed family of Christopher Ottinger of Whitemarsh in Montgomery County (fig. 15). According to the records of St. Michael's Evangelical Church in Philadelphia, Christopher Ottinger (1720–1802) was Reformed, and his wife, Maria Welsch (1720–1784), was Lutheran.[33] Whitemarsh is located near Germantown, which, together with the city of Philadelphia, became the center of German-language printing in colonial America. The Ottinger register was likely printed in Germantown about 1784 or 1785, perhaps by Peter Leibert (1727–1812) and Michael Billmeyer (1752–1838).[34] Pasted inside the front cover of a 1776 "gunwad" Bible printed by Christopher Saur II (1721–1784) of Germantown, the Ottinger/Welsch register is remarkable for several reasons. It was probably printed soon after Maria (Welsch) Ottinger's death on October 25, 1784, and it follows the 1763 Bollinger register as the second known totally printed register made for a Pennsylvania-German family. This register mentions authorship, for it says that the text was written by Christopher Ottinger in his own hand (*"Mit eigner Hand geschrieben von Christopher Ottinger"*). Like Roger Clap, Christopher Ottinger directly addressed his children, citing scripture and asking them to trust in and praise God. More important, this register hints at a print run. It begins by saying, "These four books for my four children" (*Diese vier Bücher für meine vier Kinder*), whose names and dates of birth from 1745 through 1750 are listed. Hence, the Ottinger/Welsch register suggests that only four copies were printed. It is the only known register to offer evidence of a print run, and it confirms suspicions that mere handfuls of family-specific broadside registers were printed per family.

The Ottinger/Welsch register is significant in other ways. Thanks to current research on Pennsylvania-German broadsides being conducted by Carola Wessel of Göttingen University, we know that three copies of the Ottinger/Welsch register survived.[35] Two reasons account for this high survival rate. These registers were placed in Bibles or at least given to the Ottinger children with Bibles or other books, confirming that books, and especially the Bible, were regarded as places for safekeeping. Like other totally printed registers, such as the Bowman register printed at Ephrata, the Ottinger/Welsch register was sized so that it could be pasted or otherwise fixed in a Bible or other book. Its relatively small size (8 1/2 inches by 6 3/4 inches) allows it to fit comfortably in Christopher Saur's 1776 gunwad Bible. Moreover, Christopher Ottinger's words to his chil-

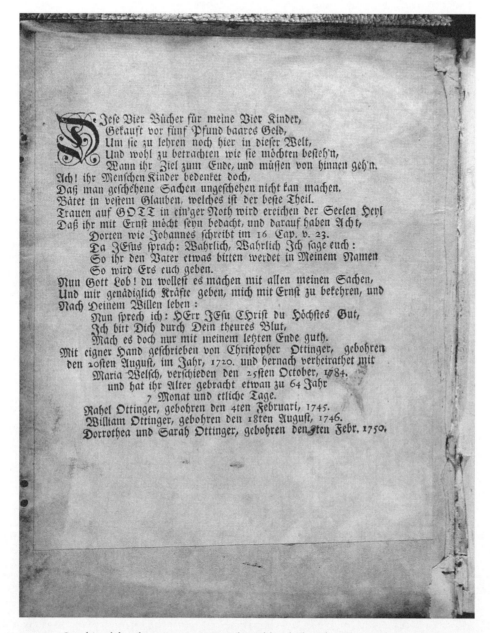

FIG. 15 Combined family register, memorial, and bookplate for Christopher and Maria (Welsch) Ottinger. Anonymous printer, probably Germantown, Pennsylvania, circa 1785. Letterpress-printed on laid paper, 8½ in. × 6¾ in. Pasted under the front cover of a 1776 Christopher Saur II Germantown Bible. Private collection.

To date, this is the second oldest entirely printed Pennsylvania-German family register we documented. Christopher Ottinger composed the dedication, in which he included a biblical quotation from John 16:23 and a father's wishes that his children trust in God. Ottinger likely commissioned the printing of the register as a tribute to his late wife, Maria, and as an expression of family values. The Ottinger/Welsch register is the only known entirely printed family register that offers evidence of a print run.

dren and the fact that he secured his message in a Bible testify to the assumption that those who created family registers intended that they would last.

Three Christopher Saurs (often referred to as Saur I, II, and III) were printers in Germantown during the colonial period. To a great extent, the Saurs served the Bucks and Montgomery Counties market, but following the Revolution, German-language job printing for these counties became more dispersed, from Philadelphia to Doylestown (Bucks County), Easton (Northampton County), Reading (Berks County), and Allentown (Lehigh County). While Pennsylvania Germans of Bucks and Montgomery Counties had a tradition for creating hand-drawn and handwritten family registers, they seemed to turn less frequently to printers.

A possible reason for this is that Bucks and Montgomery Counties may have had a shortage of printers willing to set type for small, German-language print runs. Most printers were interested in printing major publications such as newspapers, books, and almanacs. To some, job printing was viewed as an interruption that produced little income. Other printers recognized that potential revenues would not justify an investment in German types and hiring a compositor to set type in German. Their market for English-language printing was probably significantly larger than a German-language market. A handful of printers in Doylestown printed German-language newspapers and broadsides but, in *Bucks County Fraktur,* we pointed out that no printer in Bucks County produced *Taufscheine* for Pennsylvania-German families.[36] And in Montgomery County, Enos Benner (1799–1860) of Sumneytown printed only two editions of *Taufscheine* during a two-year period.[37] Scriveners and fraktur artists such as Johan Friederich Krebs (1749–1815), who made numerous *Taufscheine* for Bucks County Lutheran and Reformed families, had to purchase printed forms from printers in neighboring counties, such as Berks, Lehigh, and Northampton.[38]

Lancaster County, on the other hand, had several printers interested in German-language job printing. The Ephrata Cloister led the way, but the Cloister printers and the Baumans were followed by others such as Peter Montelius (1791–1859) in Reamstown, Jacob Ruth (1794–1878) in Elizabethtown, Jacob Stauffer (1808–1880) in Manheim and Mount Joy, and John Michael Ensminger (died 1899) in Manheim. Printers in the city of Lancaster also did job printing for German families. These include, among others, Christian Jacob Hütter (born 1771), Heinrich Grimler (circa 1777–1814), his brother Benjamin Grimler (circa 1778–1832), Herman William Villee (died 1842), the Albrecht family of printers, and Francis Bailey (1735?–1815), all willing to produce short print runs in German.[39]

The children of Christian and Elisabeth (Schnyder) Herschey of Lancaster County had a three-generation register printed about 1840, after Christian's death (fig. 16). The same printer printed an *Andenken,* or memorial, commemorating the death of Samuel Haldeman in 1840 (fig. 17). These pieces were likely

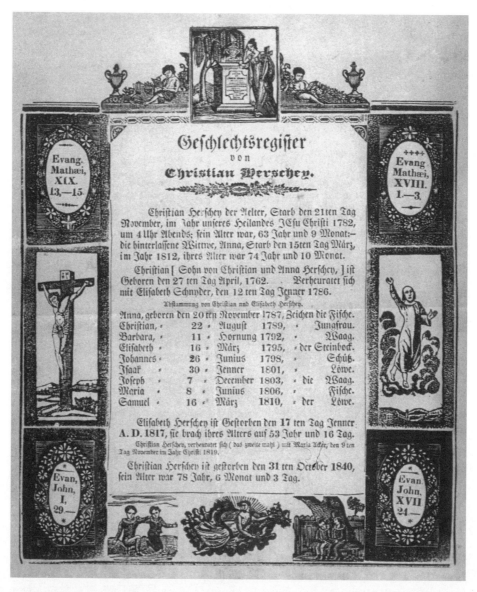

FIG. 16 Family register for Christian and Elisabeth (Schnyder) Herschey. Attributed to John Michael Ensminger, Lancaster County, Pennsylvania, circa 1840. Printed on wove paper, 14 in. × 12 in. Private collection.

This certificate was probably printed to commemorate the death of the second Christian Herschey on October 31, 1840. According to Clarke Hess, Milton S. Hershey, founder of the Hershey Chocolate Company in Hershey, Pennsylvania, was the great-great-grandson of the Reverend Christian Herschey (1719–1782) mentioned on this broadside.

John Michael Ensminger (circa 1822–1899) was trained as a printer in Lancaster and began printing in Manheim in 1838.

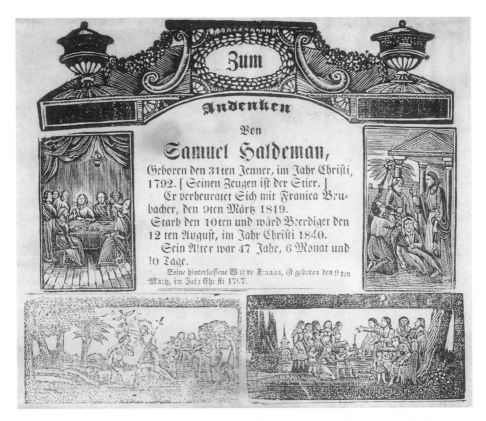

FIG. 17 Memorial commemorating Samuel Haldeman. Attributed to John Michael Ens-
minger, Lancaster County, Pennsylvania, circa 1840. Printed on wove paper, 7 in. × 9 in.
Private collection.

This *Andenken* (memorial) was printed to commemorate Samuel Haldeman, husband of
Franica [Veronica] Brubacher.

printed by John Michael Ensminger of Manheim. In *Printed Birth and Baptismal
Certificates,* Klaus Stopp pictures a *Taufschein* that was probably printed by the
same printer.[40] According to Stopp, about 1838, lithographer Godefroy Engel-
mann (1788–1839) of Mühlhausen in Alsace designed a printed border with a
blank center where any text could be written. Engelmann apparently did not
design his page specifically for *Taufscheine.* Somehow, schoolmaster and fraktur
artist Heinrich Keyser (active circa 1810–56), who taught in Manheim, pur-
chased Engelmann's certificates, which he infilled with *Taufschein* texts. Keyser
may have liked the form so much that he urged Ensminger to print similar forms
using typeset text which could be completed by hand with appropriate family
data.

Ensminger, who succeeded Jacob Stauffer in Manheim, began publishing
there in 1838, after having served a printing apprenticeship in Lancaster. He
continued printing in Manheim until the end of 1849. He carved his types from
wood and cast his own lead types. When in 1838 Stauffer moved a few miles

away to Mount Joy, where he continued printing, he took his types with him.[41] Thus, typefaces used by Stauffer and those used by Ensminger do not necessarily match. This becomes significant in attempting to identify the works of printers in the absence of an imprint (the printer's name and address).

The Herschey [Hershey] and Haldeman families were Mennonite families of northern Lancaster County, where Manheim is located. Pennsylvania-German families typically repeat call names throughout generations. The Herschey family register mentions three Christian Herscheys. The first was the Reverend Christian Herschey (1719–1782), who married Anna Hernly (died 1812). The Herschey family emigrated from Switzerland in 1719 and settled in Warwick Township, Lancaster County. The Reverend Christian Herschey was born in February 1719; he may thus have been born in Europe. The second Christian Herschey, first son of the Reverend Christian Herschey, was born April 27, 1762, and *his* first son, also named Christian, was born August 22, 1789.

The Herschey family seemed keenly interested in printed family registers. The Lancaster Mennonite Historical Society has a second known copy of the broadside Herschey/Schnyder register, but it also has two booklets printed for the Herschey family. The first of these is a four-page, German-language booklet set in German fraktur type. There is no imprint, nor is there a date, but it was compiled by Benjamin Hershey, the second son (and fifth child) of the first Christian Herschey—the Reverend Christian Herschey—mentioned on the broadside. The booklet was published after Benjamin's death, for it states that Benjamin was born March 10, 1768, and died at age 74 years, 1 month, and 26 days (May 5, 1842). The last date *printed* in the booklet is December 2, 1839, the date of death of Johannes Hershey, son of the second Christian Herschey. Judging by the typography, this booklet may have been printed by John Michael Ensminger, to whom is attributed the Herschey/Schnyder broadside. Like the Herschey/Schnyder broadside, it is titled *Geschlechts-Register.*[42]

A second booklet was published by Samuel Hershey in July 1887, when Samuel was 78 years old. This English-language booklet is set in decorative and plain English types. It expands information about the descendants of the first Christian Herschey through Benjamin's line. This booklet was printed by the "Sentinel" printshop, which succeeded the Jacob Stauffer and John Michael Ensminger printshop in Manheim.[43] (In addition to these examples of family registers made for Lancaster County Hersheys, the Lancaster Mennonite Historical Society has in its Hershey family files photocopies of numerous family registers that were penned into Bibles. The Hershey family registers, whether Bible entries or broadside or booklet formats, illustrate how some families wanted to establish permanent records.)

As mentioned above, some printed registers appear to have been prompted by a death in the family. The second Christian Herschey—the focus of the broadside-type Herschey/Schnyder register—died in 1840, and the broadside appears to have been printed about that time. In fact, the central motif at the top, show-

ing a grieving woman and a weeping willow, suggests a memorial. Christian's brother, Benjamin, died in 1842, and the little four-page booklet he compiled appears to have been printed about that time.

Other Mennonite families also favored printed family registers. The Landes family of Lancaster County had family registers printed in a small format that could be pasted inside the covers of the family Bible. The Heritage Center Museum of Lancaster County in Lancaster has a Bible with two editions of family registers printed for the Landes family (figs. 18 and 19). One was printed about 1836, and the other, about 1881. They are pasted in the front and back of the Bible. An obvious problem with setting family registers in type and printing them

Birth and Matrimonial Certificate.

Levi Landes was born on Friday morning at 5 o'clock, on the 4th day of June, 1824. *Died March 24th 1905 Aged 80 years 9 Month 20 days*

Elizabeth Landes was born on Monday morning at 12 o'clock, on the 11th day of February, 1828. *Died May 17 1914 Aged 86 yrs. 3 Mo 6 Days*

Levi Landes and Elizabeth Landes were intermarried on the 28th day of December, 1847.

Ezra L. Landes was born on Monday morning, at 11 o'clock, on the 6th day November, 1848. Died, July 16th, 1881. Aged 32 years, 8 months and 10 days.

Israel L. Landes was born the 15th day of July, 1851. Died Sept 21, 1874. Aged 23 years, 2 months and 6 days.

Levi S. Landes, was born the 1st day of January, 1853.

Jacob L. Landes was born on the 7th day of Nov. 1854.

Samuel L. Landes was born on the 14th day of Nov. 1858.

Mary Ann Landes was born on the 9th day of August, 1860.

FIG. 18 Birth and matrimonial certificate for Levi and Elizabeth (Landes) Landes. Anonymous printer, Lancaster County, Pennsylvania, circa 1881. Printed on wove paper, 7¼ in. × 7⅞ in. Courtesy Heritage Center of Lancaster County, Inc., Lancaster, Pennsylvania.

Levi Landes was a son of Samuel Landes. This register was pasted inside the back cover of the same Bible (an undated Kimber and Sharpless Bible) as the Landes/Mohler birth and matrimonial certificate (see fig. 19). It is entirely possible that Elizabeth's name before marriage was Landes, as this is a common surname in Lancaster County.

FIG. 19 Birth and matrimonial certificate for Samuel and Hannah (Mohler) Landes. Anonymous printer, Lancaster County, Pennsylvania, circa 1836. Printed on wove paper, 8½ in. × 8⅛ in. Courtesy Heritage Center of Lancaster County, Inc., Lancaster, Pennsylvania.

The Samuel Landes register is interesting in that even in the early decades of the nineteenth century, the signs of the zodiac were still considered important. Unfortunately, locations were not. This little broadside shows one of the disadvantages of a printed certificate. The death dates were penciled in, but was the same done to other copies? This register is pasted to the inside of the front cover of an undated Kimber and Sharpless Bible printed in Philadelphia (also see fig. 18).

becomes apparent on these examples. One of the examples in the Bible at the Heritage Center Museum was made for the Samuel Landes family. An identical example is known in a private collection. On both these registers, family members pencilled in events (such as marriages and deaths) that occurred subsequent to the printing. Naturally, one family member recorded information on one register, but that same information was unknown or forgotten by family members having an identical register.

The *Lebanon Courier* in Lebanon, Pennsylvania, printed an English-language

register for the Christian and Maria (Snyder) Bachman family. The latest printed date on this four-generation register was 1858. After that date, the family recorded data by hand until 1910.[44] Unlike the Landes examples, the printer provided blank space on the register for additional updated information. As anticipated, blank space quickly disappeared. The same is true for a register printed for the Mayer/Reed family about 1853. This register was likely printed by the Evangelical Association in New Berlin, Pennsylvania (fig. 20).[45] Two copies are known. One is in the Northumberland County Historical Society in Sunbury, Pennsylvania. Unfortunately, the other, once in a private collection, is now missing.[46]

Families frequently updated registers. In particular, those bound into Bibles show the hands of various professional penmen who stopped by the farmhouse and added data such as marriages, births, and deaths occurring after the last

Verzeichniß
der Geburts-Heiraths-und Sterbefälle,
in der Familie von John Mayer.

Familien Namen.	Wenn geboren.	Wenn Verheirathet.	Wenn Gestorben.
Namen der Eltern.			
John Mayer.	November 24, 1794.	July . . . 30, 1815.	
Catharine Reed.	May 6, 1800.	**December 27, 1852**
Namen der Kinder.			
Susanna. . . .	November . . 17, 1815.	September . 18, 1842.	
Catharine. . .	August . . . 25, 1817.	July . . . 24, 1849.	**März** 22, 1881
Daniel. . . .	März . . . 28, 1819.	Juny . . . 9, 1844.	Jannar 7 1883
Elias. . . .	July . . . 12, 1820.	November . 4, 1845.	
Mary. . . .	December . . 13, 1821.	**August 4, 1823**
Johann. . . .	Jannar . . 27, 1825.	December . 30, 1851.	
Elisabeth. . .	December . . 29, 1826.	Februar . 8. 1857	Jullus 21, 1878
Lidia. . . .	April . . . 24, 1829.	März 18, 1883
Enoch. . . .	May . . . 21, 1831.	März . . . 5 1854	
Sara. . . .	Juny . . . 8, 1833.	Jannar . 26, 1851.	
Emily. . . .	August . . . 21, 1834.	April . . 22, 1851.	
Rahel. . . .	Oktober . . 30, 1835.	Februar . 15, 1852.	**März** 8, 1865.
Annette. . . .	July . . . 15, 1839.	November 7. 1858.	

FIG. 20 Family register for John and Catharine (Reed) Mayer. Attributed to Solomon Georg Miller, Evangelical Association, New Berlin, Pennsylvania, circa 1853. Printed on wove paper, 10 in. × 12 in. Courtesy Northumberland County Historical Society, Sunbury, Pennsylvania.

According to Klaus Stopp, the Evangelical Association printed in New Berlin from 1838 until 1854, when the printing operation was moved to Cleveland, Ohio. Family registers were often printed following the death of a family member. In this instance, the mother of the family, Catharine (Reed) Mayer, died late in 1852. Thus, the register was likely made in 1853 or 1854, before the Evangelical Association publishing operation relocated.

entry. Again, the problem with updating totally printed registers was that there might be several copies floating around requiring revision, but not all were available to the scrivener.

Entirely printed registers are known from Pennsylvania-German families outside Pennsylvania. A circa 1830 example exists for the Wood/Harper family of the Shenandoah Valley.[47] The printing of this register is attributed to Salomon Henkel (1777–1847) of the well-known Henkel dynasty of printers in New Market, Virginia.[48] A later example from around 1896 exists, also from the Henkel Press.[49] This English-language register is interesting in that it takes the family back across the Atlantic to Saxony. It documents four generations of descendants of Abraham Miller and was made after the centennial: the family was firmly American, but it maintained an interest in European roots (fig. 21).

An English-language translation of the Christian Weber register is in the collection of the Heritage Center Museum of Lancaster County. The name of Professor R. S. Henry and his location in Hagerstown, Maryland, at the top of this register suggest that it was printed in Maryland. Henry's "literal" translation states that the Weber family was from "Charles" rather than "Earl" Township

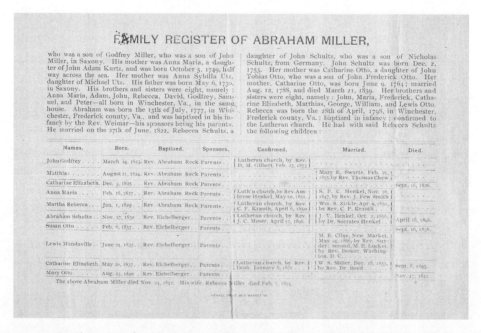

FIG. 21 Family register for Abraham and Rebecca (Schultz) Miller. Printed by the Henkel Press, New Market, Virginia, circa 1896. Printed on wove paper, 5 1/2 in. × 8 1/4 in. Private collection.

The Miller/Schultz family was related to the Henkel family of printers and preachers. Note that two Miller children married Henkels. This late-nineteenth-century register has lost all Germanic traits. Gone are fraktur type, the watercolor illumination, and the German language. Instead of one or two generations, this register includes four generations and European beginnings.

in Lancaster County, suggesting that the professor was unfamiliar with German fraktur lettering and with townships in Pennsylvania counties, thus strengthening the argument that this register was printed in or near Hagerstown. Nothing is currently known about Henry, but judging from the typography of the register, it likely dates from the second half of the nineteenth century (fig. 22).[50]

Printed registers were made for Canadian Mennonite families, including the Martins, Zimmermans, and Baumanns. In *Ontario Fraktur,* Michael Bird pictures several freehand and printed family registers, illustrating the popularity of these registers among Canadian Mennonites.[51] Canadian freehand and printed registers are stylistically similar to those from the United States. Barring written locations, family history research, recognition of artists, or known provenance, it would prove difficult, if not impossible, to distinguish a Canadian register from one made in the United States.

Besides examples printed for families located wherever Pennsylvania Germans settled, registers were printed for families of most Pennsylvania-German religious denominations. An Amish example printed about 1903 for the Lapp family of Lancaster County is known (fig. 23). This register was printed in English. According to Stopp, most printer's errors on *Taufscheine* appear on certificates printed in English. The same is undoubtedly true of family registers. The Lapp family register has a printer's error in one of the two verses at the lower right. Rather than "to joys *immortal* rise," the text reads, "to joys *immoral* rise." When the error was corrected, the printer simply flipped the sheet over and printed the corrected version on the reverse.

FIG. 22 Family register/memorial for Christian and Magdalena (Ruth) Weber. Anonymous printer, possibly Hagerstown, Maryland, circa 1875. Printed on wove paper, 9 in. × 6¾ in. Courtesy Heritage Center of Lancaster County, Inc., Lancaster, Pennsylvania.

Professor R. S. Henry of Hagerstown, Maryland, made a "literal" translation of the circa 1820 German-language register of Christian and Magdalena (Ruth) Weber. Henry seemed unfamiliar with locations in Lancaster County and fraktur lettering, for he read Earl Township as Charles Township (see fig. 12).

A Literal Translation from the German, by Prof. R. S. Henry, Hagerstown, Md.

CHRISTIAN WEBER

Was born in Charles township, Lancaster Co., in the State of Penna., on the 25th day of December, (upon Christmas day), according to the old time, in the year 1731. He was married on the 30th of September, 1749, to Magdalene Ruth, and lived with her in the marriage state 55 years, and was 16 years a widower. He was attached to the Mennonite Church and a warm professor of its faith. [It is to be desired that his posterity may follow him in this]. His disease was old age and feebleness. He died on the 13th of Feb'y, 1820, and lived 88 years, 5 weeks and 2 days. His wife bore him 8 sons and 9 daughters. By 7 sons and 5 daughters were born to him 99 grand children, 188 great grand children and 5 great, great grand children. His whole number of descendents which had been born to him himself, and during his life to his family, amounted to 309.

At his funeral a sermon was preached from the words of the 14th chap., 12th and 13th verses of the Revelation of John: "Here is the patience of the saints," etc.

Funeral hymn: "My cares, troubles, and trials come with my time to an end," etc.

FIG. 23 Family record for John K. and Susanna (Stoltzfus) Lapp. Anonymous printer, Leacock Township, Lancaster County, Pennsylvania, circa 1903. Printed on cardboard, 14 in. × 11 in. Private collection.

John K. Lapp married Susanna Stoltzfus and they lived in Leacock Township, Lancaster County. The Lapps are documented by Hugh F. Gingerich and Rachel W. Kreider in *Amish and Amish Mennonite Genealogies*. Gingerich and Kreider show that Susanna died on March 8, 1900, while the family record shows a death date of March 8, 1903. Also, Lizzie, who was born and died on the same day, is shown on the register but absent in other records. Rebecca died in 1904, but her date of death is not shown on the register. Thus, this register was printed after Susanna's death in 1903 but before Rebecca's death the following year. Registers such as this one are useful for verifying data or challenging data that might be confirmed in other sources.

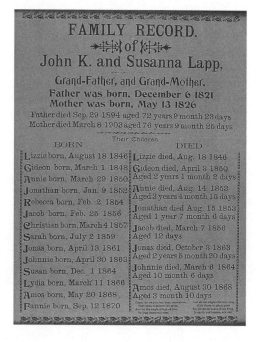

As witnessed by the Ottinger/Welsch register, printed broadside-type family registers are known for Lutheran and Reformed families. Most follow the two-generation pattern listing parents and children. Some take the form of narratives, however. For example, about 1846, the Heilmann family of North Annville Township in Lebanon County, Pennsylvania, had a family history printed as a single-sheet broadside. The only copy currently known is in the collection of Franklin and Marshall College in Lancaster. The anonymous author of the broadside attempted to list European ancestors—or at least a handful of men who shared the name Heilmann—as far back as the fifteenth century, but the actual focus of the register was Johann Adam Heilmann (1745–1827), son of immigrant Johann Adam Heilmann (1715–1770). Other single-sheet narratives include a "Historical Record" printed about 1904 for the Dunkelberger family (fig. 24). And descendants of Nicholas Wenger of Berks County had a similar register printed about 1906. Like the Christian Weber example from 1820, these narratives sometimes include additional and unexpected data that rarely appear on more typical two-generational registers. For example, information concerning immigration and even European origins might be included on these "Historical Records," but because they attempt to cover too much history about a family, the details on these overly ambitious accounts are usually sketchy.

The lingering question concerning family registers that were entirely machine printed is *why* they were printed. It must have been costly to have a family

The Wacht am Rhein Star Spangled Banner

1728 In God We Trust 1904

Dunkelbergers' Historical Record

The Dunkelbergers were industrious and patriotic citizens of what is now the kingdom of Wurttemberg, Germany. Tradition tells us that their name originated from Dunkel Berg, a spur of the Schwarzwald (Black Forest). Of their history little is known up to the Reformation. During that time they accepted the doctrines of the Reformers, and up to the present time most of them are members of the same denomination. During the Thirty Years' war they suffered severely, and welcomed with joy the appearance and aid of King Gustavus Adolphus, of Sweden. They did not have the desired religious liberty in Wurttemberg, and therefor their faces turned towards the Western world — America, and finally in the year 1728 started by way of the Palatinate (Rheinpfalz) down the Rhine to Holland, from where they sailed in the English ship Morehouse, and landed in Philadelphia August 28, 1728. From there they proceeded at once to what is now Berks County, locating a little Northwest of the present Borough of Hamburg Their names were Clement, Daniel, and John. Clement, the ancestor of the others, at once paid taxes to the English crown. Here they were frequently molested by the Indians.

John Dunkelberger, a grandson of Clement, was born near Hamburg in 1740, and in 1780 he, then a widower, with his son George moved to the lower part of Mahanoy Valley, Northumberland County, where he built the first stone grist mill and dwelling house. He married again and had two sons by his second wife, Solomon and Jonathan. His first son, George, married here in 1800, and soon after moved to Mahantongo Valley. He had four sons, Jacob, Samuel, Daniel, and John. His first son, Jacob, was born in 1802, and married in 1828 to Catharine Maurer, with whom he had nine children—Moses, William, Emanuel, Caroline, Lena, Hannah, Mary, and Salome. Jacob's first son, Moses, was born in 1829; in the year 1850 Jacob moved to Hegins Township, Schuylkill County, where he had bought a large farm and grist mill near the present town of Hegins. Here he died in 1874, and was buried in the Evangelical cemetery. His son Moses here married Elizabeth Bensinger in 1853. They are both living at present at their homestead in the town of Hegins. Their children are: R. B. Dunkelberger, a prominent business man of Reading, Pa.; Mary, wife John H. Schrope, a prosperous farmer of Hegins Township, and J. H. Dunkelberger, the writer of this article, at the homestead farm, with his two sons, Harry and Ray.

About 1780 another branch of the family at Hamburg moved to Perry County, Pa., and some of these later moved to near Niagara Falls, New York. One of these was a delegate to the Republican National Convention held in Philadelphia, when McKinley was nominated for President, for his second term. Another branch moved to Oley Township, near Reading, and at the present time quite a number live in the City of Reading. In language they are Pennsylvania German, and there are no citizens of our great nation more industrious and thrifty, more loyal and patriotic, or who have a greater love for liberty, than the Pennsylvania Germans. Therefore let us respect that language, and feel proud of our ancestors.

Their love for right and liberty was already manifested in Germany by their active part in the Thirty Years' war, and in this country when some fought for independence in the Revolutionary war. During the Civil war quite a number fought for the preservation of the Union, nearly all as volunteers. Some were killed in battle, whilst others were wounded, notably among the latter was Captain Isaac R. Dunkelberger, of the 1st Pa. Infantry, who enlisted April 20, 1861, and served during the war, was twice wounded, promoted for bravery and placed on the retired list by our Government in 1901 as Captain of Cavalry, U. S. Army. He resides at present in California, and is a grandson of John D., and son of Solomon Dunkelberger.

HEGINS, PA., MAY 15, 1904.

FIG. 24 Dunkelbergers' Historical Record. Anonymous printer, Schuylkill County, Pennsylvania, 1904. Printed on wove paper, 15 in. × 13 in. Private collection.

The Dunkelberger historical record proudly proclaims, "In language [the Dunkelbergers] are Pennsylvania German," suggesting that some members of the family spoke the Pennsylvania-German dialect. The fact that the register was printed in English, perhaps for a family reunion, implies that the majority of early-twentieth-century Dunkelbergers spoke, wrote, and read English.

register typeset only to run off a handful of copies for family members. True, the Weber/Ruth registers mention 309 descendants of Christian Weber. Obviously, to produce more than three hundred copies by hand, assuming that all the family members were alive and wanted one, would have been a daunting task. On the other hand, even if every family member were to receive a copy, 309 is a short

print run. Given that several copies of the German-language Weber/Ruth register survive, there may have been as many as 309 copies printed. But the question remains—why?

It could be, as Colket suggested, that Pennsylvania Germans thought printed registers more attractive than hand-drawn registers, which were subject to ink stains or a slip of the pen. More likely, families thought that printed registers provided a permanent record. They probably viewed machine printing as technologically superior to pen-and-ink and watercolor manuscripts made by local schoolmasters or itinerant scriveners. Thus, they hoped future generations might place higher value on a printed family register, just as they would a printed book.

Unfortunately, they may have guessed wrong. Entirely printed registers often—though not always—lacked colorful decoration. Usually, their decoration consisted only of ornamental border pieces or decorative lettering, such as fraktur typefaces. As decades passed, many fraktur were discarded, but the more colorful and decorative they were, the more families were inclined to appreciate and save them. For example, it might have been the hand decoration on an otherwise plain register printed for the Ernst/Rohrbaugh family of York County that saved the register (color plate 18). Printed about 1820, this register was hand-decorated by fraktur artist Daniel Peterman (1797–1871).

During the second half of the twentieth century, appreciation of fraktur among folk art collectors and admirers soared. Unfortunately, the plain, printed family register often suffered a lack of interest and a subsequent tragic end. Stopp's six-volume work on printed birth and baptism certificates, however, alerted the marketplace to just how rare printed Pennsylvania-German broadside-type materials are. Until Stopp's publication, colorfully decorated freehand fraktur captured most attention, even though some of the earliest and rarest family registers were printed examples. Thus, Stopp influenced the marketplace, which subsequently rescued printed family registers that might otherwise have been discarded.

Freehand Broadside-type Family Registers

Some of the earliest Pennsylvania-German family registers were drawn by hand and decorated with watercolor. Many were made by people who are today considered major fraktur artists. As noted above, most eighteenth-century fraktur artists were local German-speaking schoolmasters. The schoolmaster had the accomplished hand and the materials for drawing and decorating the register. Because schoolmasters received low wages, they often supplemented their incomes by drawing fraktur or infilling preprinted certificates. Many early and prolific artists made mostly *Taufscheine*. Apparently there was less of a market for family registers, except among Mennonites. For example, artists Daniel Schumacher, Johann Henrich Otto (circa 1733–1799), and Martin Brechall

(circa 1757–1831) drew numerous *Taufscheine*, but no family registers by their pens are known. Yet Schumacher experimented with many types of fraktur, including *Taufscheine*, marriage records, and confirmation certificates.

There were exceptions, of course. Johan Friederich Krebs was the most prolific of all fraktur artists, and he, too, made a variety of fraktur, including freehand, broadside-type family registers. Still, as seen by the index to his works in *Papers for Birth Dayes*, family registers constituted less than 1 percent of his fraktur. Thus, during Krebs's lifetime, the market for family registers was probably small.[52]

Schoolmasters who made fraktur in Mennonite communities had better luck finding acceptance for family registers. For example, Christian Strenge taught in a Mennonite community in East Hempfield Township, Lancaster County. As seen in *Papers for Birth Dayes*, more than 8 percent of his recorded works were family registers.[53] Strenge made registers for the Basslers, Ruths, Stemens, Beckers, Maurers, Gottschalls, and Kauffmanns; still others may remain undocumented (see color plate 16).[54]

One of the earliest artists to make freehand family registers was Hans Jacob Brubacher, a Lancaster County Mennonite schoolmaster. His fraktur date from 1751, yet broadside-type family registers penned by him that early are unknown. His earliest known freehand register was drawn about 1784 for the Feuth/Ansspacher [Anspacher] family. To our knowledge, this is the earliest surviving freehand, broadside-type family register made by a major fraktur artist (color plate 19). It would come as no surprise if earlier examples become known, but at present, this is the earliest example of its kind.

At times, it is difficult to determine if a freehand register was originally fashioned as a broadside-type register. Some that *appear* to be broadsides were actually written on the blank pages of Bibles or other books. They have since been removed from their books, creating the appearance that they were originally designed as single sheets with data recorded on one side.[55] The previously mentioned Franz/Miller register, for example, may have been written on a blank page of a Bible (see fig. 4). The Brubacher example made about 1784 for the Feuth/Ansspacher family, however, appears to have been created as a broadside.

Other examples of freehand, broadside-type registers are characterized as "early," but they were actually made long after the dates appearing on them. For example, fraktur artist Daniel Peterman made a family register for his own family (color plate 20). On it, he mentioned that he was born in 1797 and that his wife, Maria Altland, was born in 1799. He then lists his date of marriage and the children born; the last of the Peterman children was born in 1835. Daniel Peterman's working dates for having made fraktur are about 1819 through 1864. Certainly the date of 1835 fits within that time frame, but it is risky to suggest the register was made in 1835, for it might have been made years later. In fact, there was often a delay in making freehand, broadside-type registers.

Families often waited until they were reasonably certain that the last child had been born before having this type of register made.

Brubacher's 1784 register for the Feuth/Ansspacher family illustrates the problem of not waiting. Made for Petter [Peter] and Magdalena (Ansspacher) Feuth, Brubacher wrote the first five entries about 1784. As the Feuths added children to their family, Brubacher added data in separate blocks until the last child, Johannes, was born on March 29, 1797. Lack of sufficient space prohibited Brubacher from placing a border around Johannes's entry (see color plate 19).

Brubacher may have been acquainted with the 1763 Bollinger example printed at Ephrata, for his family registers have a similar appearance, even though they are hand-drawn. Like the Bollinger piece, Brubacher divided entries, placing them in bordered sections. The printed Bollinger register of 1763 is horizontally oriented and printed in two columns. Brubacher's register for the Feuth family is vertically oriented and penned in one column, but Brubacher made a register about 1799 for the Gochnauer/Herr family that was horizontally oriented and penned in two columns. Brubacher drew horizontally and vertically oriented fraktur of other types, and he almost always divided pages into small copy blocks, so it could be that he never saw a copy of the Bollinger register but simply used a style that was comfortable to him.

Until the first decades of the nineteenth century, freehand broadside-type registers had no established format. If the certificate was decorated, decorative elements were often minimal, consisting primarily of simple renditions of flowers and vines to form borders. Entries recording names and dates of births were often written in single or double columns. The names of parents were sometimes absent on early registers. This suggests that registers were created simply to list the family's children. Some fail to give the family surname—a critical oversight, to say the least. Often, data for the births of additional children were added by a different hand, as was true of death dates.

The formats of freehand certificates dating after approximately 1825 were often copied from preprinted registers that provided multiple vertical columns for handwritten data. Thus, there were separate columns for family names and dates of marriages, births, and deaths. Luckily, some scriveners added information beyond column headings. Thus, locations, dates of baptism and confirmation, and names of preachers were often included. In some examples, the date of burial, place of internment, and funeral text were added.

A freehand register made for the Sechler/Kistler/Oswald family of Lehigh and Schuylkill Counties, Pennsylvania, is unusually complete (color plate 21). Made by John Bouer [Bower] (active circa 1832–60), this large, horizontally oriented register has eleven columns that allow space for names, dates of birth, locations of birth, baptism data, names of sponsors at baptism, dates of confirmation, names of ministers who confirmed the children, dates of marriage, names of ministers who performed the marriages, dates of death, and information con-

cerning burial. This ambitious register tells us many things. For example, it helps us understand when registers were made. In the case of the Sechler family, no additional children are recorded following the last child, who was born in 1859. That is, only writing attributed to the hand that began the register—in this case, John Bouer—is apparent. Most broadside-type family registers appear to have been made after the last child had been born (or at least after the family *thought* that the last child had been born). Such is not the case of registers bound into Bibles, where data could be added easily for many years to come.

The Sechler/Kistler/Oswald register illustrates that no matter how complete a register is, it can create confusion. According to this register, Elias Sechler married Magdalena Kistler on Christmas Day in 1841. Elias and Magdalena had six children. No dates are provided for the sixth child, Elias. Several months *prior to* Magdalena's death on October 10, 1853—at least according to the register— Elias Sechler married Sawina Oswald. Elias and Sawina married on February 2, 1853. They had four children, the first of whom was born on April 13, 1854, or six months after Magdalena died. No explanation clears up the discrepancy in dates.

John Bouer made the Sechler/Kistler/Oswald register on oversized paper, perhaps to accommodate the unusually complete information recorded on it. More typical in size and data is the freehand Spengler/Christ register made by fraktur artist Adam Wuertz (active circa 1813–36), who worked in York County (color plate 22). This register raises hopes for descendants of this family, for Wuertz included a column called "Birthplace" *(Geburts-Ort)*. The only location he lists for births of the nine Spengler children, however, is York County. June Burk Lloyd was able to find this family in Paradise Township.[56]

Some early family registers were hybrid birth and marriage or birth, marriage, and death records. The highly unusual Maily/Herr fraktur mentioned in Chapter 3 fits into this category. Made for a Maily family of Mennonites in Lampeter Township, Lancaster County, the Maily/Herr record may have stopped with the 1796 marriage mentioned on it, because Martin Maily and his wife had no children (see color plate 10). Martin Maily (1765–1845) was the son of Johannes and Veronica (Eschelman) Maily of Lampeter Township. On April 12, 1796, he married Elisabeth Herr, daughter of Christian and Anna (Bärr) Herr. Martin Maily was known among his friends and neighbors as "Smith Martin," for he was a blacksmith. There are many Mailys named Martin in the early history of Lancaster County, including "Valley Martin," "Little Martin," and Smith Martin. Several Mailys were reportedly blacksmiths. In fact, one Martin Meylin (circa 1670–1749) was said to have made the first Pennsylvania long rifle—the so-called Kentucky rifle—although this piece of history has been disputed.[57]

Smith Martin is believed to be the great-grandson of "gunmaker" Martin Meylin. Smith Martin's father, Johannes (1739–1823)—or Hans, as he is called in many records—was the eldest son of the second Martin Meylin (1715–1751), son of "gunmaker" Martin Meylin. Hans inherited the Martin Meylin gunshop

property, which he then willed to his son, Smith Martin. Smith Martin in turn willed the gunshop property to his brother, Jacob (1774–1857),[58] as Smith Martin had no children.

One of the most important elements about this fraktur, besides its genealogical information, is the drawing of the blacksmith tools at the top. This rare motif provides a visual clue that helps identify Smith Martin, so that he is not confused with his contemporaries having the same name. Apparently, this drawing of blacksmith tools was not regarded as prideful among Maily's Mennonite neighbors, for surely Smith Martin would have been sensitive to anything prideful. It was his grandfather, Martin Meylin (1715–1751), who had built the "Palace of Sandstone" about 1740. This structure became one of the most stately mansions in the area, and Martin Meylin was criticized among his Mennonite friends and neighbors—plain people, as they are called—for its being "too palace-like."[59]

As discussed in Chapter 3, it is risky to read too much meaning into fraktur motifs. A family register made for the Christian and Barbara (Meÿli) Kindig family has a chandelier at the top (see color plate 17). The fraktur artist who made this register was Friedrich Leonhard, formerly known as the Chandelier Artist. Aside from the Kindig/Meÿli register, Leonhard made other fraktur having chandeliers, a motif he greatly favored. This does not mean that all families with chandeliers on their fraktur manufactured lighting.

One problem artists encountered when designing freehand family registers was managing space so that additional information could be added, if necessary. For example, Karl Friedrich Theodor Seybold created a freehand register for the Metzger/Huber family of Lancaster County (color plate 23). He carefully arranged his composition with rectangular text blocks in the top half of his horizontally oriented page. In these text blocks, he placed data about George Metzger on the left and his wife, Maria Huber, on the right. He separated these two blocks with information about their marriage. He then drew eight circles in the lower half of the page in which he placed information concerning the eight Metzger children, born between 1824 and 1841. The last date in Seybold's hand was 1842, when he recorded the death of Abraham H. Metzger, the seventh child. Thus, the certificate was made probably about 1842. Had another child been born after 1842, the Metzgers would have destroyed the symmetry so meticulously engineered by Seybold.

On some freehand family registers, additional information disfigured the artist's original design. Fraktur artist Andreas Victor Kessler (active circa 1791–1821) created a freehand family register in vertical format for the Benjamin Mellinger family of Manor Township, Lancaster County. A child was born to this family after Kessler carefully laid out the family data. Information about the additional child had to be squeezed in at the bottom.[60] Kessler had better luck with a register he made for the Dietrich/Hersch family of Lampeter Township, Lancaster County. Kessler seemed fairly confident that Heinrich and Sophia

(Hersch) Dietrich's family was complete with seven children, for he decorated the bottom of his page with folky lions (see color plate 9).

Another family register is known for which the problem of an added (probably unexpected) child was solved in another way. The summer 1968 issue of *Pennsylvania Folklife* pictures a family register that begins with the marriage of John and Elisabeth (Kindig) Meylin of Lancaster County (color plate 24).[61] It gives the dates of birth of the parents. John Meylin, son of Jacob and Elisabeth Meylin, was born in 1804, and Elisabeth Kindig, daughter of Christian and Barbara Kindig, was born in 1806. John and Elisabeth (Kindig) Meylin had one son, Amos, born in 1829. Apparently, he was their only child—until 1831. In 1831, Isaac was born to John and Elisabeth, who had already had their family register made. There was no space to add Isaac's data, so fraktur artist Eli Haverstick (active circa 1829–37) improvised by recording information about Isaac's birth on a small piece of paper that was framed by itself. Fortunately, Isaac's separate little footnote to this family register has not become lost.[62]

Conversely, space was often left on family registers for listing children who apparently never came to be. The Free Library of Philadelphia has one example: a register made for the Landes/Fretz family of Bucks County. The area left for a list of children remains blank to this day.[63] In another instance, ample space was provided to record the children of Isaac and Anna M. (Pierce) Esbenshade (color plate 25). This couple had three children listed on their large, vertically oriented freehand register. The last child was born in 1927, but more children might have been expected, for space remained below the data for this child. David C. Hoke (1869–1938), a twentieth-century fraktur artist who worked among Amish and Mennonite communities in northern Lancaster County, cleverly filled this unused space with two facing birds.[64]

With the availability of printed certificates in the nineteenth century, numbers of freehand examples gradually decreased. They were still being made into the twentieth century, however. August Baumann made twentieth-century freehand registers, such as the previously mentioned example he penned in 1905 for the Roberts/Weidner family of Lehigh County (see color plate 15). David C. Hoke produced most of his works in the first decades of the twentieth century. By the third quarter of the nineteenth century, the Amish had established a fraktur tradition, and family registers were an important element of that tradition. Family registers were often drawn by hand both by Amish artists and by non-Amish who worked in the local Amish community. The practice continues to this day. Amish Bishop John F. Glick (born 1912), whose family registers resemble those of David C. Hoke, still makes freehand family registers as well as other fraktur for Amish families (color plate 26). And young Amish women are being taught fraktur drawing and decorative techniques for making family registers.[65]

Artists outside the Amish community make fraktur today, and they often create family registers. Frequently referred to as "commercial artists," most of these artists produce English-language family records written in decorative penman-

ship. The term "commercial artists" is misleading, for the majority of fraktur activity was a commercial endeavor. Throughout the history of fraktur, schoolmasters charged for freehand fraktur and for decorating and completing printed forms. Printers charged to print *Taufscheine*, family registers, and other fraktur, and nineteenth- and twentieth-century scriveners charged to complete printed forms and infill Bible registers. Today's commercial artists keep alive the fraktur tradition and, in the sense that they record personal and family data, they keep alive the spirit of fraktur.

Preprinted Broadside-type Family Registers with Added, Handwritten Infill

The first preprinted broadside-type family registers with handwritten infill made for the German-speaking market in America were printed in 1808 by Ambrose Henkel (1786–1870) in New Market, Virginia.[66] Henkel's registers were available in German and English.[67] He used woodcuts to form the "Seven Ages of Man," images that surrounded columns in which the scrivener could include extensive data for the children (fig. 25). Henkel printed these registers in royal folio and marketed them locally. He printed family registers that were part *Taufscheine*—a curious and rather complex combination not used by other printers.

Some evidence shows that printers made family registers in limited numbers in the 1830s or 1840s, but they used type, border, and head- and tailpieces readily available to numerous printers of this period. Lacking an imprint, these registers can be extremely difficult to attribute to a particular printer. By 1837, lithographers were found in virtually every major city.[68] Thus, the middle of the century saw family registers for sale in printshops and bookstores in most German American communities throughout the country.

Preprinted registers were usually not as complex as those printed by Ambrose Henkel. As the nineteenth century progressed, however, the engraver increasingly added more detailed scenes to the certificate. Pictorial engravings and lithographs ranged from images of happy couples and children to ponderously religious scenes. The Victorians were known for their material extravagance, and this was reflected in their taste in printing. Blank areas that could have been decorated freehand gave way to elaborately engraved impressions that were hand tinted or machine colored.

Notably, the nineteenth-century German printers who made *Taufscheine* by the thousands—in particular, those using angel motifs that flanked the main text—seem not to have printed family registers. This is curious, as most of these printers published various other broadside-type materials, such as house blessings, spiritual mazes, and Adam and Eves. By the time preprinted registers became popular among Pennsylvania Germans, printers in New York and the Midwest already dominated the market. This may be the primary reason that German printers such as Johannes Ritter (1779–1851) in Reading and G. S.

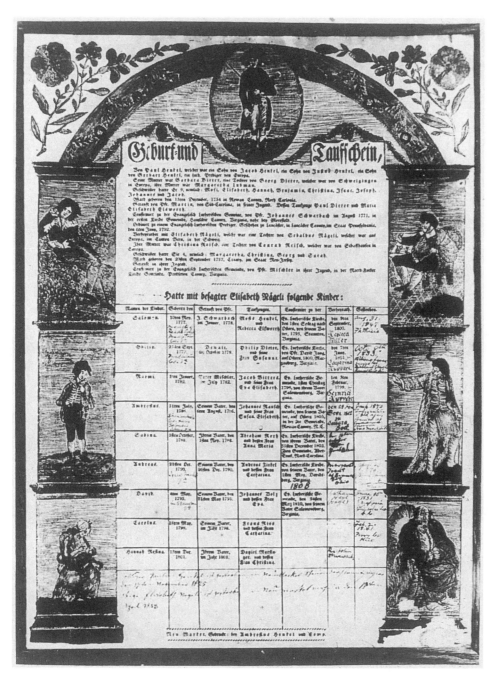

FIG. 25 Family register for Paul and Elisabeth Henkel. Printed by Ambrosius Henkel, New Market, Virginia, 1810. Printed on wove paper, 22 in. × 17½ in. Courtesy Roddy and Sally Moore.

This multi-generation *Taufschein*/family register represents the most complex example of its kind. The Henkels established a printing dynasty in the Shenandoah Valley. Beginning with Ambrosius [Ambrose] Henkel (1786–1870) in 1806, the Henkel Press was successful into the twentieth century. By 1808, the Henkels were printing in English as well as German.

Copies of this *Taufschein*/family register were printed only from 1808 to 1811. It was probably too complicated to be commercially successful. On this example, familial data until 1810 were typeset. Manuscript entries were made until 1870, the year Ambrosius died.

Peters (1793–1847) in Harrisburg, Pennsylvania, avoided participating in the register market. Additionally, Bibles having preprinted registers were readily available. Again, it was much easier to add who had been born, had married, or had died in a book—as opposed to taking a certificate off the wall, unframing it, making additions, and then reassembling and rehanging the piece.

As was true of *Taufscheine,* the earliest preprinted registers were decorated and infilled by German-speaking schoolmasters such as Daniel Peterman (see color plate 11) and later by the same professional scriveners who completed printed *Taufscheine.* This practice apparently began in Pennsylvania in the second quarter of the nineteenth century. Evidence suggests that schoolmasters were paid by the job—that is, for decorating and infilling the entire certificate. Later scriveners were paid as much as ten or fifteen cents per word or per phrase. In early America, cash was not easily parted with, and a register, like the infill in Bibles, required many words. But clearly, many family registers, even those requiring considerable text, were written in fancy penmanship and/or colorfully decorated, framed, and hung.

Having a register written in beautiful fraktur lettering (and later, Spencerian or calligraphic writing) must have been important to the family—not only to enjoy on a personal level but also to transform the record into a cherished and enduring keepsake. Parents were proud to show the births of their children, and they wanted the certificate written in the finest hand of their day, not the simple unadorned script of a family member. For example, scrivener Gottlieb Schmid (active circa 1845–63) used a German-language preprinted form made by an unknown printer for the Unger/Roth family of Berks County. The last date attributed to Schmid's hand was 1861. Later family events were recorded by others, such as the death date of October 2, 1897, for the mother of this family (color plate 27). Most preprinted registers were printed in English, but Pennsylvania Germans frequently wrote data in German on these English-language forms (color plate 28). Considerable evidence in the field of fraktur demonstrates that Pennsylvania Germans remained comfortable writing German on personal documents until the end of the nineteenth century.

Preprinted family registers had an advantage over handwritten examples. Column headings served as reminders for recording pertinent data. Almost without exception, the date of a child's birth was known, but the date of baptism was often forgotten and remained blank.[69] Unfortunately, printers seldom included columns for location. For example, the Altland/Streher register, decorated and partially infilled by Daniel Peterman, gives no location (see color plate 11). The anonymous printer of the Altland/Streher register may have been familiar with registers from the Henkel Press, for the Ages of Man motifs appear on this print. Two copies of the print are known and both record data for families from York County.

The best-known and most commercially successful printer of preprinted broadside family registers was Nathaniel Currier (1813–1888), who joined in

partnership with James Merritt Ives (1824–1895) in 1857. Currier and Ives printed registers in German and English. By far, most were English-language certificates. The copyright date on the first known German edition, printed by Nathaniel Currier, was 1846 (color plate 29), followed by an 1869 edition.[70] Currier certificates included four columns: names, dates of birth, dates of marriage, and dates of death. Pillars separated the columns, and each section was topped by a relevant family scene, such as doting parents with a child. This format was commonly used throughout the nineteenth century and into the twentieth. But there were other printers, albeit less well known, of these certificates. By 1850, broadside-type preprinted family registers were popular across America, regardless of communities' ethnic origin or religious denomination. And eager printers and lithographers, ready to tap this market, made their preprinted certificates available by the thousands.[71]

As Barnhill has pointed out, the population was expanding rapidly by 1850, as were road, railway, canal, and steamboat systems that could move commerce to most parts of the country.[72] Concurrently, mass-produced certificates became so heavily machine decorated that the only role for the professional scrivener or family member was to fill in the names, dates of marriage, births of children, and dates of death. The hand-drawn coffin, stark black crosses, weeping willows, and birds and flowers of no known species were gone. And spontaneity was gone. The engravers provided detailed, lifelike scenes and people and structures. Americans of all religious persuasions, geographical regions, and racial and ethnic backgrounds participated in recording family data on preprinted forms made available to them through expanded commerce. Lacking fraktur lettering and imaginative watercolor decoration, the Germanic character of the earlier broadside register all but disappeared—swallowed up by the rapid spread of the English language, expanding settlement, and changes in decorative tastes.

Preprinted Family Registers Bound into Bibles

Most commonly, family registers were bound between the Old and New Testaments in Bibles. In general, these Bibles are referred to as "family" Bibles and are marketed as such to this day. Less expensive Bibles, such as those found in motels or given away without cost, usually have no family register but may have a short section for writing notes at the back.

There are several reasons that Bible-entry registers are more common than other types. As previously mentioned, the Bible was the most important book American families owned, and many felt that their family records would be safe there. More than 80 percent of Pennsylvania-German families were Lutheran and Reformed.[73] Members of these denominations preferred Bible-entry registers over other registers. Bible-entry registers made for Lutheran and Reformed families dramatically swelled the numbers of this type of register, which was also

popular among Mennonites, Amish, and others. Consequently, Bible registers became the most numerically significant of the six categories of family registers.

Also, after about 1875, urban dwellers constituted a significant population favoring Bible-entry registers. Several scriveners associated with fraktur served this market. For example, William Henning (1822–1895) worked in the city of Lancaster. According to Josh Reeder in "William Henning, Fraktur Scrivener," Henning worked at several locations within the city. He often signed his registers and wrote his current address beneath his signature. Reeder discovered that Henning's various addresses included hotels and taverns. Henning made numerous Bible-entry registers in an amazingly beautiful handwriting: it is so sharp and clear that it has, at times, been taken for printed lettering (fig. 26).[74]

Thousands of Bible-entry registers survive—and for several reasons. Registers recorded in Bibles were generally of a later date than broadside-type registers. Naturally, the earlier the document, the less likely it remains with us—especially a broadside-type document. Though people saved books, they frequently discarded single sheets, especially when they could no longer read them because they were written in German. Besides being protected better in Bibles, many nineteenth- and twentieth-century Bible-entry registers were written in English. Thus, the family recognized names and preserved these records because they appeared relevant.

In 1805, Gottlob Jungmann of Reading, Pennsylvania, printed the first *"Fam-*

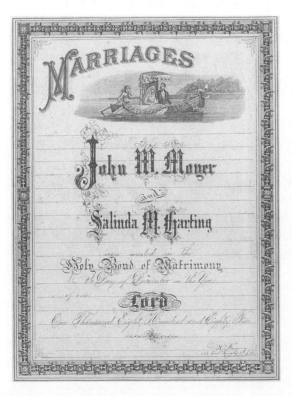

FIG. 26 Page from family register for John W. and Salinda M. (Harting) Moyer. Signed W. Henning, 333 East King Street, Lancaster. Printed and hand-lettered on wove paper, 11½ in. × 9 in. Preprinted insert removed from Bible. Private collection.

All writing below the headline "Marriages" was penned by William Henning about 1885. According to Josh Reeder, the address of 333 East King Street in Lancaster was the address of a public house known as the "German Tavern" and, during the late 1800s, the "General Taylor."

ilien-Verzeichniß" in a Bible made for the Pennsylvania-German market. The Jungmann register consisted of four pages of double columns bound between the Old and New Testaments. Columns included *Heyrathen [Heiraten]* (marriages), a second page of *Heyrathen, Geburten* (births), and *Todesfälle* (deaths). By 1828, the popular Kimber and Sharpless Bibles printed in Philadelphia greatly expanded the availability of the Bible-entry family register. By the 1840s, family registers were found in Bibles printed for German and English readers across America.

Significantly, American Bible printers led the way in printing German-language family register inserts.[75] Prior to the mid-nineteenth century, Bibles printed in German-speaking Europe lacked preprinted family registers. Several reasons have been suggested for their absence. In Europe, there was no separation of church and state. In fact, during the centuries of feudalism, the church often became the record keeper for the state. Because the church kept records, there was no need for repetition. Additionally, many European ancestors of Pennsylvania Germans would have been uncomfortable with records. Among religious denominations that were not sanctioned by the state, records could become dangerous. In fact, written records could jeopardize your life if you were Anabaptist, such as Mennonite or Amish. A history of reliance on oral tradition as well as the time and materials (and expense) required to record personal data might be further reasons. And, possibly, the common person considered it presumptive to keep records as if his family rubbed shoulders with nobility. Perhaps all of the preceding played a part in German-speaking Europe's delay in embracing the Bible as a vault in which to preserve treasured personal history.

Some nineteenth-century preprinted family registers bound into Bibles were made by the printer of the Bible and simply run off like other pages. Others were lithographed, often in color—a technology not available to all Bible publishers and printshops. These printers had others print decorative registers and then added them to the Bible between the Old and New Testaments prior to binding. The paper stock and typefaces on these additions often differ from the balance of the book, as do decorative borders and, of course, the use of color. Some are not even printed on a uniform size of paper. When Bibles lacked bound-in family registers, some nineteenth-century families glued, pinned, or even sewed preprinted or handwritten registers into them.

In some instances, families re-bound their old, probably tattered Bibles with a preprinted family register fastened inside. For example, the Gorg [George] and Susanna (Friedrich) Schulz family of Goshenhoppen in Bucks County had a family Bible that had been printed in Basel, Switzerland, in 1720. Undoubtedly, this Bible saw hard use over the years, so the family had it re-bound about 1856. When they did, they had a broadside-type preprinted register bound between the Old and New Testaments. The printer of this register is unknown, but it was infilled by professional penman Martin Wetzler (active circa 1854–88), who dated it 1856.[76]

Preprinted Bible registers consisted of multiple pages with space for names and dates of parents; names and dates for births; names and dates for marriages; and dates of death. Many preprinted Bible registers are plain in design, with a simple border. For example, the Fenstermacher/Zimmerman register has a plain border (color plate 30). Because professional scriveners such as Ferdinand Klenk (active circa 1855–82) charged ten to fifteen cents per word or phrase, the cost of making Bible-entry registers could be steep.[77] Consequently, some entries were written in plain hands, probably by family members. For example, a four-page Bible register made for Jonathan and Sarah (Gingrich) Epler of Lebanon County demonstrates that professional scriveners, including Klenk, made some entries in highly skilled writing (color plate 31). Sometimes these entries alternate with plain handwriting. The plainer hands suggest that family members either decided to record information themselves as events took place or that they took cost-cutting measures to record data rather than pay a scrivener. That said, many notes are found tucked into Bibles having information later recorded in the Bible register by professional scriveners. Thus, some families were willing to wait and then pay scriveners so they could avoid disfiguring the register with poor hand-writing.

The Epler/Gingrich register begins with Jonathan and Sarah Epler, but it continues with information about the Samuel S. and Mary A. Miller family of Dauphin County. Mary A. Miller (1843–1902), whose name is also written "Maria" in this record, was the fourth and last child of Jonathan and Sarah Epler. She and Samuel S. Miller (1843–1892) had four children, whose birth records in the Bible were written in various hands. Inexplicably, this record also mentions people having other surnames, including Heistand, Shirk, Plank, and Myers. These people were probably relatives, but no details provide clear indications of family relationships. The four-page to eight-page formats of Bible-entry registers provided ample space for data, and they were thus well suited for recording and later updating detailed information—but even so, this information sometimes remains unclear.

Bible-entry registers reveal instances of children conceived prior to marriage. Gloria Allen examined 131 textile and manuscript registers and found that children were conceived out of wedlock in approximately 30 percent of families prior to 1800 and about 20 percent between 1800 and 1850.[78] New England examples constituted 75 percent of Allen's sample. The other 25 percent came from the mid-Atlantic states and Ohio. A sampling of 118 eighteenth- and nineteenth-century Pennsylvania-German registers listed in the first three volumes of *German-American Family Records in the Fraktur Tradition* showed roughly the same figures. Thirty-six instances, or about 30 percent, of families of Pennsylvania-German heritage appear to have been unwed at the conception of their first child—or they had premature babies. This same sample included three instances of children born out of wedlock.[79] Dates of parents' marriage and the fast-approaching birth of their first child were generally recorded without comment.

By the mid-nineteenth century, the Bible-bound register became multi-page and increasingly elaborate as the engraver took over all aspects of decoration. Ordinarily, the fanciest printed page was the first page of the register. It was dedicated to the marriage of the parents. The second and third pages were for births, and the last page was for deaths. This formula was not followed by all printers, for there are numerous variations. As with the Epler/Gingrich register, scriveners often added decoration to plain pages having only a simple printed border. Scrivener Henry S. Eisenhuth (1830–1897) drew grapevines to decorate Bible records. Joseph H. McGlaughlin (1867–1942) added colorful "ribbon candy" borders on his Bible registers (color plate 32). Others drew caskets, gravestones, and weeping willows to decorate pages having to do with death. August Baumann's Bible-entry registers often show hand-drawn portraits, supposedly of family members (color plate 33).

Occasionally, the preprinted register bound into a Bible has the problem associated with freehand examples—a lack of space. Examples are known where there were not enough lines to enter the births of all the children. Additional children had their names recorded on slips of paper that were attached to the register by a straight pin. This practice may have been a holdover from the days when the family would note on a small slip of paper the birth of a child, tuck it for safekeeping in the Bible, and then await the arrival of professional penmen to record the data on the fixed pages of the Bible register. These Bibles often contain the handwriting of several itinerant scriveners (color plates 34 and 35).

Though Lutheran and Reformed families seemed less interested than Mennonites in broadside-type registers, they embraced Bible-entry family registers to an equal extent. The favored use of Bible-entry registers probably coincided with general, nationwide acceptance of this type of register among other ethnic groups. Yet even before this type of register became dominant, families were already recording data on blank pages in Bibles.

Freehand Family Registers Written on Blank Pages of Bibles

"For hundreds of years people have been entering on blank Bible leaves records of weddings, births and deaths," noted Margaret T. Hills in 1961.[80] Hills was addressing English-language Bibles. At least in German-language Bibles, the evidence does not support this conclusion. In fact, when Hills wrote this statement, her assumption might have been an exaggeration for English-language Bibles as well. Until the Reformation of the sixteenth century, most families did not own Bibles, which were generally printed in Latin and owned by clergy. Following the Reformation, Bibles were increasingly printed in the vernacular so that everyone could read them. But these Bibles were expensive, and not all households owned them. The same may have been true in English-language areas of Europe and America. Studies of probate inventories from seventeenth-century

New England suggest that in some areas, 60 percent of households owned Bibles, but in other areas, this number dropped to 30 percent.[81]

In colonial America, people of German heritage probably fared better than their English neighbors when it came to owning Bibles. English-language Bibles were not readily available in America, for they had to be imported. To protect British printers and publishers, the Crown effectively discouraged English-language Bibles being printed here. Thus, although New England aggressively promoted literacy and the reading of scripture, the percentage of Pennsylvania-German colonial households owning Bibles might actually have been higher than in New England, for German-language Bibles *were* printed in America prior to the Revolution. In fact, three editions of German-language Bibles were printed in colonial America. Christopher Saur I (1695–1758) of Germantown, near Philadelphia, printed an edition in 1743. His son, Christopher Saur II, printed two more—in 1763 and 1776. In an effort to place a Bible in every German-speaking household, the Saurs were willing to give Bibles to the poor at no charge. (Saur detractors concerned about the elder Saur's version of the Bible wanted *their* versions made available as well.[82])

There is evidence that even before the Saurs, as early as the 1720s, German Bibles were being distributed in America. The *Lebenslauf* of John Nicholas Schaefer, who was born March 7, 1722, in Weisersdorf in Schoharie County, New York, mentions the distribution of German-language Bibles there. The pastor who baptized Schaefer was Bernhart von Düren, who had "attended the University at Halle." Schaefer, whose family moved to the Tulpehocken area of Berks County when he was two, wrote in his *Lebenslauf* that Bernhart von Düren "received many Bibles sent out from Halle, which he parceled out among his congregation and good friends."[83] With numerous German-language Bibles available in America, the price of these Bibles dropped significantly, causing them to become even more widely disseminated.[84]

Genealogical records were undoubtedly penned in family Bibles in Europe, but only further research can determine whether that practice was widespread and just when it began. As they broke with the Catholic Church during the Reformation, Protestant families learned to read and write so that they could read the Bible without the assistance of clergy. These families were eager to acquire their own Bibles, which were printed in the German vernacular as early as 1466.[85] As a consequence, Protestant families became particular candidates for recording data in family-owned Bibles.

Nevertheless, until about the seventeenth century, few families could afford Bibles. Printers became keenly aware of a growing market for Bibles, but they were faced with a host of problems when it came to producing them. One problem involved targeting a viable market during a period of increasingly fractured and complex religious turmoil. To take on a project as large and costly as typesetting and printing a Bible, printers wanted their versions to be accepted widely and marketable. But Bibles printed in the vernacular had to be translated. De-

bates about translating from Latin, or from the original Greek and Hebrew versions, became contentious. Translators' credentials, accuracy, and bias raised other issues. Nevertheless, printers recognized a growing and lucrative market, and by the seventeenth century, more affordable Bibles printed in the vernacular became available.[86]

To our knowledge, no thorough assessment has been made of early German-language Bibles in Europe to determine if they included family registers, to what extent they included family registers, and when and where this tradition might have started. In all probability, such records, if they exist in significant numbers, probably appear in Bibles distributed among Protestant families. Most early German-language Bibles we have examined have no family registers at all. When family records are penned into early European Bibles, they often begin with dates from the second half of the seventeenth century. But, typically, these start with "chain-of-ownership" records rather than with actual family registers.

Chain-of-ownership bookplates showing numerous owners were popular in Europe, and many mistake them for family registers. Chain-of-ownership records may be the precursors of family registers, for many owners were undoubtedly related. It is difficult to be certain of family relationships in chain-of-ownership bookplates, though. For example, if a Bible passed from a man to a woman having a different surname, the family historian might guess that she was his married daughter, but the historian cannot be certain without verifying the information from other sources. Nevertheless, even though information is minimal, it has value and may exist nowhere else.

As Bibles became widely available, families recorded their histories in them, but this trend did not seem popular in America until after the Revolution, and especially after 1800. Prior to that, Pennsylvania Germans favored single-owner bookplates. This was not always true, of course, for books did change hands and some owners placed their names on flyleaves in a chain-of-ownership fashion, or they created a second bookplate in the book. Some of those bookplates record limited and rather sketchy biographical data, usually about the book's owner. Overall, these single-owner bookplates—many of which are works of art—are unlike the chain-of-ownership bookplates that list owners over many decades.

Of course, many families brought Bibles with them from Europe. For example, unlike many other Bibles, a Bible printed in Zurich by Christoph Froschauer was acceptable among Mennonites. Printed between 1524 and 1589, there are many editions of the Froschauer Bible, some of which are quite rare.[87] According to Urs B. Leu, deputy head of the Old and Rare Book Department of the Central Library of Zurich, numerous Froschauer Bibles made their way to America.[88] Many have family registers recorded on blank flyleaves, and some of the registers were started in Europe. Most of these registers, however, were written on *this* side of the Atlantic, and most concern family history here.

Registers in a Longenecker family Bible illustrate this point. The most complete register in this Bible was written for the Christian Longenecker family of

Rapho Township, Lancaster County. The register begins with the date Christian Longenecker was born. Water staining makes the month difficult to read, but the date of Christian Longenecker's birth was likely November 11, 1731. The Bible was printed in 1770 in Nürnberg. Thus, the record, which was written on blank pages bound into the Bible, could not have been started before 1770. Moreover, the last date in the hand of the person who began the record appears to be 1795, so the register was likely written then. As was typical of such registers, no location was given, but family historian Richard Cryer published the will of Hans Longenacker [*sic*] in the November/December 1999 issue of the *Longenecker Family Newsletter.*[89] Fortunately, the Christian Longenecker family register mentioned his father Hans and gave the date of August 30, 1767, when Hans died. According to Cryer, Hans Longenacker made his will on August 14, 1767. It was probated on September 26, 1767. The Longenecker register also mentions Christian Longenecker's surviving siblings, all of whom are listed in the will. Although the register itself offered no insights into the whereabouts of the Longenecker family when the register was made, research confirmed that the family was already in Rapho Township even before Christian Longenecker's family Bible was printed in Germany. Such instances of registers written in German Bibles after a family's relocation to America are typical.

Even examples that mention where in Europe the family lived hint that the record was penned following immigration. Evidence suggesting that records were made here is based on research into the family background as well as visual clues, such as art and handwriting. The latest date in the hand that started the record, if identifiable, best indicates when a register was made. Often handwriting can be attributed to a known fraktur artist or scrivener. For example, a register made for the Hartmann/Schmeck family of Berks County was written in a Bible printed in Zurich in 1755. The register was written by Gottlieb Schmid, who signed and dated it August 24, 1859. Even had Schmid not signed the register, his handwriting is easily identifiable.[90]

Occasionally, two or more registers appear in a single Bible. In some instances, the earlier registers were made in Europe, and later registers were made here. Such examples are uncommon, and they often fail to note the relationship of one register to another.

An example of a family register that was started in Europe is known from the Peter Stauffer Bible now owned by the Mennonite Heritage Center in Harleysville, Pennsylvania. This register appears in a 1565 Froschauer Bible having several blank pages filled with chain-of-ownership records followed by several family registers. The chain-of-ownership records begin in 1673—more than a century after the Bible was printed—when the son of Jacob Dättweiler [Detweiler] owned the Bible. The son's first name is not recorded. The second name to appear in the Bible, also in 1673, is that of Hans Rudolph Ringier. Obviously, confusion already becomes apparent about the relationship, if any, between Jacob Dättweiler and Hans Rudolph Ringier. The next name to appear in the

Bible is Jost Künner of the Kirschheusserhof in Pfalz. Künner, who got the Bible from his father, owned it in 1709. Künner sold the Bible to Petterus [Peter] Stauffer in 1712. Peter Stauffer married Barbara Wisler the following year on July 23, 1713. Stauffer lists children born to him and Barbara (Wisler) Stauffer. The oldest was Christian Stauffer, born June 27, 1714, who came into possession of the Bible next. Christian immigrated about 1730 to Bucks County, where he died in 1764. About the time Christian Stauffer immigrated, another family name—that of Hüstandt [Hiestand]—interrupts Christian Stauffer's family register. The Stauffer record continues in 1733 with the marriage of Christian Stauffer to Elisabeth Maier. Presumably, Christian and Elisabeth were married in America. The record then continues with the children of Christian and Elisabeth (Maier) Stauffer, born between 1734 and 1750.

This same Bible record lists children born, beginning in 1760, to Jacob Lädtermann [Leatherman/Letterman]. According to the Lädtermann register, Jacob Lädtermann was the son-in-law of Christian Stauffer. Jacob Lädtermann came to own the Bible in 1764 after he purchased it from his father-in-law. Also recorded in the Bible are the births, between 1759 and 1764, of the children of Johann Jacob Hackman, another of Christian Stauffer's sons-in-law. The entry concerning the Hackman family does not state Hackman's relationship to Christian Stauffer.

Portions of the extensive Peter Stauffer Bible record are difficult to read. The record is translated and discussed, however, by Joel D. Alderfer in the September 1994 issue of the *MHEP Newsletter*[91] and in the October 1994 issue of *Mennonite Family History*. Such family registers provide a wealth of information and can be helpful, but they also require additional research. Had it not been for Alderfer's own research, readers of the Stauffer family register would not know when Christian Stauffer immigrated, where he settled in America, and how Hackman was related to him.[92]

Another example of a chain-of-ownership record appears in a 1716 Nürnberg Bible (fig. 27). Information in this Bible begins with a birth record that says that Johannes Timothe Sauerbrun was born December 3, 1689, in Sanct Lambrecht [Saint Lambrecht, Austria]. Timothe Sauerbrun owned the Bible in 1719. In 1728, the Bible was in the possession of his brother, Heinrich Sauerbrun. In 1763, the Bible belonged to Jacob Heller, who had been given the Bible by his mother, Maria Elisabetha (Sauerbrun) Heller of Sanct Lambrecht. By 1810, the Bible belonged to Margaretha Lang of Neustadt. According to this record, Margaretha Lang was a daughter of the late Jacob Heller. To this point, family relationships in the chain-of-ownership record are reasonably clear. But eventually, the Bible made its way through the Schock and Schmidt families, from Württemberg in Germany to Baltimore, Maryland, and then to Harrisburg, Pennsylvania. No family register appears in this Bible, and family relationships subsequent to the Heller entries remain vague or nonexistent.

It is important to note that chain-of-ownership records—unlike most family

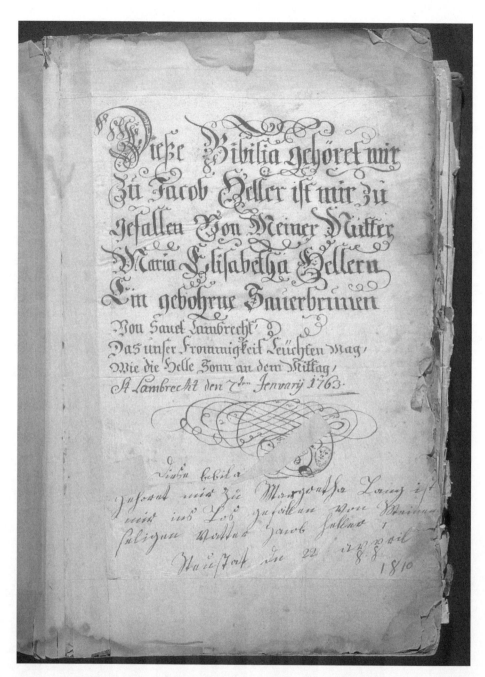

FIG. 27 Bookplate showing book ownership in the Heller family. Anonymous scrivener, Sanct Lambrecht [Austria], 1763. Hand-lettered on laid paper, 14½ in. × 9½ in. Endpapers in 1716 Nürnberg Bible. Private collection.

One page of a multi-page "chain-of-ownership" bookplate. Such bookplates are often mistaken for family registers. The Bible passed through several families with different surnames (relationships unknown), and it eventually made its way to Dauphin County, Pennsylvania.

registers—often give locations along with dates that books came into the posses-
sion of their owners. It seems logical that they would mention locations. Books
were dear, and if a book were lost or stolen, it could be returned to the rightful
owner if the location had been noted. Thus, as sketchy as other information is,
locations were necessary in these types of records.

In preparation for publishing *America's First Bibles, with a Census of 555
Extant Bibles*, Edwin A. R. Rumball-Petre surveyed early American Bibles, list-
ing each example he personally examined or could document.[93] By 1940, when
he published the work, Rumball-Petre had been able to locate 103 of 134 known
copies of the 1743 Christopher Saur Bible; 106 of 125 known copies of the 1763
Saur edition; and 176 of 195 known copies of the 1776 edition—the so-called
gunwad Bible. Fortunately, Rumball-Petre noted which copies of those he could
trace had family registers in them. His notes indicate that 11 percent of the 1743
edition, 12 percent of the 1763 edition, and 13 percent of the 1776 edition had
family registers. Some of these family registers have early dates, but despite these
dates, it should be assumed that many were penned following the Revolution.
For example, a copy of the 1763 edition has a record for the Samuel Snavely
family that begins with a date in 1742. Because the record ends with a date in
1828, however, chances are that the entire record was written then. Another for
the Nice family begins with a date of 1770 and ends with a date of 1787, and
still another, for the Winter family, has a record that begins in 1781 and ends in
1821.[94] As with other handwritten records, the last date in the same hand as
that of the person who began the record is the most reliable for determining
when the register was written. Thus, to date Bible-entry registers as well as other
types of family registers, scholars must recognize the handwriting of the scriv-
ener who began the record and those who added data later. Even then, scholars
must exercise extreme caution, for a person living in the nineteenth century
might have recorded information dating from the eighteenth century.

Many of the family names recorded by Rumball-Petre are Mennonite names.
This stands to reason, for the Saurs printed their Bibles in Germantown and
distributed them in areas populated by large numbers of Mennonites. Mennonite
names such as Detweiler, Oberholtzer, Longenecker, Stauffer, Gehmann, Halde-
man, Schenck, Musser, Alderfer, Hunsberger, and Scherk [Shirk] appear in the
Rumball-Petre survey, demonstrating once again how Mennonites embraced this
form of personal record keeping.

Rumball-Petre's study demonstrates that the percentage of early English-lan-
guage Bibles having family registers is smaller than that for German-language
examples. In 1782, Robert Aitken (1734–1802) of Philadelphia published the
first English-language Bible printed in America. Rumball-Petre reports having
traced 50 of 71 copies known to him in 1940. Only four had family registers,
and one of these was for the Aitken family. And of the Mathew Carey Bible
printed in 1790 in Philadelphia—the first Catholic Bible printed in America and,
according to Rumball-Petre, the rarest of early Bibles printed on these shores—

only 2 of the 27 copies he traced had family registers. Although this sample is small, it suggests that Pennsylvania Germans and especially Mennonites led the way in penning freehand family registers into Bibles.

To our knowledge, the earliest surviving Pennsylvania-German family register in any category is a simple two-page example written in fraktur lettering on the blank pages of an undated Froschauer New Testament (fig. 28).[95] This register was made for the Herr family of Conestoga in Lancaster County. The father of this family was John Herr (1685–1756), who is referred to as Land Agent John Herr to distinguish him from others having the same name. Called "Hans Hare" in some records, he is believed to have married Frances Brechbill, although her name is not mentioned in the family register.[96] The latest date shown in the original hand in this register was 1720. This date records the death of Bishop Benedict Brechbühl [Brechbill/Brackbill] (1665–1720), who was responsible for shepherding many Mennonite families into Lancaster County when he immigrated in 1717.[97] The Herr family register has no decoration beyond the fraktur lettering in the text.

The Herr register is important because of its early date, for it may even predate Blake's genealogical contribution to Captain Roger Clap's 1731 history. That does not mean, however, that the Herr register is necessarily the earliest register in America. It is the earliest Pennsylvania-German family register we have been able to document, but there may be earlier registers written in English, German, or perhaps even in Dutch, French, or Spanish.

Family registers recorded in books were not restricted to Bibles. In *Maintaining the Right Fellowship,* John Ruth mentions an instance in 1801 when John Detweiler of Skippack willed a "large Dutch Book of the Sufferings of the true and faith in Christ"—a *Martyrs Mirror*—to his son-in-law, Henery [Henry] Hunsicker. Detweiler specifically mentioned that he wanted Henery Hunsicker to inherit the book so that Detweiler's children "may at any time see their age as they are all entered therein."[98] Detweiler's request illustrates the problem with family registers entered into a Bible or other book. Only one descendant will inherit the book, and when other descendants move away and become scattered, their access to the Bible becomes severely restricted.

As a sage once said, "The best form is a blank page." The blank pages in Bibles having family data entries sometimes lack organization other than chronological listings of births. Thus, there exist records of births of children without surnames; the same first names of children, but without explanation; wedding dates without the wife's name; dates of death but not birth; frequently no location; and partial entries that, for whatever reason, were never finished. The information is valuable, but it often brings more questions than answers.

On the other hand, some fraktur artists preferred blank pages, for they chose not to use the register bound into the Bible, or the Bibles they wrote in did not have a preprinted register. The lack of a structured register allowed artists more freedom for creativity, and they used this "free space" to great advantage. Just

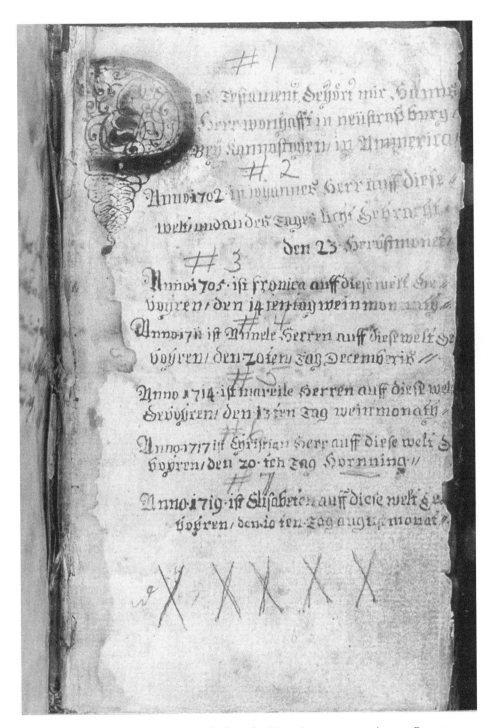

FIG. 28 Page from family register made for John Herr. Anonymous scrivener, Conestoga, Lancaster County, Pennsylvania, 1720. Hand-lettered on blank page of undated Froschauer Bible. Laid paper, 7 in. × 3¼ in. Courtesy Lancaster Mennonite Historical Society, Lancaster, Pennsylvania.

To date, this is the earliest Pennsylvania-German family register we have documented. It appears to have been completed in 1719, but the addition of Benedict Brechbühl's date of death in 1720 on the facing page may have been written in the same hand.

because these registers lacked structure in terms of text does not mean that they were carelessly penned. In fact, artistically, some of these records rate highly: they are among the most beautiful family registers ever created. They were often written by exceptionally talented schoolmasters such as fraktur artists Andreas Schwartz Kolb, Johann Adam Eyer (1755–1837), his brother Johann Friedrich Eyer (1770–1827), David Kolb/Kulp (1777–1834), Rudolf Landes (1789–1852), Christian Alsdorff (circa 1760–1838), Abraham Brubaker (1760–1831), Christian Strenge, Johannes Moyer (1769–1812), and others. Popular among Mennonite families in Bucks, Montgomery, and Lancaster Counties, these records demonstrate exquisite design and penmanship, with writing in black and/or red ink fraktur lettering and German script. These registers often begin with large letters having elaborate strapwork, pen flourishes, and intricacies that represent *Frakturschriften* at its best. Whereas border decoration on *Taufscheine,* family registers, and other fraktur is often divorced from the text, the dynamic penmanship exhibited on these family registers (and, similarly, on writing examples) *is* the art.

But those who penned family history on blank pages had to be careful. Although printed forms are rigid, they help writers remember data that should be recorded. Less skilled penmen, or family members creating a register, often failed to include important information. More often than not, the information they omitted was the location of the family. The family intended the Bible to stay with the family forever, and it was assumed that the family would remain in place, so perhaps they saw no need to note the location. And probably some simply forgot. Whatever the case, numerous registers go on for pages, detailing names of children, dates they were born, times of day they were born, and the signs of the zodiac—but not the location.

Sometimes, however, researchers get lucky. A Bible-entry register written in German script for the Freyer family, with dates ranging from 1749 to 1886, is several pages long. Freyer is a fairly common German name and would be difficult to trace. Naturally, the family historian would search in Pennsylvania, as there were Freyers there. But happily, the person who penned a portion of the Freyer record mentioned, almost as if by accident in one of the last entries, that the family was in Baltimore, Maryland. Yet a surviving *Taufschein* made for the same family places the family in Northampton County in Pennsylvania, where at least one of the children was born. Thus, researchers must consult several records to learn the whereabouts of their families, even if a location is mentioned on the family register. In other words, researchers should not assume that all events listed in a family register took place in one location.

There is another problem with family records written on the blank pages of Bibles. Paper was dear, and Pennsylvania Germans had a reputation for frugality. They tended to use as much blank space as possible, recording data to the very edge of the page. Likewise, early *Taufscheine* were decorated right to the edge of the paper. But on a *Taufschein,* the main text is in the center. No one likes to

see decoration sacrificed, but margins filled with decoration meant no loss of data through edgewear. Unfortunately, pages in Bibles often suffer edgewear and therefore loss of data.

This did not happen with forms *printed* in the Bible, for printed forms had margins around them. The previously mentioned Fenstermacher/Zimmerman and the Epler/Gingrich Bible registers had such borders. In modern terms, these margins are called the grip, and printers need the grip to feed paper through the press to avoid smearing ink. Because there are margins on preprinted forms, penmen spared data from loss through edgewear by using these forms. Some registers have color printed to the very edge of the paper so that the grip is not seen. To accomplish this, printers used oversize paper which they then trimmed to the size of the Bible pages. Still, there was no loss of data, because the printed decoration created a protective margin.

Some family registers written on the blank pages of Bibles reach relatively far back into the history of the family. Even these generally stop short of mentioning immigration or where the family came from in Europe, however. Perhaps the reason freehand records have a greater chance of beginning with earlier data is that the preprinted register usually started with the marriage of the parents of the present family. Such registers were meant to list the parents and their children. But Bible-entry registers on blank pages allowed more latitude. The Mennonite Heritage Center in Harleysville and the Lancaster Mennonite Historical Society in Lancaster have originals or photographs of beautifully written Mennonite examples that continue for several pages.[99] Some of these begin with information dating back to the early 1700s. For example, a register made for the Johann Georg Bachmann (born 1724) family begins with a date of 1717, the year Georg's older brother Henrich was born (color plate 36). As was typical of many registers having early dates, the register was made later. The art and most of the text was penned by Johann Adam Eyer, who was not born until 1755. The Bachmann/Oberholtzer register gives no location, but family history indicates that this family immigrated about 1717 and settled in Saucon Township in present-day Bucks County.

Registers written on blank pages of Bibles and other books were made throughout the history of family registers in this country. Besides eighteenth- and nineteenth-century examples, Amish artist Barbara Ebersol made one such register for the Blank/Stoltzfus family of Lancaster County (color plate 37). The latest date on this register is 1915. Other such records exist.[100] Unfortunately for family historians, most have never been systematically recorded and published.

Freehand Family Registers in Booklet Form

The sixth type of family register includes freehand registers in book or pamphlet form. These registers are especially rare, probably because of the work and time

required to produce them. The best-documented hand-scrivened and decorated examples are those drawn early in the nineteenth century by the anonymous Virginia Record Book Artist (or, as some prefer, the Family Record Book Artist) and several copy artists who worked in the Shenandoah Valley of Virginia and in what is now West Virginia.[101] While the artwork of the Virginia Record Book Artist appears influenced by fraktur, his known works were written in English. Most of his booklets record the births, marriages, and deaths of people with British surnames—but not all. This anonymous artist was probably of Anglo-Saxon rather than German extraction (fig. 29).

Just as works by William Murray of New York appear in publications about fraktur, the Virginia Record Book Artist and the contemporaries who mimicked his style are generally included in fraktur studies. There are several reasons for this. The Virginia Record Book Artist and his contemporaries worked in areas settled by Pennsylvania Germans in Virginia and West Virginia. They worked during the height of fraktur production, and their works have fraktur-like motifs. Moreover, they record family history—a theme so prevalent in Pennsylvania-German decorated manuscripts. Taken together, these characteristics tempt most scholars to include these artists as fraktur artists. Unfortunately, studies of works by the Virginia Record Book Artist are hampered because booklets pro-

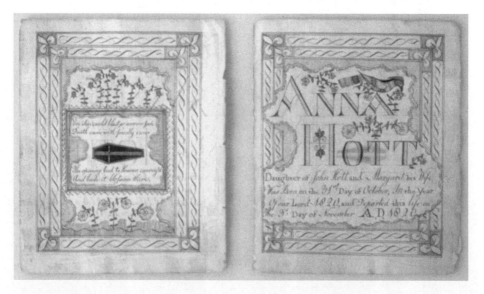

FIG. 29 Birth and death record for Anna Hott. Attributed to Virginia Record Book Artist, Frederick or Berkeley [now West Virginia] Counties, Virginia, circa 1820. Hand-drawn, lettered, and watercolored on wove paper, 6 in. × 5 in. (each page). Collection of the Museum of Early Southern Decorative Arts, Winston-Salem, North Carolina.

The anonymous Virginia Record Book Artist (active circa 1795–1825) worked primarily in Frederick County, Virginia. In this example he documented the brief life of Anna Hott, who lived only four days. Unfortunately, the Virginia Record Book Artist did not record locations.

duced by him and the copy artists are often separated, and the pages are scattered.

The tradition of making manuscript family register booklets also existed in New Jersey. In 1987, David B. McGrail mentioned several early-nineteenth-century registers in his article, "Late Eighteenth- and Early Nineteenth-Century Illuminated New Jersey Documents: An Introduction and a Checklist." Like works by the Virginia Record Book Artist, many of the examples from New Jersey that McGrail lists have British surnames. Still, for want of a better word, McGrail used the term "fraktur" as a simple way to classify these decorated manuscripts, many of which are stylistically similar to fraktur made by and for Pennsylvania Germans.[102]

An interesting variant of the book-form register is the hybrid hand-lettered and machine-printed book. Milton B. Eshleman (1835–1899) of Paradise in Lancaster County made some of these curiosities throughout the 1860s. Among others, he had printed a "Register of Consanguinity" containing data for seventy-five families related to the Reverend Jacob Neff (1724–1814) of Lancaster County. Only the title page, and page numbers one through fifty with headings, were machine printed (fig. 30). All familial information was handwritten. In keeping with the appreciation for fine penmanship so inherent in the fraktur tradition, entries were written in a graceful and legible English. Naturally, later hands are in evidence as having added data.

The Eshleman books have no watercolor illumination and, because they are written in English, they have no fraktur lettering. Thus, we notice signs of these genealogical records entering mainstream America. They could be made for any family, not just a Pennsylvania-German family.

A handful of Eshleman books exist. Two Jacob Neff books begin with the family of Benedict Brechbühl, who died in 1720, as mentioned above. Jacob Neff's wife, Anna (Brechbill) Neff (1733–1825), was Benedict Brechbühl's granddaughter. Data entered by hand in the Neff family books appear contemporary with the printed title page, for entries in the original hand go up to 1867. Both Neff copies have added data. In one, information was added as late as 1924. Data added after 1867 are for ancillary lines, thus making each book unique.

One special benefit with a genealogy book is that flesh can be put on old bones. Eshleman's project was extremely manpower intensive, yet his books provided space for important observations regarding the individuals listed. For example, occupations of men are included as well as locations of families that moved west. One note says that Mennonite preacher Uhlrich Brechbill (1703–1739), son of Benedict and father of Anna (Brechbill) Neff, "met his death by being run over with his own wagon, while hauling Flour to Philadelphia." And while many of the families listed are pacifist Mennonites, we read that brothers Aldus (1830–1862) and Jefferson Neff (1834–1863) were killed in Virginia dur-

REGISTER

OF

CONSANGUINITY,

CONTAINING A RECORD OF

SEVENTY-FIVE FAMILIES,

AND

The Names of Three Hundred and Twenty Descendants

OF

REVEREND JACOB NEFF,

Who Resides at Strasburg, Lancaster County, Pennsylvania,

COMPILED AND ARRANGED BY

MILTON B. ESHLEMAN,

OF PARADISE, LANCASTER COUNTY, PA.

COMPLETED JULY 4, 1867.

FIG. 30 Title page of "Register of Consanguinity" for Jacob and Anna (Brackbill) Neff. Milton B. Eshleman, Paradise, Lancaster County, Pennsylvania, 1867. Printed on wove paper, 7¾ in. × 10½ in., fifty pages. Private collection.

Throughout the 1860s, Milton B. Eshleman (1835–1899) compiled and infilled a handful of genealogy books. He doubled up on page numbering, assigning two pages the same number. Thus, his page numbering ends at page fifty, but there are actually one hundred pages of handwritten text. The title page shown here says that this book is a record of seventy-five families and the names of 320 descendants of Jacob Neff (1724–1814). Remarkably, only the title page, column headings, and pagination are printed. The balance of the book is handwritten in English, probably by Eshleman himself. The only decoration in the book is shown here in nine decorative English types (some in different point sizes). The only link to a Germanic past is that virtually all surnames recorded in the book are Pennsylvania German.

ing the "rebellion." Few family registers allow space to provide such poignant detail.

Handwritten books represent a transitional aspect to family registers. Like Bible-entry handwritten registers, they are multi-page documents. Moreover, Eshleman's books show that Eshleman researched back in time. In other words, he introduced *family history,* rather than adhering to the traditional approach apparent in a typical two-generation family register. We also see that Eshleman included extended family in his research, for collateral lines appear with direct ancestry. Thus, Eshleman's books represent a departure from the broadside-type or Bible-entry register. They present a stepping stone to the full-blown, book-length family histories being printed today.

Obviously, writing book-length genealogies by hand was impractical. Producing multiple copies of a single edition was time-consuming, and Eshleman added to his work by creating more than one edition. His books are remarkable, for they demonstrate the care with which he approached his project. He made certain that the handwriting was legible. He ensured that each book was properly indexed and cross-referenced. He had title pages printed, along with headers for each page. Although he used a somewhat unconventional numbering system, he numbered pages. And he had each book bound. Printed book-length genealogies became the next step. Consequently, the second half of the nineteenth century saw a significant increase in the numbers of these genealogies.[103]

Entirely printed genealogies in book form became especially popular late in the nineteenth century. A random statistical sample indicates that they peaked numerically about 1896,[104] but they became popular again late in the twentieth century, probably because home publishing on personal computers allowed family historians to produce their own books. In fact, the home computer had a profound effect on genealogy. At last, family historians could efficiently manage vast amounts of data. Until the home computer, family historians were at the mercy of large publishers. And these publishers correctly recognized that the market for family-specific publications was far too small to expect commercial success.

But the last quarter of the twentieth century changed the field of American genealogy forever. Within just a few years, Americans celebrated the bicentennial, purchased home computers, armed themselves with technologies to reach worldwide resources, and prepared for the turn of the century and the new millennium—all with a renewed interest in family history. These events caused Americans to develop a curiosity about heritage, and some intensely investigated their ancestry.[105] Thus, the family register evolved from a one-page work of art into something that immigrant ancestors may have dreamed about but never imagined would actually come true. Their descendants cared. Not only that, they cared enough to write books.

Like all primary sources, family registers provide the most reliable information available. They were usually, although not always, created close in time to the events they record. Nevertheless, the texts of family registers are occasionally incomplete, misleading, inaccurate, and confusing. The 1720 Land Agent Hans Herr register, for example, neglected to name Herr's wife. Despite the care taken to detail the alignment of planets for the birth of Abraham Bollinger, the 1763 Bollinger register failed to name his parents. And the Sechler register created confusion when it failed to explain why Elias Sechler married his second wife before his first wife had died. But the major limitation of family registers was that families grew well beyond the immediate family, and space on the page simply did not allow for additional data.

Consequently, Americans abandoned traditional family registers in favor of printed books. Like their predecessors, attempts at printed books were often

clumsy. They, too, were (and sometimes still are) incomplete, misleading, inaccurate, and confusing. For example, in 1869, the Reverend Samuel Heinecke wrote his "Genealogy from Adam to Christ," which he published in Lancaster in 1881.[106] The six-page "Adam to Christ" portion prefaced a longer genealogy—that of "Adam Heinecke and Henry and Elizabeth Vandersaal." The Heinecke/Vandersaal genealogy then led to Samuel Heinecke's "personal history," which Heinecke began by proclaiming that he was born in Reamstown in Lancaster County.

The second paragraph of Heinecke's personal history has this rather strange passage: "When I was fourteen years of age, one of the most wonderful incidents occurred here that ever I had seen or heard of." Rather than describe the incident, Heinecke continued, "My grandfather, Henry Vandersaal was, at the time I speak of, seventy-three years old, and was severely afflicted with dropsy. He was unable to walk or lie down, consequently, he had to sit in an arm-chair day and night, and to rest his head upon a small table standing before him, with a bookcase within easy reach, so that he could read if he desired to do so. Thus he passed away time as best he could for five long, painful, wearisome years."[107]

This sad description is followed by the death of Henry Vandersaal's daughter, Catherine. Heinecke finally described the "most wonderful incident," which was a local revival that brought converts among Heinecke's family and friends, but the passage that alludes to the wonderful incident—followed immediately by his grandfather's suffering—demonstrates that not all family historians are careful writers. Heinecke might have expressed at least some sympathy for his grandfather. Worse, Heinecke suggests that the wonderful incident was triggered by Catherine's death. If Heinecke had asked his grandfather and Catherine about all this, they might justifiably have claimed that they failed to view this part of life as "wonderful."

In another example, Robert Elliott Flickinger published *The Flickinger Families in the United States* in 1926.[108] Genealogists understand that Flickinger might not have been able to cover the entire family in a single volume. They, more than most people, recognize that families are large, and one book might not allow enough space. But most readers are unprepared for Flickinger's criteria for choosing a stopping point. Flickinger did not end his book when he finished a chapter. He did not end it with a paragraph, nor even a complete sentence—*not even a complete word*. Instead, Flickinger gave the grammatical term "incomplete sentence" new meaning when he ended page 132—and his book—thus: "About 1780, during the period of the Revolution, accompanied by his son, Peter Philip Flickinger, his wife and son Charles, Peter moved to the west side of the Susquehanna, and lo- (Continued, included and concluded in Family History)." Had Flickinger squeezed in just a few more words, he could have mentioned the place west of the Susquehanna where researchers could continue searching for this line of the Flickinger family.

A third example brings us back to the Muhlenberg family. In a 38-page mono-

graph published in 1916, W. C. Heyer wrote about Anna Maria Weiser (1727–1802), daughter of the Indian interpreter Conrad Weiser (1696–1760) and wife of Henrich Melchior Muhlenberg.[109] Anna Maria (Weiser) Muhlenberg must have led an interesting life. She undoubtedly witnessed scores of Indians appear at her parents' home as they held crucial meetings with her father—meetings that kept peace among the Six Nations during the critical French and Indian War period. She married an immigrant who became the patriarch of the Lutheran Church in America after calming nerves among various factions of Germans whose numerous (and sometimes hair-splitting) religious beliefs caused tensions during the Great Awakening and William Penn's "Holy Experiment" with religious freedoms. She lived during the Revolution, during which her husband felt certain misgivings about rebelling against the Crown and yet her sons fought for that very end. She surely heard about her eldest son's bold announcement when Peter Muhlenberg threw off his clerical robe and became the celebrated "fighting parson."

Yet Heyer discussed no effects whatsoever these events had on Anna Maria. She must have had mixed emotions about the Revolution. Perhaps she felt sympathetic toward her husband's attempt to maintain a neutral point of view. Or perhaps her viewpoint was more closely aligned with those of her sons. Though Henrich Melchior Muhlenberg was Peter Muhlenberg's father, Anna Maria Weiser was his mother, and she was *American* born.[110] It may have been her influence that turned her children into Americans and, in fact, into rebels. She must have had many fears about the fate of her children—and perhaps a twinge of guilt that she may have caused them to choose a path viewed by some as outright treason. Yet Heyer ignored this part of her life entirely.

Moreover, he failed to give her dates of birth, marriage, and death. In fact, Heyer seemed to have an aversion toward dates and hard data. He offered no dates concerning Anna Maria's parents or husband, including the dates they immigrated.[111] He neglected the birth dates of her children—certainly memorable days in the life of any mother. Instead, Heyer described his view of the ideal Christian wife. His monograph might just as well have been called "A Checklist of Hundreds of Phrases That Can Be Used to Describe a Good Christian Woman." Such accounts disappoint those searching for nuggets of useful and meaty information.

On the other hand, the authors of these accounts—as well as those who penned family registers on single sheets of paper or in Bibles—produced *something*. In this way, Americans are fortunate. Their ancestors in faraway lands often had few shreds of written records detailing the lives of those who came before them. Members of some ethnic groups have nothing beyond oral history. Others not only lack oral history but also lack even a general history of the region whence they came, for there was no written language. Still others are more fortunate in that records are available, but not all records were organized into anything that even resembled a cohesive or comprehensive family history.

There were exceptions. Obviously, some Europeans were interested in documenting family history. For instance, Magdalena (Van Sintern) Kolb's "genealogist" cousin near Hamburg in Germany asked her to compile information about the American branch of the family. Other examples are known. But Americans often began their history in the New World with amnesia about their past. This was especially true if they were of humble origin, as most were. But status did not prevent Americans, including Pennsylvania Germans, from creating family documents—nor did it prevent them from hiring artists and penmen to decorate them. Overall, American families became so successful that they developed a sense of empowerment that comes with self-determination. Even families that were considered humble in Europe eventually developed increased self-esteem after immigrating. As a consequence, rather than listing personal data on slips of plain paper, which would have been a sufficient method of record keeping, these families celebrated self-worth with colorfully decorated registers. Thus, in America, families lacking rank or wealth became candidates for producing family registers—and produce them they did.

EPILOGUE

PENNSYLVANIA GERMANS RESPONDED TO taking root on American soil by creating family registers. By severing family ties through immigration and subsequently casting their lot with American patriots, as most did, Pennsylvania Germans staked their claim on an American future. Their attention to future generations, as seen in family registers, presented an about-face in the orientation of Western civilization's view of family, which traditionally focused on ancestry. But Americans were establishing their own traditions, and American family registers became products of these traditions.

The act of immigrating, together with the success of the American Revolution, created a sense of "newness" in America. This fresh start culminated in a forward-looking optimism, experimentation, and self-assuredness. Fundamentals such as a high rate of literacy, a well-endowed natural environment, and freedoms from excessive government and church regulation contributed to America's bright future. But it was the *newness* that inspired Americans to write their own small slices of "history." These "histories," when taking the form of family registers, were based on recent events and were exceedingly narrow in scope. But their limited perspective emboldened Americans to write new "in the beginnings." They had no qualms about lopping off a centuries-old past located far across the ocean. They simply started over. And when they did, they intended their records to endure. In hopes that future generations would appreciate their efforts, Americans decorated their registers, placed them in Bibles, or had them printed, hoping that such measures would contribute to their longevity. As a consequence, family registers became welcome building blocks that, in Ola Elizabeth Winslow's words, are fundamental to our national history and pride.

Families creating registers harbored no unrealistic expectations that their audience would be large. On the contrary, they knew their registers targeted small numbers of readers consisting mainly of family members—many as yet unborn. Some directly addressed future readers with explicit messages. Christian Weber openly urged his progeny to remain Mennonite, and Christopher Ottinger passed moral, religious, and family values to his children through biblical citations. But in addition to expressly stated sentiments, Pennsylvania Germans made family registers to last. The intent of permanency implies that families

envisioned future generations that would find these registers of value. Clearly, those who made family registers were reaching out to their "latest posterity."

Pennsylvania Germans maintained a widespread and long-lived interest in commemorating personal events with decorated manuscripts that marked occasions such as birth and baptism. This fondness for decoration and recording family milestones remained entrenched in the Pennsylvania-German culture for generations that spanned the better part of three centuries. The ethnically cohesive lifestyle of the Pennsylvania-German farm family, retention of the German language, and maintenance of traditional values resulted in prolonged interest in creating and preserving these records. Also, the Germanic love of color and Old World motifs, religious values, accessibility to fraktur-making schoolmasters and scriveners, and availability of German-language printers shaped the history of Pennsylvania-German registers. These factors contributed to the development of Pennsylvania-German registers in six discernible forms.

There is little evidence to suggest that an evolutionary process resulted in the Pennsylvania-German family register. Instead, the six forms of family registers appeared on the scene almost spontaneously. The only evolutionary process that materialized was one that resulted from a practical solution to a perpetual problem. One-page broadside-type family registers and even four- to eight-page Bible-entry registers presented limited space. As families became more ambitious in recording subsequent generations, space became a major problem—and as they researched their pasts, space restrictions became crucial. Consequently, family-specific, book-length genealogies eventually became the favored method for recording family data.

Booklets such as those made by Milton Eshleman brought Pennsylvania-German family registers full circle to Roger Clap and James Blake Jr. Naturally, Eshleman was not the first to create booklets. Genealogy books and booklets printed prior to the Civil War for Pennsylvania Germans, although uncommon, are known. The four-page German-language booklet published about 1842 for the Benjamin Hershey family is an example. Following the Civil War, when Eshleman was still creating his handwritten family histories, genealogy books made for Pennsylvania-German families were becoming popular and were increasingly printed in English rather than German. Thus, Eshleman and others entered the nineteenth-century American mainstream: by century's end, book-length genealogies had become common among many ethnic groups.

The book-length family history took a giant step away from family registers made in the fraktur tradition. Rather than the snapshot approach of the immediate family found on single-sheet or multi-page Bible-entry registers, the genealogy book focused on the history of the family as far back as the author could go. Concurrently, family historians included extended families, just as Magdalena (Van Sintern) Kolb did. Thus, the family historian producing a book attempted a thoroughness that was never the purpose of the person creating a family register. Moreover, the books they produced were designed not so much

as works of art as means of imparting information. And while the focus of the typical family register was the immediate family, the discovery of family origins became a main objective for the late-nineteenth- or twentieth-century family historian. Yet despite their differences, the family who created or commissioned a family register and the family historian who wrote a genealogy had two things in common. They both made records for the future, and they intended these records to become family keepsakes, to be read and enjoyed forever.

While book-length genealogies became a welcome development, the Pennsylvania-German illuminated family register still enjoys a unique place in Americana. It combined Old World technique with the individual freedoms afforded citizens of the United States. Prior to the Revolution, Americans increasingly felt a sense of limitless freedoms. When fraktur artist John Thomas Schley—born in the Palatinate, but by 1761 a schoolmaster in Frederick, Maryland—wrote to his relatives in Mörzheim, he pleaded with them to make America their home for the sake of the children. "Conditions here would be a thousand times better than abroad," he wrote, adding, "here at least [the children] have a chance to do well in time—in a short time, in fact—and live in plenty."[1] This prevailing attitude among colonial Americans swelled into a tide as the American Revolution released an outpouring of self-confidence and pride in being American.

In the history of family registers, patterns emerge that reflect the American dream. It seems reasonable that early Americans (including Pennsylvania Germans), who were putting the past behind them, felt no intense interest in mentioning where the family originated. They had broken their ties with Europe. There was no looking back—and no going back. Not only did most registers fail to record where in Europe the family called home, but they were also limited to one or two generations—generations that had their futures ahead of them. Portentously, these registers reflected the regeneration of families living in a new world and a new nation.

Religious freedoms are also manifested in American registers. In Europe, common people were often forced by law to adopt the state religion, but Americans could pursue their own consciences and attend to their own spiritual needs. In Pennsylvania, this gave Anabaptist families opportunities to record family data without fear of the authorities using their records against them.

As nineteenth- and twentieth-century descendants of pioneer families of German heritage pushed west, they distanced themselves further from their pasts. Many had no idea of their ethnic background or native tongue, let alone the names of their forefathers. Yet while their memories dimmed, their yearning to rediscover their roots grew stronger. Thus, as families across the nation looked back, many stumbled across unique, irreplaceable, and all-important primary sources, such as family registers. As a result, family registers became windows onto Pennsylvania-German history and culture through familial linkage, language, customs, folk art, and traditions.

Except among commercial artists and conservative Mennonites and Amish,

few family registers are produced today in the fraktur tradition. Even Bible-entry registers, which remain popular throughout America, are generally less decorative than those made in the nineteenth and into the early decades of the twentieth century. Instead, the continuation of the family register in today's culture is apparent in function alone. Lacking decoration, the visual charm and celebration of events yielded to recording life events with efficiency and expediency, as if family milestones were ordinary occurrences.

But it was not the lack of decoration that clinched the decline of Pennsylvania-German family registers. In a way, family registers fell victim to the American dream. As families took hold on American soil, they spread and increased in such numbers that many pages were required to capture family history on paper. Consequently, the snapshot of the immediate family changed into an entire landscape that demanded considerable space. As the space required to convey the message expanded, it was the *message* in family registers that signaled the functional end of the traditional single-sheet or Bible-entry register.

History gives due credit to Revolutionary War heroes like Peter Muhlenberg. It will never let us forget the accomplishments of his father, Henrich Melchior Muhlenberg, and his grandfather, Conrad Weiser. But the histories of many other Pennsylvania Germans are recorded on personal documents such as family registers. For all their faults and awkward attempts at recording family events, whether on a register or in the book-length history that, from necessity, evolved from the family register, we applaud the men and women who wrote about their families in America. The creators of these records had only vague ideas about what constituted a complete and informative document. They could not have imagined the keen curiosity their descendants would have about early personal records. They had no clue that their works would undergo intense scrutiny down to the last detail, including art and text—and even the paper they used. They never dreamt that artistic elements would be analyzed for hidden meanings, nor that their texts would be examined closely for tidbits of information that would prove useful for reconstructing family history. They probably never once thought that their descendants, in the not too distant future, would no longer read and speak German but would remain fascinated by the beautifully penned and decorated documents they inherited. Overall, they underestimated the interest their records would generate.

Yet those who commissioned family registers were not oblivious to the interests of future generations. The very existence of numerous surviving family registers refutes the idea that early Americans were indifferent to the future. On the contrary, eighteenth-, nineteenth-, and twentieth-century German-speaking Americans produced a large body of personal literature that intrigues today's historians. Their documents are historically and artistically captivating, for they offer a peek into the niche our ancestors occupied in the world of the Pennsylvania Germans.

Pennsylvania-German family registers are charming, at times illegible, and

sometimes confusing, but the important point is that we have a source of visual culture and specialized, grassroots literature that contributes building blocks toward an American identity. And for that, today's Americans look at those who produced family registers as heroes. They were among our first historians. More important, they wrote histories we care most about—our personal histories.

APPENDIX A: FRAKTUR ARTISTS AND SCRIVENERS WHO DREW AND/OR INFILLED FAMILY REGISTERS

Unless otherwise noted, all locations given are in Pennsylvania. The abbreviation a. c. stands for "active circa." The abbreviation c., for "circa," precedes approximate life dates.

Name	Dates	Location
Abbreviated Township Scrivener	a. c. 1880	Lancaster County
F. D. Acker	a. c. 1890	Lehigh County
Christian Alsdorff	c. 1760–1838	Southeastern Pennsylvania
Ampersand Scrivener	a. c. 1860	Berks and Lehigh Counties
Angel Artist	a. c. 1875	Ohio
James Anson	a. c. 1804	New York
Joseph D. Bauman	1815–1899	Ontario, Canada
August Baumann	a. c. 1879–1905	Southeastern Pennsylvania
Elizabeth K. Beiler	a. c. 1900	Lancaster County
Johann Wm. Bernthausel	a. c. 1798–1815	Berks County
Joseph Beutler	a. c. 1840	Wayne County, Ohio
Adam Bixel	1879–1923	Indiana and Ohio
David Bixler	a. c. 1828–64	Lancaster County
Benjamin L. Blank	a. c. 1908–15	Lancaster County
Francis Blum	a. c. 1890–1908	Lancaster County
John Bouer/Bower	a. c. 1832–60	Northampton and Schuylkill Counties
Frederick Bowers	a. c. 1925	Lancaster County
Hans Jacob Brubacher	1725–1802	Lancaster County
Abraham Brubaker	1760–1831	Lancaster County
Nathaniel P. Buckley	a. c. 1833–48	York and Adams Counties
Circle One M. Scrivener	a. c. 1869–88	Southeastern Pennsylvania
Ludwig Crecelius	a. c. 1830	Berks County
A. D. Deibert	a. c. 1888–96	Lehigh County and Maryland
Constantin Jacob Deininger	a. c. 1833–71	Berks and Lehigh Counties

M. H. Diffenbaugh	a. c. 1887	Lancaster County
Edward Dinsh	a. c. 1875–79	Berks and Lehigh Counties
John G. Doell	1833–1908	Lancaster County
Rudolph Dünger	a. c. 1839–77	Huntingdon, Schuylkill, and Northumberland Counties
John Ebermann	a. c. 1825–28	Lancaster County
Barbara Ebersol	1846–1922	Lancaster County
Ehre Vater Artist	a. c. 1782–1828	Southeastern Pennsylvania, the Carolinas, and Virginia
Henry S. Eisenhuth	1830–1897	Southeastern Pennsylvania
Justus I. H. Epstein	a. c. 1873–1900	Southeastern Pennsylvania
Johann Adam Eyer	1755–1837	Southeastern Pennsylvania
Johann Friedrich Eyer	1770–1827	Southeastern Pennsylvania
Wilhelmus Antonius Faber	a. c. 1790–1818	Southeastern Pennsylvania
Peter Fake	a. c. 1820	Probably southeastern Pennsylvania
E. Fisher	a. c. 1878–99	Southeastern Pennsylvania
Footed Letter Scrivener	a. c. 1843–63	Southeastern Pennsylvania
C. R. Frailey	a. c. 1878	Probably southeastern Pennsylvania
J. George E. Franck	a. c. 1878–1912	Southeastern Pennsylvania
Wilhelm Gerhard	1864–1914	Ontario, Canada
Henry B. Gingrich	a. c. 1930	Ontario, Canada
John F. Glick	born 1912	Lancaster County
Jno. Goodhart	a. c. 1870–93	Berks County
William Gottschall	a. c. 1850	Berks and Lebanon Counties
Graduated Numbers Scrivener	a. c. 1888–1914	Southeastern Pennsylvania
Samuel Gramley	a. c. 1849	Centre County
Jacob Gross	1807–1900	Bucks County
William Gross	a. c. 1861–86	Southeastern Pennsylvania
Rudolph H. O. Grossmann	a. c. 1850–87	Southeastern Pennsylvania
John H. Guertler	a. c. 1845–72	Berks and Lehigh Counties
Henry Hagey	a. c. 1905	Montgomery County
Georg August S. Hainbach	a. c. 1876–1919	Southeastern Pennsylvania
Eli Haverstick	a. c. 1829–37	Lancaster County
C. W. Hayne	a. c. 1847–69	Southeastern Pennsylvania
Heart and Hand Artist	a. c. 1850–55	Maine and Vermont
John Heinz	a. c. 1856–85	Berks and Lehigh Counties
John Heller	a. c. 1884–93	Northampton County
William Henning	1822–1895	Southeastern Pennsylvania
David Hinkel	a. c. 1875–98	Northampton County
Christian G. Hirsch	a. c. 1875–1908	Southeastern Pennsylvania

Johannes S. Hoffman	a. c. 1802–33	Southeastern Pennsylvania
David C. Hoke	1869–1938	Lancaster and Lebanon Counties
Isaac Ziegler Hunsicker	1803–1870	Montgomery County and Ontario, Canada
S. B. Jordan	a. c. 1870	Rockingham County, Virginia
Andreas Victor Kessler	a. c. 1791–1821	Southeastern Pennsylvania
Anthony Kirchhof	a. c. 1836–46	Southeastern Pennsylvania
Ferdinand Klenk	a. c. 1855–82	Southeastern Pennsylvania
Andreas Schwartz Kolb	1749–1811	Southeastern Pennsylvania
David Kolb/Kulp	1777–1834	Bucks County
A. Kolona	a. c. 1915	Lancaster County
Harrison W. Kramer	1866–1920	Lancaster County
Johan Friederich Krebs	1749–1815	Southeastern Pennsylvania
Rudolf Landes	1789–1852	Bucks County
Israel Landis	a. c. 1870	Lancaster County
J. S. Lasher	a. c. 1900	York County
Abraham Latschaw	1799–1870	Ontario, Canada
John Layton	a. c. 1825	New Jersey
Friederich Leonhard	a. c. 1803–27	Southeastern Pennsylvania
Francis Levan	a. c. 1826–50	Southeastern Pennsylvania
Peter Marcle	a. c. 1840–50	York County
Joseph H. McGlaughlin	1867–1942	Lancaster County
Irwin Peter Mensch	1881–1951	Berks County
Peter T. Meyer	a. c. 1870	Berks and Northampton Counties
Eduard Miller	a. c. 1873–1905	Berks and Lebanon Counties
Fr. Mittelman	a. c. 1840–55	Lancaster and York Counties
Louis Monarch	a. c. 1900	Lancaster County
Johannes Moyer	1769–1812	Bucks County
William H. Muench	1799–1885	Snyder County
Karl Münch	1769–1833	Southeastern Pennsylvania
William Murray	1756–1828	New York
James M. Newcomer	a. c. 1868–73	Cumberland County
New Jersey Artist	a. c. 1800	New Jersey
Joel Ney	a. c. 1879	Berks and Schuylkill Counties
Open Block-Letter Scrivener	a. c. 1860	Berks County
C. S. Oppermann	a. c. 1880	Berks and Lehigh Counties
Daniel Otto	c. 1770–1822	Southeastern Pennsylvania
Charles Overfield	a. c. 1830–67	Southeastern Pennsylvania
Daniel Peterman	1797–1871	York County

Francis Portzline	1771–1857	Southeastern Pennsylvania
Fr. Reinhard	a. c. 1878	Lancaster County
Rockhill Township Artist	a. c. 1830–53	Bucks County
Peter B. Schauer	a. c. 1865	Berks County
Conrad Schlunegger	1857–1942	Indiana and Ohio
Gottlieb Schmid	a. c. 1845–63	Southeastern Pennsylvania
Johannes Schopp Artist	a. c. 1774–1800	Southeastern Pennsylvania
Louis Schubert	a. c. 1873–1900	Southeastern Pennsylvania
Jacob Schumacher	a. c. 1820	Montgomery County
Israel Semmer	a. c. 1844–70	Southeastern Pennsylvania
Karl Friedrich Theodor Seybold	a. c. 1813–46	Lancaster and Northampton Counties
James Shaw	a. c. 1856–67	York and Adams Counties
Charles B. Smith	a. c. 1861–1911	Southeastern Pennsylvania
Snowflake Scrivener	a. c. 1871–1901	Southeastern Pennsylvania
Spiral Artist of Dauphin County	a. c. 1853–78	Dauphin County
Thomas Stevens	a. c. 1915	Lancaster County
Benjamin B. Stoltzfus	1895–1982	Lancaster County
Benjamin L. Stoltzfus	1888–1951	Lancaster County
Christian Strenge	1757–1828	Lancaster County
W. F. Suess	a. c. 1890–99	Berks County
R. D. Ulrich	a. c. 1900–13	Berks County
John Van Minian	a. c. 1805–42	Southeastern Pennsylvania, Maryland, New Jersey, and Vermont
Virginia Record Book Artist	a. c. 1795–1825	Virginia
Thomas H. Wall	a. c. 1876–98	Southeastern Pennsylvania
Anna Weaver	a. c. 1854	Probably Lancaster County
Augustus Weintraut	a. c. 1875–1904	Berks and Lehigh Counties
Martin Wetzler	a. c. 1854–88	Southeastern Pennsylvania
J. J. Woodring	a. c. 1883–90	Lehigh and Northampton Counties
Adam Wuertz	a. c. 1813–36	York County
Henry Young	1792–1861	Southeastern Pennsylvania

APPENDIX B: IMPORTANT DATES IN FORMS OF FAMILY REGISTERS

PRINTED REGISTERS WITH FAMILY DATA PRINTED ON A PRINTING PRESS

- 1763: Bollinger register printed at the Ephrata Cloister
- c. 1785: Ottinger register printed, probably in Germantown
- 1794: Second Bollinger register printed at the Ephrata Cloister
- c. 1802: Earliest known English-language register printed for a Pennsylvania-German family
- Peak period: 1800–1920 and continuing, especially among conservative Mennonites

FREEHAND REGISTERS

- 1784: Feuth register made by Hans Jacob Brubacher; Mennonites make freehand registers and continue making them today
- Peak period: 1800–80

PREPRINTED REGISTERS WITH ADDED, HANDWRITTEN INFILL

- 1790s: Richard Brunton preprinted registers (Connecticut)
- 1808: Ambrose Henkel German and English registers (Virginia)
- 1846: German-language form printed by N. Currier (New York)
- Peak period: 1830–1910; printed in various languages, especially English

PREPRINTED REGISTERS BOUND INTO FAMILY BIBLES

- 1791: Preprinted register bound into Isaiah Thomas Bible (Massachusetts)
- 1805: Preprinted register bound into Gottlob Jungmann Bible
- Peak period: 1828–present

FREEHAND REGISTERS WRITTEN ON THE BLANK PAGES OF BIBLES AND OTHER BOOKS

- 1720: John Herr register handwritten on blank pages of undated Froschauer New Testament
- Peak period: 1740–present

HANDWRITTEN, BOOK-FORM REGISTERS

- 1795–1840: Virginia Record Book Artist and copy artists
- 1810–40: New Jersey artists
- 1860–65: Milton Eshleman books
- Peak period: 1810–40

The following terms in German are frequently encountered on family registers. Numerous spelling variations, including Pennsylvania-German dialectical and phonetic spellings, appear on family registers. For example, the word "year" appears in German as *Iahr, Jahr,* and *Yahr.* Similarly, the German for "married" appears as *verheirathet, verheiratet, verheyrathet,* and *verheurathet.* Those researching German-language family registers should avoid holding fraktur artists, printers, and scriveners to a spelling standard. Following the German terms are English terms pertinent to the discussion of family registers.

GERMAN TERMS

Abend	evening
Abstammung	descent [as in "descended from"]
Abstammungstafel	descendants table or genealogical table
Ahn	ancestor
Ahnentafel	A genealogical table showing direct ancestors. In an *Ahnentafel*, ancestors are numbered, and collateral lines are not shown.
alt	old
Alte	old woman
Alter	elder, old man
Andenken	token of remembrance, memorial
Anmerkungen	remarks, comments
Anno	From the Latin "Anno Domini," or "in the year of our Lord."
Babe	baby
beerdigen	to bury
begab sich in den Ehestand	gave himself in matrimony
begraben	to bury
Begräbnißtag	day of burial
Bruder	brother
Caunty	county

Confirmation, Konfirmation	confirmation
days of the week in German	*Sontag, Sonntag* (Sunday); *Montag* (Monday); *Dienstag* (Tuesday); *Mittwoch* (Wednesday); *Donnerstag* (Thursday); *Freitag* (Friday); *Samstag, Sonnabend, Satertag* (Saturday)
Denkmal, Denkmahl	memorial
diet, dide	Phonetic spelling of the English word "died."
Dorf	village
Drilling	triplet
durch wen	by means of
Ehefrau	lawful wife, married wife
Ehegatten	legally married couple
Ehegattin	lawful wife, married wife
eheliche	married [female only]
ehelich Hausfrau	lawful wife, lawful housewife
Ehemann	husband
Ehestand	marriage, matrimony
Eltern	parents
Eltern selbst	parents themselves
-en, -in	A German suffix added to the surnames of unmarried females. For example, Elisabeth Müller's maiden name would read "Elisabeth Müllerin."
Enkel	grandson, grandchild
Enkelin	granddaughter
Evangelisch	German term referring to Protestants.
fallen	to die
Familie	family
Familien Register	family register
Familientafel	family table, family register
folgende	German for "following," as in *"Folgende Kinder,"* or "the following children."
Frakturschriften	fraktur writing(s)
Frau	wife or "Mrs."
Gatte	husband
Gattin	wife
geb.	German abbreviation for "born."
geboren	born
geborene	German for "born," but precedes the wife's maiden name, as in "Elisabeth, geborene Müllerin."
Geburt	birth
Geburts-Ort	birthplace

Geburts-Register	birth register
Geburts-Schein	birth record, birth certificate
Geburts-und Taufschein	birth and baptism certificate
Gemahl	consort, spouse, husband
Gemahlin	consort, spouse, wife
geschieden	divorced
Geschlechtsregister	genealogical register, register of lineage
gestorben	dead, deceased [on fraktur, often followed by date plus age at death in years, months, and days]
getauft	baptized
Goettelbrief	An alternate term used primarily in Alsace, in France, for *Taufpatenbrief* or *Taufzettel*.
Gottesacker	cemetery [literally, "God's acre"]
Grossdade (Großdade)	Pennsylvania-German dialect for "granddaddy."
Grosseltern (Großeltern), Grossaltern	grandparents
Grossmame (Großmame)	Pennsylvania-German dialect for "grandma."
Grossmutter (Großmutter)	grandmother
Grossvater (Großvater)	grandfather
Haus Buch	house book
Hausfrau	wife, housewife
Heirat	marriage
Heirath	Archaic German for "marriage."
Heirathen, Heyrathen	Archaic German for "marriages."
heißen	to call, to name
Herr	"Mr.," husband, preacher, Lord
hinterlassen	to leave behind
Hornung	Archaic German for "February."
-in	See *-en*.
Jahr	year
Jungfrau	girl, "Miss"
Jüngling	bachelor, youth, boy
Jungster	young child
Kind	child
Kinder	children
Kindlein	little child
Kirche	church
Kirchhof	churchyard, cemetery
klein	small, little
Knabe	boy
Leben	life

Lebenslauf	German for "course of life account." Also called "biographies," many *Lebensläufe* are autobiographical.
Lecha Caunty	Lehigh County (Pennsylvania)
ledige standes	single status
Leichenbegängniß	funeral, burial
liebe	loving
Mädchen	girl
Minute	minute
Mittag	midday, noon
Mittwoch	midweek, Wednesday
Monat	month
months in German (spellings most often encountered on family registers)	*Januar, Jänner, Jenner, Hartung, Eismonat* (January); *Februar, Feber, Februarius, Hornung* (February); *März, Mertz* (March); *April, Abrill, Ostermonat* (April); *Mai* (May); *Juni, Junius, Brachmonat* (June); *Juli, Julius, Heumonat* (July); *August, Augustus* (August); *September, Herbstmonat* (September); *October, Oktober, Weinmonat* (October); *November* (November); *Dezember, December, Christmonat* (December).
Morgen	morning
Muhme	aunt
Mutter	mother
Mutter-Seite, Mutterlicherseits	mother's side, maternal side
nachfolgende Kinder	the following children
Nacht	night
Name	name
namens	by the name of
nämlich	namely
nennen	to call by name
Onkel	uncle
Ort	place, location
Pfarrer	pastor
Prediger	preacher
scheiden	to divorce
Schein	certificate
Schwester	sister
Sohn	son
Sohnlein	little son
Staat	state [as in the state of Pennsylvania]
Stadt	city

starb	died
Sterbefälle	deaths [frequently used as heading for a column on family registers]
Tag	day
Tante	aunt
Taufe	baptism
taufen	to baptize
Taufpate	godfather, male sponsor at baptism
Taufpatenbrief	German for a "baptismal letter," given at baptism from a sponsor to a child.
Taufpatin	godmother, female sponsor at baptism
Taufschein	baptism certificate
Taufzettel	A term used primarily in Switzerland for *Taufpatenbrief*. An alternate, phonetic spelling of *Taufzettel* is *Taufzedel*.
-ten	German word ending added to a number, just as "th" is added to numbers in English. For example, "*12ten*" becomes "12th."
Tochter	daughter
Tochterlein	little daughter
Tod, Todt, Tot	death
Todesfälle	deaths
todt	dead
todtgeboren	stillborn
Trauschein	certificate of marriage
Trauung	wedding
Uhr	German for "hour," "o'clock," as in "*um sieben Uhr*," or "about seven o'clock."
unehelich	illegitimate
unverheiratet	unmarried
Ureltern	ancestors
Urenkel	great-grandson
Urenkelin	great-granddaughter
Ur Urenkel	great-great-grandson
Ur Urenkelin	great-great-granddaughter
Vater	father
Vater-Seite, Väterlicherseits	father's side, paternal side
verheiraten	to marry
Verzeichnis, Verzeichniss (Verzeichniß)	register, catalog
Vetter	cousin
vormittag	before noon
Vorschrift	writing example

Vorvater	ancestor, forefather, progenitor
Vorväter Verzeichniß	ancestor catalog
wann	when
Weib	wife
weiland	late [as in "the late Henrich Schüller"]
Witwe	widow
Witwer	widower
wo	where
Woche	week
wohnhaft	residing in
Yahr	year
Zeichen	German for "sign," as in signs of the zodiac. In German, the signs of the zodiac are *Widder* (Aries), *Wage* (Libra), *Stier* (Taurus), *Zwillinger* (Gemini), *Krebs* (Cancer), *Löwe* (Leo), *Jungfrau* (Virgo), *Scorpion* (Scorpio), *Schütze* (Sagittarius), *Steinbock* (Capricorn), *Wasserman* (Aquarius), and *Fische* (Pisces).
Zeuge	witness
zweiter Ehe	second marriage
Zwilling	twin

ENGLISH TERMS

Amish, Old Order Amish	A religious sect closely related to Mennonites; an Anabaptist sect.
Anabaptist	Term used to describe religious groups that do not practice infant baptism. Amish and Mennonites fall into this category.
black letter	Term used to describe a type of decorative calligraphy used in medieval Europe; monks' writing.
boilerplate copy	A modern term for standard text. On preprinted family registers and *Taufscheine,* the standard text, or boilerplate, has blanks so that family data can be added.
broadside	A single sheet of paper printed on one side only. Broadside-type materials also include partially hand-drawn and partially printed certificates, such as most Currier and Ives registers and *Taufscheine.*
call name	The name by which a person is addressed. During the eighteenth and nineteenth centuries,

	call names for boys were usually the second name. For example, Johannes Georg Hummel would have been called Georg Hummel.
Dunker	A member of the Church of the Brethren.
flyleaves	Blank pages in books that precede the title page and follow the last printed pages.
font	A complete set of the alphabet in type of one style and one size.
fraktur	In America, a term used to describe eighteenth-, nineteenth-, and twentieth-century decorated manuscripts made by and for Pennsylvania Germans. In Europe, the term is used to describe German-language typeface or writing style.
German Americans	Immigrants of German heritage who came to America in the mid-nineteenth century. Unlike Pennsylvania Germans, who tended to be farmers from southern Germany, most German Americans came from northern Germany; they also immigrated later than Pennsylvania Germans, most of whom immigrated before 1800. German Americans were skilled laborers seeking job opportunities in the industrial cities of the American Midwest.
Gothic	English equivalent to fraktur writing and German fonts. Old English Gothic is a typeface often compared to fraktur lettering.
Harmonist Society	Society founded by Georg Rapp. These Separatists built communities near Pittsburgh, Pennsylvania, and in Indiana. The Harmonist Society thrived throughout the nineteenth century.
illuminated manuscript	Watercolor- or ink-decorated manuscript.
imprint	A printer's name and address.
infill	Genealogical data recorded on preprinted or handwritten manuscripts.
job printing	Printing of incidental materials, such as billheads, letterheads, advertising pieces, broadsides, church memberships, diplomas, confirmation certificates, marriage certificates, *Taufscheine,* and family registers.
laid paper	Paper made from cotton or linen rag primarily before 1800. Laid paper has faint parallel lines called "chains," which can be seen when laid

	paper is held to strong background light.
Mennonite	An Anabaptist religious order.
Moravian	A religious sect known for attempting to unite German churches in eighteenth-century southeastern Pennsylvania, for proselytizing among Indians, and for marriage by lot.
née	French for "born" when written before a woman's maiden name, as in "Elisabeth, née Miller."
Palatinate, the	English for Pfalz.
Pennsylvania Dutch	A term often used to mean Pennsylvania German.
Pennsylvania Germans	German-speaking immigrants and their descendants who came to America before 1800 from southern Germany, German-speaking areas of Switzerland, and Alsace in present-day France. Most settled in southeastern Pennsylvania.
Pietist	A term referring to members of a seventeenth-century revivalist movement among Lutheran churches in Germany.
print run	The number of copies a printer will print for a single job.
royal folio	Paper measuring approximately 24 inches by 17$\frac{1}{2}$ inches.
Schwenkfelder	A religious order whose members were followers of Caspar Schwenkfeld von Ossig (1489–1561).
script	Cursive writing in which letters of the alphabet are strung together with ligatures. The pen is lifted to signify word breaks. This is unlike handwritten fraktur lettering, in which the pen is lifted between each character.
Sectarians	Persons who subscribe to religious faiths that deviate from general religious tradition.
Separatists	Persons who withdraw from established religions.
surname	Family name.
tailpiece	A term used in printing to describe a piece of decoration often used to fill out a page of printed text.
tipped in	Term used when registers or other pages are pasted into an already bound book. Rather than glued completely on to another page, tipped-in

	pages are pasted along a narrow edge, and that edge is placed into the gutter of the book. Thus, tipped-in pages are hinged between other pages.
watermark	A method used by papermakers for marking paper.
wove paper	Paper with a plain surface, as opposed to laid paper, which has wire marks.

NOTES

Prologue

1. Daniel J. Boorstin, *The Americans: The Colonial Experience* (New York: Vintage Books, 1958), 145.
2. Roger Clap, *Memoirs of Capt. Roger Clap* (Boston: B. Green, 1731).
3. For a discussion of the complex settlement of Pennsylvania and the Pennsylvania-German character in the context of Pennsylvania history, see Randall M. Miller and William Pencak, eds., *Pennsylvania: A History of the Commonwealth* (University Park, Pa.: The Pennsylvania State University Press, 2002).
4. Demographic studies concerning the various religions among Pennsylvania Germans disagree on exact figures, but most conclude that Lutheran and Reformed families constituted about 80 to 90 percent of German immigrants into Pennsylvania before 1800. For information concerning the religious, political, and ethnic makeup of Pennsylvania-German populations, see James T. Lemon, *The Best Poor Man's Country: A Geographical Study of Early Southeastern Pennsylvania* (New York: W. W. Norton, 1972); Aaron Spencer Fogleman, *Hopeful Journeys: German Immigration, Settlement, and Political Culture in Colonial America, 1717–1775* (Philadelphia: University of Pennsylvania Press, 1996), 86 and 102–3; and Eberhard Reichmann, LaVern J. Rippley, and Jörg Nagler, eds., *Emigration and Settlement Patterns of German Communities in North America* (Indianapolis: Indiana University–Purdue University, Max Kade German-American Center, 1995), 3–22.
5. William Bradford, *Of Plymouth Plantation,* ed. Harvey Wish (New York: Capricorn Books, 1961), 60.
6. Boorstin, *The Americans,* 152.
7. Stephen L. Longenecker, *The Christopher Sauers: Courageous Printers Who Defended Religious Freedom in Early America* (Elgin, Ill.: The Brethren Press, 1981), 19.
8. Ibid.
9. Ralph L. Ketcham, *Benjamin Franklin* (New York: Washington Square Press, 1966), 120.
10. Paul A. Wallace, *The Muhlenbergs of Pennsylvania* (Philadelphia: University of Pennsylvania Press, 1950), 70.
11. Ibid., 116.
12. Ola Elizabeth Winslow, *American Broadside Verse* (New Haven: Yale University Press, 1930), xviii.

Chapter 1

1. Kent R. Weeks, *The Lost Tomb* (New York: William Morrow, 1998), 251. See also Ernst Doblhofer, *Voices in Stone: The Decipherment of Ancient Scripts and Writings* (New York: Collier Books, 1961).
2. See, for example, *Ahnentafels: Ancestral Charts for Families of German Heritage* (Kensington, Md.: The Mid-Atlantic Germanic Society, 2001), vol. 1.
3. Klaus Stopp, personal communication, September 9, 2001.
4. German-language European broadside-type family registers are known. Often, they resemble stylized family trees and date back several generations, as would large pedigree charts showing coats of arms. For example, in *Frakturmalen und Schönschreiben,* Ethel Ewert Abrahams pictured two family

registers, circa 1745, from Amsterdam made for the Van der Smissen family. See her *Frakturmalen und Schönschreiben: The Fraktur Art and Penmanship of the Dutch-German Mennonites While in Europe, 1700–1900* (North Newton, Kans.: Mennonite Press, 1980), 33.

5. *Gothaisches genealogisches Wörterbuch der adlichen Häuser* (there are 160 volumes, beginning in the nineteenth century and continuing to the present day). See also J. Siebmacher's *Grosses und Allgemeines Wappenbuch* (Nürnberg: Von Bauer und Raspe, 1883); Ottfried Neubecker, *Grosses Wappen-Bilder-Lexikon* (München: Battenberg, 1985); and *Allgemeine Deutsche Wappenrolle*, ed. Wappen-Herold (n.p.: Deutsche Heraldische Gesselschaft E.V., 1988). Citations courtesy of Klaus Stopp, undated personal communication.

6. D. Eduard Grimmell, *Hessisches Geschlechterbuch* (Limburg an der Lahn: C. A. Starke, 1967). Also see Manfred Dreiss's *Deutsches Familienarchiv: Ein Genealogisches Sammelwerk* (Neustadt an der Aisch: Degener, 1997), 121 vols., as well as *Deutsches Geschlechterbuch*, 144 vols. Citations courtesy of Klaus Stopp, undated personal communication.

7. Neubecker, *Grosses Wappen-Bilder-Lexikon*.

8. In a chapter called "The European Background of Pennsylvania's Fraktur Art" in *Bucks County Fraktur*, Don Yoder wrote that Henrich Melchior Muhlenberg prepared several baptism certificates on May 3, 1777, in response to the Militia Law. See *Bucks County Fraktur*, ed. Cory M. Amsler (Doylestown, Pa.: The Bucks County Historical Society; Kutztown, Pa.: The Pennsylvania German Society, 1999), 34. These certificates were needed for men between eighteen and fifty-three to prove their ages in the event they needed, in Muhlenberg's words, to "help defend the land." An example of one such certificate is pictured in *Winterthur Portfolio 8*, ed. Ian M. G. Quimby, and published for The Henry Francis du Pont Winterthur Museum (Charlottesville: University Press of Virginia, 1973), 26. The certificate was made for Isaac Meier, son of Isaac and Susanna Meier. The younger Isaac Meier was born May 6, 1754. This certificate was made as an official document. Written in German script on a small slip of paper, it has no decoration and ends, "This is testified from the church book of the Lutheran congregation at Lancaster, Henrich Muhlenberg."

9. Ervin Beck, "Indiana Amish Family Records," *Pennsylvania Folklife* 39, no. 2 (1989–90): 73–81.

10. Norman L. Kleeblatt and Gerard C. Wertkin, *The Jewish Heritage in American Folk Art* (New York: Universe Books, 1984), 37, 64, 71, 102, and 103.

11. Amsler, ed., *Bucks County Fraktur*, 198.

12. Lutheran and Reformed church books in Europe and in America often include at the back several pages showing family units. Because mentions of individual family members were scattered throughout these records, lists by groups served to assemble data concerning a single family in one place.

13. For overviews of American fraktur, see Donald A. Shelley, *The Fraktur-Writings or Illuminated Manuscripts of the Pennsylvania Germans* (Allentown, Pa.: Pennsylvania German Folklore Society, 1961), and Corinne and Russell Earnest, *Fraktur: Folk Art and Family* (Atglen, Pa.: Schiffer Publishing, 1999).

14. The Peirce family register is in the possession of the American Antiquarian Society, Worcester, Massachusetts.

15. Lawrence C. Wroth, *The Colonial Printer* (1931; reprint, Charlottesville, Va.: Dominion Books, 1964), 29–30.

16. Special thanks is due to James Green of The Library Company of Philadelphia for calling our attention to other early printed broadside-type family registers. One was possibly printed about 1766 in New Bern, North Carolina, for the Davis family. The only known copy is at the University of North Carolina. Although New Bern was settled by German-speaking immigrants, this register appears to have been made for a family of British heritage. In addition, James Green located a printed register for the Thomas family. It was printed sometime after 1787.

17. Meredith B. Colket, "Family Records Printed During the Colonial Period," *The Papers of the Bibliographical Society of America* (New York: The Bibliographical Society of America, 1963), 57:61–67.

18. The Clap history/genealogy is in the collection of the American Antiquarian Society, Worcester, Massachusetts. A photocopy of Captain Roger Clap's published account was provided to us by Readex Microprint Corporation, Chester, Vermont.

19. Colket, "Family Records," 67.

20. Ibid.

21. Georgia Barnhill, Andrew W. Mellon Curator of Graphic Arts at the American Antiquarian

Society, Worcester, Massachusetts, personal communication, March 7, 2001. Through her work on New England family registers, Barnhill independently arrived at the same conclusion.

22. Colket, "Family Records," 66.

23. Ibid.

24. Shelley, *Fraktur-Writings,* 30.

25. Gloria Seaman Allen, *Family Record: Genealogical Watercolors and Needlework,* exh. cat. (Washington, D.C.: DAR Museum, 1989), 7.

26. Henry C. Mercer, "The Survival of the Mediaeval Art of Illuminative Writing Among Pennsylvania Germans," *Proceedings of the American Philosophical Society* 36 (September 1897): 424–33. Republished in *Bucks County Fraktur,* ed. Amsler, 5–13.

27. Henry S. Borneman, *Pennsylvania German Illuminated Manuscripts* (1937; reprint, New York: Dover Publications, 1973), 8.

28. Shelley, *Fraktur-Writings,* 70.

29. Ibid., #301 through #305.

30. Russell D. Earnest and Corinne P. Earnest, *Papers for Birth Dayes: Guide to the Fraktur Artists and Scriveners* (East Berlin, Pa.: Russell D. Earnest Associates, 1997). Unless otherwise noted, attributions to fraktur artists and scriveners and the source for data regarding fraktur artists and scriveners come from this publication.

31. Klaus Stopp, *The Printed Birth and Baptismal Certificates of the German Americans,* 6 vols. (Mainz, Germany: Klaus Stopp; East Berlin, Pa.: Russell D. Earnest Associates, 1997–2001). Stopp's work has alerted scholars to the scarcity of many editions of printed birth and baptism certificates. Stopp chronologically organized the numerous editions printed in various locations in Pennsylvania and other mid-Atlantic states and in the Midwest. His six-volume study serves as a model for future scholars interested in organizing the nationwide evolution of family registers from the standpoint of print technology.

32. Steven M. Nolt, *Foreigners in Their Own Land: Pennsylvania Germans in the Early Republic* (University Park, Pa.: The Pennsylvania State University Press, 2002), 2–3.

33. Allen, *Family Record,* 1.

34. Ibid., 4–5.

35. Ibid., 2.

36. Random samples were taken from all six categories of family registers; 44 percent of this sampling came from Bible-entry registers.

37. Scriveners who penned family registers in Bibles occasionally signed their works; in other cases, their works can be attributed to them confidently, based on their handwriting. Many of these scriveners are known to have worked in urban areas. Josh Reeder, the leading researcher on fraktur scriveners, has identified many of their birth and baptism certificates and Bible records. Reeder determined that scriveners such as Justus Epstein (active circa 1873–1900) and William Henning (1822–1895) worked almost exclusively in cities such as Reading and Lancaster, respectively. In comparing numerous Bible records made for urban families and those made for rural families, a pattern emerges, one suggesting that urban families were smaller. For example, in a sampling of 23 late-nineteenth-century Bible registers written by William Henning in Lancaster, 3.4 children, on average, were born per family. When sampling 101 Bible registers made for Pennsylvania-German families in rural and urban areas together, the average family had 7.4 children.

38. Earnest and Earnest, *Papers for Birth Dayes,* 17–18.

39. Allen, *Family Record,* 3. Others agree. In 1999, Bob Brooke wrote that the last two decades of the nineteenth century saw an "explosion of interest in genealogy." Brooke pointed out that this interest prompted magazines such as *Gleason's Pictorial Drawing Room Companion* and *Harper's Bazaar* to "print blank family records for their readers to tear out and keep." See Bob Brooke, "Victorians Popularized Decorative Family Trees," *AntiqueWeek,* April 12, 1999, 7B.

40. See, for example, the third volume of Netti Schreiner-Yantis's *Genealogical and Local History Books in Print,* 4th ed. (Springfield, Va.: Genealogical Books in Print, 1985). This volume lists more than 4,200 family-specific genealogy publications that were in print as of 1985. Many of these date from the closing decades of the nineteenth century.

41. Simon J. Bronner, Interim Director, School of Humanities at Penn State Harrisburg, personal communication, May 28, 2002. See also *Der Reggeboge* 25, no. 1 (1991).

Chapter 2

1. For a general history of the word "fraktur," see Corinne and Russell Earnest, "Fractur, Fraktur," *Der Reggeboge* 36, no. 2 (2002): 25–36.

2. John Demos, introduction to *The Art of Family: Genealogical Artifacts in New England,* by D. Brenton Simons and Peter Benes (Boston: New England Historic Genealogical Society, 2002), xii.

3. See especially David Luthy, *Amish Folk Artist Barbara Ebersol: Her Life, Fraktur, and Death Record Book* (Lancaster, Pa.: Lancaster Mennonite Historical Society, 1995), and Louise Stoltzfus, *Two Amish Folk Artists: The Story of Henry Lapp and Barbara Ebersol* (Intercourse, Pa.: Good Books, 1995).

4. John T. Humphrey, President of the Mid-Atlantic Germanic Society, personal communications, 2000–2002. For discussion of *Lebensläufe,* see Katherine M. Faull, *Moravian Women's Memoirs: Their Related Lives, 1750–1820* (Syracuse, N.Y.: Syracuse University Press, 1997).

5. See the introduction to *The Pennsylvania German Fraktur of The Free Library of Philadelphia,* comp. Frederick S. Weiser and Howell J. Heaney (Breinigsville, Pa.: The Pennsylvania German Society and Philadelphia: The Free Library of Philadelphia, 1976).

6. The closest counterpart Europeans had to the American *Taufschein* (fraktur birth and baptism certificate) was the *Taufpatenbrief* or *Taufzettel.* These hand-drawn or printed certificates commemorated baptisms, but they were given from the baptismal sponsor(s) to the child rather than given by the parents to the child. Contemporary with American *Taufscheine,* these European certificates were often folded over coins or medals meant as gifts from sponsors. They became especially popular in Alsace and in Bern, Switzerland. Compared with American *Taufscheine, Taufpatenbriefe* and *Taufzettel* are disappointing records concerning family data. Often, only the names of the sponsors were written on these certificates, and sometimes a date—which may or may not be the date of baptism. These documents frequently lacked the child's name, the child's date of birth, the child's parents' names, and the location. For more on *Taufpatenbriefe* and *Taufzettel,* see Corinne Earnest and Klaus Stopp, "Early Fraktur Referring to Birth and Baptism in Pennsylvania: A *Taufpatenbrief* from Berks County for a Child Born in 1751," *Pennsylvania Folklife* 44, no. 2 (1994–95): 84–88. For more on *Taufzettel,* see Konrad Weber, *Berner Taufzettel: Funktion und Formen vom 17. Bis 19. Jahrhundert* (Bern: Benteli Verlag, 1991); Konrad Weber with the collaboration of Klaus Stopp, *Schweizer Taufbriefe aus dem 19. Jahrhundert* (Bern, Langnau, Murten: Licorne-Verlag, 2001); Dominique Lerch, *Imagerie populaire en Alsace et dans l'Est de la France* (Nancy, France: Presses Universitaires de Nancy, 1992); and François Lotz, *Les Goettelbriefe (souhaits de baptême)* (Silva, Italy: D'Artegrafica, 1996).

7. *Hausbuch für die deutsche Familie* (Frankfurt am Main: Verlag für Standesamtswesen GmbH., 1956).

8. Fogleman, *Hopeful Journeys,* 89.

9. Earnest and Earnest, *Fraktur: Folk Art and Family,* 27.

10. John T. Humphrey, *Understanding and Using Baptismal Records* (Washington, D.C.: Humphrey Publications, 1996), 14. Humphrey's study provides an excellent review of baptismal practices among the many religious denominations in eighteenth- and nineteenth-century southeastern Pennsylvania. For more on religions among Pennsylvania Germans, see Shirley J. Riemer, *The German Research Companion* (Sacramento, Calif.: Lorelei Press, 1997), 427–58. Riemer includes brief historical accounts of Lutherans, Reformed, Pietists, Anabaptists, Mennonites, Amish, Schwenkfelders, Moravians, Huguenots, Harmonists, the Amana Colonies, Hutterites, Dunkers, United Brethren in Christ, German Methodists, Roman Catholics, and German Jews.

11. Amos Hoover, personal correspondence, May 2002.

12. Frederick S. Weiser in *Arts of the Pennsylvania Germans,* by Scott T. Swank (New York: W. W. Norton for The Henry Francis DuPont Winterthur Museum, 1983), 233.

13. Amos Hoover, personal correspondence, May 2002.

14. See Stopp, *Printed Birth and Baptismal Certificates,* especially vol. 6.

15. Ibid., 1:113–14, #20 and #21.

16. For an excellent account of the Great Awakening as it pertains to Pennsylvania Germans, see the second volume of Charles H. Glatfelter's *Pastors and People: German Lutheran and Reformed Churches in the Pennsylvania Field, 1717–1793,* published in 1981 by the Pennsylvania German Society, Breinigsville, Pennsylvania.

17. Karl John Richard Arndt and Reimer C. Eck, eds., and Gerd-J. Bötte and Werner Tannhof, comp., *The First Century of German Language Printing in the United States of America* (Göttingen: Niedersächsische Staats- und Universitätsbibliothek Göttingen; Birdsboro, Pa.: The Pennsylvania German Society, 1989).

18. This fraktur bookplate was brought to our attention by Amos Hoover.

19. Russell and Corinne Earnest, "A Living Tradition: Perspectives on North American Amish Fraktur," *Pennsylvania Mennonite Heritage* 23, no. 1 (2000): 2–12. For more on Amish arts, see Patri-

cia T. Herr, *Amish Arts of Lancaster County* (Atglen, Pa.: Schiffer Publishing, 1998), and Daniel and Kathryn McCauley, *Decorative Arts of the Amish of Lancaster County* (Intercourse, Pa.: Good Books, 1988). For more on Mennonite arts, see Clarke Hess, *Mennonite Arts* (Atglen, Pa.: Schiffer Publishing, 2002).

Chapter 3

1. Betty Ring, *Girlhood Embroidery: American Samplers and Pictorial Needlework, 1650–1850* (New York: Alfred A. Knopf, 1993).

2. Allen, *Family Record*, 2. According to Allen, registers on paper peaked numerically about 1810. Textile registers peaked about 1820. Allen's sample is based on 131 registers, 75 percent of which are New England examples. The remaining 25 percent are from the mid-Atlantic states and Ohio, but they are not necessarily Pennsylvania-German registers.

3. Tandy and Charles Hersh, *Samplers of the Pennsylvania Germans* (Birdsboro, Pa.: The Pennsylvania German Society, 1991), 58 and 290. In personal communications from 1999 to 2002, Patricia Herr, a leading expert on Pennsylvania-German needlework, suggested that Pennsylvania-German motifs on needlework were the product of tradition as opposed to formal instruction.

4. According to Tandy and Charles Hersh in *Samplers of the Pennsylvania Germans,* Pennsylvania-German samplers reached their numerical peak between about 1810 through 1859 (58). Ellen J. Gehret reported that Pennsylvania-German decorated towels reached their peak between 1820 and 1850. See Gehret's *This Is the Way I Pass My Time* (Birdsboro, Pa.: The Pennsylvania German Society, 1985), 8.

5. On occasion, fraktur lettering was stitched on decorated towels. See Gehret, *This Is the Way I Pass My Time,* 128, 131, 171, and 256. Special thanks to Tandy Hersh for pointing out these examples of fraktur lettering or German script used on decorated towels.

6. Other translations of *Geschlechtsregister* include "Family Line(s)," "Generations," and "Register of Lineage."

7. Courtesy of Amos Hoover, The Muddy Creek Farm Library, Ephrata, Pennsylvania. See also Michael S. Bird, *Ontario Fraktur: A Pennsylvania-German Folk Tradition in Early Canada* (Toronto: M. F. Feheley Publishers, 1977), 94.

8. Amos Hoover, personal communication, March 1, 2002.

9. D. Brenton Simons, "New England Family Record Broadsides and 'The Letterpress Artist' of Connecticut," *New England Historical and Genealogical Register* 153 (October 1999): 387–406.

10. Ibid.

11. Attribution courtesy of Clarke Hess, Lititz, Pennsylvania.

12. Russell and Corinne Earnest, "Where's the Cow: A New Look at Motifs on American Fraktur," *Folk Art* 25, no. 4 (2000–2001): 44–53.

13. Peter Benes, "Decorated New England Family Registers, 1770 to 1850," and Georgia Brady Barnhill, "Keep Sacred the Memory of Your Ancestors: Family Registers and Memorial Prints," both in *Art of Family,* by Simons and Benes, 13–59 and 60–74, respectively.

14. Mary Jane Lederach Hershey, "Andreas Kolb (1749–1811): Mennonite Schoolmaster and Fraktur Artist," *The Mennonite Quarterly Review* 61, no. 2 (1987): 127.

15. Thomas A. Sherk, *The Sherk Family* (Baltimore: Gateway Press, 1986), 36.

16. Benes, "Decorated New England Family Registers," 21.

17. Ibid., 25.

18. June Burk Lloyd, *Faith and Family: Pennsylvania German Heritage in York County Area Fraktur* (York, Pa.: York County Heritage Trust, 2001), 17–20.

19. Ibid., 18.

20. See Michael S. Bird, *O Noble Heart, O Edel Herz* (Lancaster, Pa.: The Heritage Center Museum of Lancaster County; Virginia Beach, Va.: Donning Company Publishers, 2002). Bird was able to locate examples of Pennsylvania-German fraktur that show obvious Christian motifs, but many other examples illustrated by Bird confine religious sentiments to the text.

21. Earnest and Earnest, *Fraktur: Folk Art and Family,* 81–82.

22. Ibid.

23. Papermakers frequently mark paper as it is being manufactured. For a catalog of watermarks that appear on American paper or on paper used in America, see Thomas L. Gravell and George Miller, *A Catalogue of American Watermarks, 1690–1835* (New York: Garland Publishing, 1979), and Gravell

and Miller, *A Catalogue of Foreign Watermarks Found on Paper Used in America, 1700–1835* (New York: Garland Publishing, 1983).

24. Thomas L. Gravell, George Miller, and Elizabeth Walsh, *American Watermarks, 1690–1835* (New Castle, Del.: Oak Knoll Press, 2002).

25. Stopp, *Printed Birth and Baptismal Certificates.* See especially the section on Ephrata in the second volume.

26. Shelley, *Fraktur-Writings,* 23.

27. Georgia Barnhill, personal communication, July 20, 2000.

28. Special thanks is due to Georgia Barnhill of the American Antiquarian Society in Worcester, Massachusetts, for showing us examples of Isaiah Thomas Bibles during our research at the Society, August 24, 2000.

29. Barnhill, "Keep Sacred the Memory of Your Ancestors: Family Registers and Memorial Prints," unpublished manuscript; an edited version by the same title appears in *Art of Family,* by Simons and Benes, 60–74.

30. Ibid.

Chapter 4

1. Numerous biographical encyclopedias were published for Pennsylvania counties in the closing decades of the nineteenth century and in the opening years of the twentieth. Family biographies in these encyclopedias tend to boast of a family's success. Many focus on urban families, probably because highly successful agents collecting information for individual biographies found numerous contributors—who paid to be included in the volumes—in dense populations. Thus, farmers and their families were sometimes poorly represented in "Glory Album" encyclopedias.

2. Daniel Kolb Cassel, *A Genealogical History of the Kolb, Kulp, or Culp Family and Its Branches in America* (Norristown, Pa.: Morgan R. Wills, 1895), 483–84.

3. Ibid., 11–12.

4. John L. Ruth, *Maintaining the Right Fellowship* (Scottdale, Pa.: Herald Press, 1984), 142.

5. Cassel, *History of the Kolb Family,* 11–12.

6. Ibid.

7. Ruth, *Maintaining the Right Fellowship,* 142.

8. Amos Hoover made the same observation in personal interviews throughout 2001.

9. Beverly Repass Hoch, CGRS, *From Ziefen to Sally Run: Swiss Pioneer Jacob Repass (1737–1814) on the American Frontier* (Wytheville, Va.: Jacob Repass Memorial Fund, 1993), 71. See also Corinne P. Earnest and Beverly Repass Hoch, *German-American Family Records in the Fraktur Tradition* (East Berlin, Pa.: Russell D. Earnest Associates, 1991–94), 1:174–75.

Chapter 5

1. Simon J. Bronner, personal communication, May 28, 2002.

2. An 1802 edition of a Mathew Carey Bible was sold at Horst Auction Center in Ephrata, Pennsylvania, on March 31, 2001. This edition had a bound-in preprinted family register.

3. Photocopies of family registers found in Gottlob Jungmann Bibles are housed in numerous historical societies throughout southeastern Pennsylvania, including, for example, the Mennonite Heritage Center in Harleysville, Pennsylvania.

4. For more on the Virginia Record Book Artist, see Carolyn J. Weekley, "Decorated Family Record Books from the Valley of Virginia," *Journal of Early Southern Decorative Arts* 7, no. 1 (1981): 1–19.

5. For histories of the Ephrata Cloister, see, among others, E. G. Alderfer, *The Ephrata Commune: An Early American Counterculture* (Pittsburgh: University of Pittsburgh Press, 1985); Felix Reichmann and Eugene E. Doll, *Ephrata: As Seen by Contemporaries* (Allentown, Pa.: The Pennsylvania German Folklore Society, 1953); and James E. Ernst, *Ephrata: A History* (Allentown, Pa.: The Pennsylvania German Folklore Society, 1963). See also Julius Friedrich Sachse, *The German Sectarians of Pennsylvania: A Critical and Legendary History of the Ephrata Cloister and the Dunkers,* 2 vols. (Philadelphia: Printed for the author, 1899–1900; reprint, New York: AMS Press, 1971).

6. Michael Showalter, Ephrata Cloister Museum Educator, personal communication, May 3, 2001.

7. Some maintain that earlier American fraktur exists. For example, in *The Red Hills,* Cornelius Weygandt pictured a decorated religious text dated 1726. It remains uncertain, however, that this piece is actually American. See Weygandt, *The Red Hills: A Record of Good Days Outdoors and In, with Things Pennsylvania Dutch* (Philadelphia: University of Pennsylvania Press, 1929), 125.

8. Sachse, *German Sectarians,* 2:222.

9. Stopp, *Printed Birth and Baptismal Certificates,* 2:98–217.

10. Identification of the watermark is credited to Jerome Anderson, Timothy Salls, and Chad Leinaweaver of the New England Historic Genealogical Society, Boston, Massachusetts.

11. Arndt and Eck, eds., *First Century of German Language Printing,* 133.

12. Clarence Edwin Spohn, "The Bauman/Bowman Family of the Cocalico Valley: Printers, Paper-makers, and Tavernkeepers," *Journal of the Historical Society of the Cocalico Valley* (Ephrata, Pa.) 19 (1994). According to Spohn, John Bauman moved the Cloister press to his home in Ephrata (25). Information regarding the Bauman family of printers came from Spohn and Stopp.

13. This register sold at Horst Auction Center in Ephrata, Pennsylvania, on June 15, 1991.

14. Special thanks to Clarke Hess of Lititz, Pennsylvania, who brought this register to our attention, and to Carolyn Wenger, Curator of the Lancaster Mennonite Historical Society in Lancaster, Pennsylvania, for allowing us to examine it. The original Bowman register is in the collection of the Herr House Museum owned by the Lancaster Mennonite Historical Society.

15. The current location of this register is unknown. Fortunately, a photocopy exists. It was published by Clarence Spohn in the 1994 issue of the *Journal of the Historical Society of the Cocalico Valley.* Spohn suggested that the printer was Samuel Bauman (1788–1820). The printer may have been Samuel's father, John Bauman (1765–1809).

16. Special thanks to Amos Hoover and Klaus Stopp for confirming this translation made by C. Richard Beam in 1989. Bird's *Ontario Fraktur* calls this printed broadside a "memorial." Bird also mentions that one of Christian Weber's descendants was Weber's great-granddaughter, Anna Weber (1814–1888), who became a fraktur artist in Canada. We were unable to make an exact typographic match of the Weber register to Ephrata printers Joseph Bauman or Richard Heitler (1795–1847). This example may have been printed elsewhere, perhaps in Reading.

17. William Henry Egle, *Notes and Queries: Historical, Biographical, and Genealogical Relating Chiefly to Interior Pennsylvania,* 3d ser. (1896; reprint, Baltimore: Genealogical Publishing, 1970), 3:229.

18. Colket, "Family Records," 63. The only known copy of the 1763 Bollinger register is in the New England Historic Genealogical Society in Boston. Some have suggested other copies exist. We followed every trail to locate other copies but, to date, only one copy is known to us.

19. D. Brenton Simons, "New England Family Record Broadsides and Portraiture, and the Letter-press Artist of Connecticut," in *Art of Family,* by Simons and Benes, 98.

20. Colket, "Family Records," 63.

21. Gary L. Bollinger, *Research and Ramblings on the History of the Bollinger Family of Lancaster, Pennsylvania* (Northfield, Minn.: Self-published, 1998). Colket speculated that the father on the 1763 Bollinger register was Jacob Bollinger, but evidence points more strongly toward immigrant Rudolph Bollinger. Bollinger family data was provided courtesy of Gary Bollinger of Northfield, Minnesota; Tony Bollinger of Erwin, Tennessee; and Ken and Vic Leininger of Denver, Pennsylvania, and Quarryville, Pennsylvania, respectively.

22. Only one other fraktur has been attributed to the unnamed artist who decorated the Bollinger/Nees register. It is a watercolor drawing of what is believed to be George Washington on horseback. It is drawn on a full-size sheet having the "CB" watermark for Christian Bauman of the Ephrata Cloister.

23. Barnhill, "Keep Sacred the Memory."

24. Richard Warren Davis, *The Stauffer Families of Switzerland, Germany, and America (Including Stouffer and Stover)* (Provo, Utah: Richard Warren Davis, 1992), 106.

25. Colket, "Family Records," 67. See also Meredith B. Colket's article, "The Stauffer-Stouffer (Stover) Family of Pennsylvania," *Genealogies of Pennsylvania Families from the Pennsylvania Genealogical Magazine* (Baltimore: Genealogical Publishing, 1982), 3:1–50.

26. In a personal communication dated February 4, 2002, Richard Warren Davis noted that his information concerning the Stauffer Bible register came from the transcript of the record, not the original.

27. Some handwritten registers also use roman lettering for Latin words such as "Anno."

28. Davis, *The Stauffer Families,* 105–6.

29. "Our Manheim Newspapers," in *Historical Manheim, 1762–1976* (n.p., n.d.), and "Through the Years with the Sentinel Printing House and the Manheim Sentinel," in *Manheim Bicentennial, 1762–1962* (n.p., n.d.). See also Eugene R. Rightmyer, "Less-Known Biologists of Lancaster County," *Papers of the Lancaster County Historical Society* 57, no. 3 (1953): 50–53.

30. For more on the location of the Stauffer family at the time of Johannes Stauffer's birth, see Davis, *The Stauffer Families,* 55–56 and 105–6.

31. Ibid., 105.

32. Anne Frysinger Shifflet, *Pennsylvania German Ancestors: A Family History, Frysinger, Schaffner, Royer, Keller, and Related Families in Lancaster, York, Berks, Dauphin, and Lebanon Counties* (Frederick, Md.: AFS Publications, 1999), 406. In an article called "The Ephrata Printers" that appeared in *The Pennsylvania Dutchman,* Alfred L. Shoemaker wrote that Bauman relocated in 1831 (see *The Pennsylvania Dutchman* 4, no. 9 [1953]: 11). Clarence Spohn wrote that Bauman relocated in 1830 (see Spohn, "The Bauman/Bowman Family of the Cocalico Valley," 54).

33. St. Michael's Evangelical Church Records of Philadelphia, bound facsimile of handwritten transcriptions, The Historical Society of Pennsylvania.

34. James Green, The Library Company of Philadelphia, personal interview, February 6, 2003.

35. Carola Wessel, Göttingen University, personal correspondence, February 8, 2003. Wessel found an identical copy of the Ottinger/Welsch register at the American Antiquarian Society in Worcester, Massachusetts. She noted that it might once have been pasted in a Bible but now stands alone. This was confirmed by Georgia Barnhill in a subsequent communication. Wessel located a third copy at the Pattee Library of The Pennsylvania State University. After examining that copy, we determined that it likely belonged to Christopher and Maria Ottinger's daughter, Rahel [Rachel], who was born February 4, 1745. It remains pasted inside the front cover of a 1776 Saur Bible.

36. See our "Ausfullers und Dindamen: The Fraktur Scriveners of Bucks County," in *Bucks County Fraktur,* ed. Amsler, 178–93. Several nineteenth-century printers in Doylestown printed German-language newspapers and broadsides. These printers are listed by Alfred L. Shoemaker in *Pennsylvania Folklife* 3, no. 15 (1952): 4–15.

37. Stopp, *Printed Birth and Baptismal Certificates,* 5:22–23.

38. Earnest, "Ausfullers und Dindamen," 181–82.

39. Stopp, *Printed Birth and Baptismal Certificates,* vols. 1–6.

40. Ibid., 1:108, #15, and 6:168–69, #1018.

41. "Through the Years With The Sentinel."

42. Photocopies of the Benjamin Hershey and Samuel Hershey booklets are in the Hershey family file at the Lancaster Mennonite Historical Society.

43. Ibid., Hershey family file, Lancaster Mennonite Historical Society.

44. Courtesy Clarke Hess, Lititz, Pennsylvania.

45. This attribution is based on border pieces similar to those found in Stopp, *Printed Birth and Baptismal Certificates,* 3:200–201.

46. We owe special thanks to John Vidosh of Sunbury, Pennsylvania, for calling this register to our attention.

47. Special thanks to June Burk Lloyd, Librarian at the York County Heritage Trust, York, Pennsylvania, for sharing a photocopy of the Wood/Harper family register. According to Lloyd, this register is pictured in *The Simon Walter Family,* comp. Ethel (Walter) Hupp and John C. Hupp, published in 1959.

48. This attribution is based on similar examples seen in Stopp, *Printed Birth and Baptismal Certificates,* 5:228–29 and 6:269.

49. This example has the imprint "Henkel Print New Market VA."

50. Special thanks to Peter Seibert, Director, and Wendell Zercher, Curator, at the Heritage Center Museum of Lancaster County in Lancaster, Pennsylvania, for calling this register to our attention.

51. Bird, *Ontario Fraktur,* 93–95, 110, and 132.

52. Earnest and Earnest, *Papers for Birth Dayes,* 460–67.

53. Ibid., 742–46.

54. Ibid.

55. Examples include a "Birth Register" made for the Fretz/Kolb family of Bedminster Township, Bucks County, Pennsylvania. This example is signed by John Moyer and dated July 16, 1782. It is pictured in *Bucks County Fraktur,* ed. Amsler, 101. Another example is attributed to fraktur artist Adam Eyer. This register is pictured in the second volume of *The Pennsylvania German Fraktur of The*

Free Library of Philadelphia, comp. Weiser and Heaney, #538. The latest date on this register is June 26, 1782. It was made for the Kolb/Fretz [*sic*] family of Montgomery County, Pennsylvania. We owe special thanks to William Lang and Joël Sartorius of the Rare Books Department at The Free Library of Philadelphia for their assistance in examining this record.

56. Lloyd, *Faith and Family,* 112–13.

57. *The Kentucky Rifle Association [Newsletter]* 4, no. 2 (1978): 4–10. See also Herbert H. Beck, "Martin Meylin: A Progenitor of the Pennsylvania Rifle," *Papers of the Lancaster County Historical Society* 53, no. 2 (1949): 33ff.

58. H. Beck, "Martin Meylin," 50.

59. Ibid., 51.

60. Courtesy Clarke Hess, Lititz, Pennsylvania.

61. Earl F. and Ada F. Robacker, "Floral Motifs in Dutchland's Art," *Pennsylvania Folklife* 17, no. 4 (1968): 4. In a symposium held on October 13, 2001, Wendell Zercher, Curator at the Heritage Center Museum of Lancaster County, presented information concerning this fraktur. Based on similarities in art and handwriting to signed examples, Zercher identified the artist as Eli Haverstick.

62. The two pieces of the Meylin/Kindig register are currently in The Dietrich American Foundation in Chester Springs, Pennsylvania.

63. See *The Pennsylvania German Fraktur of The Free Library of Philadelphia,* comp. Weiser and Heaney, vol. 1, #184. This incomplete register was made for Joseph Landes and Sara Fretz, who married in 1795. It is attributed to fraktur artist Rudolf Landes (1789–1852).

64. Peter Seibert, Director of the Heritage Center Museum of Lancaster County, first suggested that the two large birds on this fraktur were likely drawn to fill space. When compared to other Hoke family registers decorated with floral borders and fancy lettering that often included metallic gold paint and glitter, this piece is unusually bold and folky.

65. Amos Hoover, personal communication, July 31, 2001.

66. Stopp, *Printed Birth and Baptismal Certificates,* 5:202–11, #898.1 through #900.

67. Ibid., 5:204.

68. Barnhill, "Keep Sacred the Memory."

69. This was often true on *Taufscheine* as well. Mennonites frequently used *Taufscheine* printed forms on which they left blank the information concerning baptism. Thus, the omission of data about baptism does not necessarily mean that the family forgot.

70. Wendy Shadwell of the New-York Historical Society confirmed the existence of the 1869 edition of a German-language Currier and Ives register (personal communication, May 2001). This register is not listed in Walton Rawls, *The Great Book of Currier and Ives' America* (New York: Abbeville Press, 1979).

71. Barnhill, "Keep Sacred the Memory."

72. Ibid.

73. Lemon, *The Best Poor Man's Country,* 18.

74. Josh Reeder, "William Henning, Fraktur Scrivener," *Antique Review* (June 1996): 16–17.

75. Letter dated February 1, 2001, from Dr. Eberhard Zwink, Württembergische Landesbibliothek, to Prof. Dr. Klaus Stopp. See also David Luthy, "The First Century of German Bibles Printed in North America: 1743–1842," *Pennsylvania Mennonite Heritage* (October 1990): 32–38.

76. In October 2000, this register was in an antique shop in Fleetwood, Berks County, Pennsylvania.

77. Josh Reeder, "A Fraktur Scrivener Rediscovered," *Antique Review* (March 1996): 38. Several years ago, Reeder located a Bible register penned by scrivener Ferdinand Klenk for his own family. Klenk gave a relatively thorough account of himself. Among other information given, Klenk said that he was born in Windischenbach near Oehringer in Württemberg and that he emigrated in 1846 with his father, Christoph. Reeder's discovery of this family record was especially fortunate. Had this Bible fallen into the hands of someone who knew nothing about Klenk and the fact that he is considered a major scrivener in the field of fraktur, this information would probably have been lost.

78. Allen, *Family Record,* 4.

79. Earnest and Hoch, *German-American Family Records in the Fraktur Tradition,* vols. 1–3.

80. Margaret T. Hills, ed., *The English Bible in America: A Bibliography of Editions of the Bible and the New Testament Published in America, 1777–1957* (New York: American Bible Society and The New York Public Library, 1961), xxiv. Note that Hills begins with the date of 1777. This is the date of a New Testament printed and sold by Robert Aitken of Philadelphia. The combined Old and New Testaments were not printed in America in English until Robert Aitken printed his Bible in 1782.

81. Hugh Amory and David D. Halls, eds., *A History of the Book in America, Volume I: The Colonial Book in the Atlantic World* (Worcester, Mass.: American Antiquarian Society; New York: Cambridge University Press, 2000), 124–25. See also Allen, *Family Record*, 1.

82. The elder Christopher Saur is believed to have been a Separatist. See Longenecker, *The Christopher Sauers*, 52, and chapter 3, note 38. See also Donald F. Durnbaugh, "Was Christopher Sauer a Dunker?" *Pennsylvania Magazine of History and Biography* (July 1969), and Luthy, "First Century of German Bibles."

83. William T. Parsons, "Lebenslauf von Joh. Nic. Schaefer: Autobiography of John Nicholas Schaefer, 1722–1807," *Pennsylvania Folklife* 28, no. 3 (1979): 6.

84. Longenecker, *The Christopher Sauers*, 54.

85. *In the Beginning Was the Word,* exh. cat. (Washington, D.C.: The Cathedral Rare Book Library, 1965), 33, #27.

86. A Bible printed in Latin by Johannes Froben in Basel in 1491 is called the first "poor man's Bible." It was printed in octavo. This relatively small size earned the Bible its colloquial name, for it represented a savings in materials for the printer. See *In the Beginning Was the Word,* 34–35, #37. According to Urs B. Leu, Martin Luther (1483–1546) together with others translated the New Testament from Greek to German. Luther published this translation in September 1522, earning it the name "the September Testament." According to Leu, this New Testament cost a "modest price." It should be kept in mind, however, that Luther's September Testament included the New Testament alone. And the "poor man's Bible" was published in Latin rather than in the German vernacular. See Urs B. Leu, "The Froschauer Bibles and Their Significance for the Anabaptist Movement," *Pennsylvania Mennonite Heritage* 25, no. 2 (2002): 10–19.

87. Leu, "The Froschauer Bibles."

88. Urs B. Leu, "The Significance of the Froschauer Bible in the Anabaptist Movement," October 22, 2001 lecture at the Lancaster Mennonite Historical Society in Lancaster, Pennsylvania. See also David Luthy, "Anabaptist Testaments and the 'Lord's Prayer,'" *Family Life* (June 1980): 19–21.

89. Richard Cryer, *Longenecker Family Newsletter* 1, no. 4 (1999): 2–4. Richard Cryer is reconstructing the history of the Longeneckers in Pennsylvania in part through family artifacts. Historically, genealogists ignored this avenue for researching family history. Instead, they relied on standard records such as wills, deeds and indentures, land records, and church and military records. Increasingly, family historians are adding material culture to their research. They frequently use these primary sources to interpret family history. Cryer's remarkable efforts add not only previously unknown information but also a richer heritage to the Longenecker family history.

90. Courtesy Josh Reeder.

91. The *Mennonite Historians of Eastern Pennsylvania (MHEP) Newsletter* is published by the Mennonite Heritage Center, Harleysville, Pennsylvania.

92. Joel D. Alderfer, "Peter Stauffer Family Bible Record Rediscovered," *MHEP Newsletter* 21, no. 5 (1994): 6–8. Also see Joel D. Alderfer, "The Peter Stauffer Family Bible Record Is Found," *Mennonite Family History* 13, no. 4 (1994): 170–71.

93. Edwin A. R. Rumball-Petre, *America's First Bibles, with a Census of 555 Extant Bibles* (Portland, Me.: The Southworth-Anthoensen Press, 1940; facsimile edition, Mansfield Centre, Conn.: Martino Publishing, n.d.).

94. Ibid., #170, #172, and #189, respectively.

95. The original register is at the Lancaster Mennonite Historical Society. Curator Carolyn Wenger graciously allowed us to examine this early record. See also John Landis Ruth, *The Earth Is the Lord's: A Narrative History of the Lancaster Mennonite Conference* (Scottdale, Pa.: Herald Press, 2001), 195 and 206–7.

96. "Readers' Ancestry," *Pennsylvania Mennonite Heritage* 8, no. 2 (1985), 36.

97. For more on this family, see Ruth, *The Earth Is the Lord's*, 206–8.

98. Ruth, *Maintaining the Right Fellowship*, 166.

99. See the numerous family files at the Lancaster Mennonite Historical Society. Many of these files have photocopies of Bible-entry family registers. In addition, the Mennonite Heritage Center in Harleysville, Pennsylvania, has photocopies of Bible-entry registers arranged in a three-ring binder, so that access to data on these registers is especially convenient for researchers.

100. Courtesy Amos Hoover, Muddy Creek Farm Library, Ephrata, Pennsylvania.

101. Weekley, "Decorated Family Record Books."

102. David B. McGrail, "Late Eighteenth- and Early Nineteenth-Century Illuminated New Jersey Documents: An Introduction and a Checklist," *New Jersey History* 105, no. 1–2 (1987): 63 n. 2.

103. Schreiner-Yantis, *Genealogical and Local History Books in Print,* vols. 1–5.

104. Ibid.

105. In 1998, *USA Today* published findings gathered by Mantz Marketing Research for American Demographics. These results show that half the adult population in America between the ages of forty-five and sixty-four say that they are interested in family history. Their interest varies in degree. Most (about 94 percent) discuss family history with relatives, while others (about 57 percent) write family histories or create family trees.

106. Rev. Samuel Heinecke, Elder, *Genealogy from Adam to Christ, with the Genealogy of Adam Heinecke and Henry Vandersall, from 1747 to 1881,* 2d ed. (Lancaster, Pa.: John A. Hiestand, 1881).

107. Ibid., 85–86.

108. Robert Elliott Flickinger, *The Flickinger Families in the United States* (Des Moines, Iowa: Success Composition and Printing, 1926).

109. W. C. H[eyer], *Anna Weiser Muhlenberg (Mrs. Patriarch H. M. M.): A Morning Star in the Destiny of a Continent* (Shamokin, Pa.: The Leader Publishing, 1916).

110. Anna Maria Weiser was born in 1727 in Schoharie, New York. For more on the Weiser family, see *Weiser Families in America: Prepared for the Three-Hundredth Anniversary of the Birth of John Conrad Weiser (1696–1760),* ed. Frederick S. Weiser, Paulette J. Weiser, and Edward H. Weiser. This two-volume history was published in 1997 by The John Conrad Weiser Family Association, New Oxford, Pennsylvania.

111. The Conrad Weiser family immigrated to New York with the "1709ers." Henrich Melchior Muhlenberg immigrated in 1742.

Epilogue

1. See *The Report* (Baltimore) 37 (1978): 26.

Allen, Gloria Seaman. *Family Record: Genealogical Watercolors and Needlework*. Exh. cat. Washington, D.C.: DAR Museum, 1989.

Amsler, Cory M., ed. *Bucks County Fraktur*. Doylestown, Pa.: The Bucks County Historical Society; Kutztown, Pa.: The Pennsylvania German Society, 1999.

Bird, Michael S. *Ontario Fraktur: A Pennsylvania-German Folk Tradition in Early Canada*. Toronto: M. F. Feheley Publishers, 1977.

Earnest, Corinne and Russell. *Fraktur: Folk Art and Family*. Atglen, Pa.: Schiffer Publishing, 1999.

Earnest, Russell D., and Corinne P. Earnest. *Papers for Birth Dayes: Guide to the Fraktur Artists and Scriveners*. East Berlin, Pa.: Russell D. Earnest Associates, 1997.

Hess, Clarke. *Mennonite Arts*. Atglen, Pa.: Schiffer Publishing, 2002.

Lloyd, June Burk. *Faith and Family: Pennsylvania German Heritage in York County Area Fraktur*. York, Pa.: York County Heritage Trust, 2001.

McGrail, David B. "Late Eighteenth- and Early Nineteenth-Century Illuminated New Jersey Documents: An Introduction and a Checklist." *New Jersey History* 105, no. 1–2 (1987).

Shelley, Donald A. *The Fraktur-Writings or Illuminated Manuscripts of the Pennsylvania Germans*. Allentown, Pa.: Pennsylvania German Folklore Society, 1961.

Simons, D. Brenton, and Peter Benes. *The Art of Family: Genealogical Artifacts in New England*. Boston: New England Historic Genealogical Society, 2002.

Spohn, Clarence Edwin. "The Bauman/Bowman Family of the Cocalico Valley: Printers, Papermakers, and Tavernkeepers." *Journal of the Historical Society of the Cocalico Valley* (Ephrata, Pa.) 19 (1994).

Stopp, Klaus. *The Printed Birth and Baptismal Certificates of the German Americans*. 6 vols. Mainz, Germany: Klaus Stopp; East Berlin, Pa.: Russell D. Earnest Associates, 1997–2001.

Weiser, Frederick S., and Howell J. Heaney, comp. *The Pennsylvania German Fraktur of The Free Library of Philadelphia*. Breinigsville, Pa.: The Pennsylvania German Society; Philadelphia: The Free Library of Philadelphia, 1976.

INDEX

Page numbers in *italic* refer to illustration captions.